The Graphic Designer's Guide
to Pricing, Estimating & Budgeting

■

Theo Stephan Williams

■

ALLWORTH PRESS
NEW YORK

08 07 06 05 04 8 7 6 5 4

Published by Allworth Press
An imprint of Allworth Communications
10 East 23rd Street, New York, NY 10010

Cover design by Douglas Design Associates, New York, NY
Page composition/typography by Sharp Des!gns, Lansing, MI

ISBN: 1-58115-098-9

LIBRARY OF CONGRESS CATALOGING-IN-PUBLICATION DATA
Williams, theo Stephan, 1960–
The graphic designer's guide to pricing, estimating & budgeting / by Theo Stephan Williams.—Rev. ed.
p. cm.
Rev. ed. of: Pricing, estimating & budgeting. c1996.
Includes index.
ISBN 1-58115-098-9
1. Commercial art—Economic aspects—Handbooks, manuals, etc. 2. Commercial art—Practice—Handbooks, manuals, etc. I. Williams, Theo Stephan, 1960– Pricing estimating & budgeting. II. Title.
NC1001.6 .W55 2001
741.6'068—dc21
2001022383

Printed in Canada

Contents

Acknowledgments

This book is dedicated to my dad, whose spirited love for his own work and entrepreneurialism—way before anybody ever knew what that meant—paved the way to my own independence.

My mother's endless supply of hugs and her constant reminder to me as a young girl that I could do *anything* I put my mind to is one of my greatest rewards.

Thanks to Tad Crawford, who believed in the first edition of this book enough to ask me to revise and republish it with Allworth Press.

Special thanks to Anne Hellman, who helped convert a run-on file of the original manuscript into a great working document. The entire Allworth Press staff is to be commended for their ongoing professionalism, creativity, and perseverance—thanks everyone!

Last, but never least, thanks to my husband Joel for unbegrudgingly, generously giving me alone time whenever I ask for it, ignoring all of my panic attacks, and always validating me in true *Mars and Venus* fashion.

■

Why Me?

You're probably wondering why you picked up this damn book in the first place. Pricing, estimating, budgeting, and everything revolving those three things in our industry are more than a royal pain, and everyone knows it.

You've had the highs of that corporate client who had to get it done and never balked once at your pricing. You didn't even give him an estimate. He begged you to give it to him over the phone. The day of your presentation, he got so excited, he called some of his colleagues in to show off your ideas. You even got paid two weeks after you submitted your invoice. Now, *this* is what a graphic designer lives like! Wrong.

Sure, it might happen every once in awhile. But realistically, this isn't going to be the norm, even if you are one of those design firm names seen in every awards annual, industry magazine, and big design show. Even the big guys have to get down to basics—pricing, estimating, and budgeting.

When I started out on my own in 1983, I truly expected the worst. I sold my beautiful car so as not to have a car payment. I paid off all of my charge accounts before I quit my job in anticipation of not being able to pay monthly minimum payments. I even went so far as to lie to my parents, telling them I got laid off, so they would feel sorry for me and lend me money if I couldn't scrape up enough work to feed

myself. I moved a twin bed into my bedroom to allow room for a desk, drafting table (prehistoric, pre-computer days!), and supplies—moving to a two-bedroom apartment would have been too expensive.

Well, doomsday never arrived. In fact, business was so good that after two short months of paying tow bills from my "new" used car's traumatic breakdowns, I bought a new car. My zero-balance credit cards were once again self-activated, to the delight of my wardrobe. Exactly one year after breaking free from the entanglements of the corporate ball-and-chain, I bought my own home and created a nice studio space to welcome clients and vendors. And I did it all with profit. You can profit, too, by establishing guidelines and simple disciplines for yourself that will soon begin ticking like clockwork!

Profit—you've got to have it to survive. Sure, you can get by for a while breaking even on jobs. But it won't take long to burn out, shrivel up, and change careers. Graphic design can and should be a very lucrative industry. Just how profitable you are goes back to basics: What are your rates? Are your estimates comprehensive yet concise? Do you have an efficient method of project management? This book will help you answer these questions and will give you many ways to accomplish the feat of profitability.

Profiting from your graphic design business is essential, not only for you but for the entire industry. There are two reasons a business fails: (1) You don't have enough sales, or (2) You are not profitable—meaning, you're either not charging enough for your services or you're mismanaging budgets. You are doing not only yourself, but also your colleagues across the nation, a great disservice by not charging your clients enough money for your work to be profitable.

Why you? Because you love being a graphic designer, you want to be successful, and you know that to achieve the ultimate successes of it all, you've got to be a savvy businessperson. And if you're not the master of the issues detailed in this book, you can forget any business dreams in graphic design . . . I hear there's a burger joint down the street looking for a few good flippers!

The Quintessential Rose-Colored Glasses

I can promise you that the three hardest things you'll ever do in the business of graphic design is figure out how much to charge for your services, how to do an estimate, and how to manage project budgets

completely and efficiently. We graphic designers tend to walk around in those great rose-colored glasses, sporting the latest in designer fashion frames, never even *thinking* about charging for our work. Why should we? Our work is cool, someone will buy it.

A stigma is truly present everywhere in the design world surrounding "money issues." Having to actually deal with them can seem worse than anything you might have ever imagined for yourself. But wait! It's not so bad—really! You can even delegate a lot of this stuff.

The truth of the matter is that once you find out how to successfully perform the tasks of pricing, estimating, and managing budgets, you'll probably want to perform a lot of these tasks yourself. There is no greater feeling than taking complete ownership of a project—and that means administratively as well as creatively.

This book is written by the ultimate wearer of those aforementioned rose-colored glasses. So, it's really true—you can have your rosy glasses and your financial acumen, too! Once you're the master of this pricing, budgeting, and estimating destiny, people will want you to come talk to them about it, lecture at design conferences, even write books. Because, you see, we're all so afraid of the subject.

At a recent international design conference, I, along with almost two thousand other graphic designers, sat in a packed conference room listening to three top-notch design firm owners discuss "the business of graphic design." They all showed their work and discussed, in panel style, how they had obtained the projects and what types of awards they eventually won with them. I found myself getting really agitated because this wasn't about "business" at all.

Finally, during Q&A an astute designer in the audience asked my favorite guy up there (and a popular speaker at these conventions), "How much did you charge for the XYZ (not the real name) logo?" Well, ladies and gentlemen, my favorite Mr. Guru blew it big time. He stuttered and faltered, and from the fortieth row I saw those telltale signs of stress bead onto his forehead. His answer was that "it was proprietary information." We were all there in that room to learn about the business, and this guy let two thousand people down. During that same conference the same person who had asked the question happened to be in my pricing seminar. I had hoped she would be. I answered her question. Of course, I didn't know for sure how much my colleague had charged his client for the logo . . . but I knew how much he *should've* charged!

I believe that I can make a pretty unanimous conclusion about graphic designers. I have interviewed over a hundred design firm owners for various articles, books, etc., and if my Mr. Guru is any good example—as the other interviewees were—we all like making money. We like to spend money. We like to have nice homes that look like a photographer could come in at a moment's notice and take a shot for a home interiors magazine. We like nice clothes; we wear trendy (rose-colored optional) glasses.

But the other unanimous thing is we don't like pricing and managing the projects that we are lucky enough to obtain. Yet another affirmation is the absolute necessity for a systematic yet unintimidating approach to these tasks. The result is in these pages. You will find different types of forms, checklists, and tips prescribed from a compilation of ongoing research in my seventeen-year-plus history of owning my own graphic design business.

Check out the appendixes as a detailed reference for forms reviewed in this book. The section was written by Tad Crawford, author of *Business and Legal Forms for Graphic Designers*. Tad's book contains more substantive, specific forms and includes ready-to-use formats on CD-ROM for your use and personal modification. I suggest reading *my* book with a highlighter or notepad nearby to create a nice, individually edited version for your future handy reference.

So, lighten up about the money issues already. Relax, sit back, and enjoy the fruits of your labor even more by learning new ways to price, estimate, and manage the plethora of projects that are cascading in your direction.

Making Your Mark

Your decision about how much to charge for the services you provide is a most significant one. Establishing rates presents many challenges and raises many questions: What is the economy like in your area? What are the average rates now being charged for the services you will provide? Do you want to be on the low end, high end, or in the middle? Ultimately, you will want to set a price that's high enough to cover your expenses and earn you a profit, and low enough to be competitive for the work you do.

Always think about pricing directly in connection with profit—they really do go hand in hand. Also, be very business-minded when

you approach this decision. Study your individual situation using the guidelines in this chapter. Establish your pricing with self-confidence, and know that this is one area of your business that deserves a little science, math, and introspection. I promise, it's not as hard as you think!

You've heard words like "overhead" and "profit" a million times, but when you personally decide to go solo—either by freelancing, setting up a small studio, or hiring a staff—suddenly, these words fall squarely from the skies above onto your vulnerable shoulders. Wouldn't it be easier if you could look up, see the words coming down, and catch them easily as they fell your way? Now, you can!

"Overhead" is academically defined by *Webster's* as "of or pertaining to the operating expenses of a business concern." Many designers refer to it as a mysterious journey into the unknown. Fortunately, you're not one of those designers. Just being aware of overhead's existence is enough to get you started thinking a bit differently. Overhead is truly something to embrace with understanding and openness—not run from in fright or denial. It's the difference between knowing whether you are able to afford the huge loft studio that perfectly reflects the city's colors beneath you or the small-but-quaint efficiency office with no windows and a copy machine down the hall. More important, understanding your own overhead will help you immensely in establishing correct pricing, estimating, and projecting budgets that will make you more profitable!

Making your mark means setting your course, understanding your personal work process and your individual motivations. Maybe money isn't your number one goal . . . it seldom is for graphic designers. Just know that to maintain good professional status in not only your community but the global design community, you must have a strategic operating procedure for your business. I hate to use the words "system" and "business culture," because that makes most people tell me, "Look, I started my own firm so that I wouldn't have to follow any rules or have any corporate culture."

My reply is, "Good luck."

Understanding Some Accounting Terms

Do yourself a magnanimous favor right now and learn just some basic accounting terms. You should have at least a tax accountant who is

doing your taxes for you; if you've got employees, you probably have a CPA or full-service accounting firm helping you. Take your accountant to lunch. Boring, yes? No. For the mere price of a plate of chicken lo mein or pesto vegetarian pizza, your accountant would love to mentor you on the basics . . . and the basics are all you need. Words like "overhead," "assets," "liabilities," "credits," "debits," and "depreciation" are all key to your knowledge bank. You may understand what they mean generally, but learn to apply their meaning directly to your business.

Use the list provided on page 7 as a guide to learning your own overhead. Notice that the list is split into two categories: fixed and unfixed (or variable) expenses. No, this is *not* Accounting 101. It's plain and simple list making, which is virtually foolproof. It will be easier for you to complete these lists by determining monthly cost figures and then multiplying by twelve to obtain an annual figure.

Fixed expenses are just that—expenses that are the same every month, like rent and equipment loan payments. Remember that when you buy a new car or add the latest in computer technology, your fixed list will change. The total of your monthly fixed-expenses list is the amount of gross revenue (income) that you need to generate to break even.

As you are preparing your fixed list, other items will come quickly to mind that will actually belong on your unfixed-expenses list—it's like playing word association. Go ahead and start a separate column with unfixed items now because you'll need both lists as you learn how to figure your ideal hourly rate. (Some of that is covered in this chapter, and more is covered in chapter 2.)

Your unfixed list will include expenditures that fluctuate monthly, like fees to service bureaus and delivery services. Most of your unfixed expenses will directly correlate to how busy you are during a given period. The unfixed list is somewhat of a challenge because it is not consistent like your fixed list. If you're just starting your business, call some suppliers and ask them to help you establish a monthly average by comparing accounts that resemble your own potential usage. After you get a few months of business under your belt, you will be more knowledgeable about what to expect from your unfixed category. Many unfixed costs come as startling surprises that, if left off your list, will certainly end up costing you money.

Assessing the reality of your fixed and unfixed lists is the absolute cornerstone of any business. Take the time to review these lists with a

FIXED EXPENSES	UNFIXED EXPENSES
Salaries	Freelance Help
Studio Rent	Professional Education
Car Payment/Maintenance	Type Output Services
Health Insurance	Color Output Services
Equipment Loan/Lease Payment	Photography Fees
Business Contents Insurance	Travel
Accounting Fees	Meals/Entertainment
Telephone Bill	Art Supplies
Heating Bill	Office Supplies
Electric Bill	Postage
Dues/Subscriptions	Delivery Services
Payroll Taxes	Sales Taxes
City/State Taxes	Self-Promotion
Social Security (FICA)	Bank Charges
Personal Property Taxes	Legal Fees
	Printing Costs
	Color Separations Costs
	Maintenance/Repairs

fresh mind a day or two after you complete them. If possible, share them with a mentor or colleague to make sure you haven't forgotten anything that may not be listed on the guide provided (like snow removal if you're in Minneapolis, for example). These expenses are literally your foundation for determining a fee structure that will work positively for your individual business needs. Review this list twice a year (mark your calendar to remind yourself) because as your business grows or changes, this list will need to be adjusted accordingly. The outcome of this list making will be a clear picture of the real level of income that you need to generate, not only to break even but to actually live on, too!

Don't let the various tax items listed above send you over the edge. Instead, pay a tax accountant a small monthly fee (your accountant's monthly fee is already on your fixed list!) to monitor these tax issues and prepare your tax forms for you.

Now, take a break from the list making and begin a quest to really define an income for yourself. Be objective with your ego in determin-

ing what you think you're worth from a salary standpoint. Face the facts of your geographical environment. Are freelancers a dime a dozen in your area? Are you establishing a small firm with employees? Are you a consistent award-winning designer in your region or a relatively unknown and inexperienced entrepreneur? Most of us begin working in this industry as the latter—skilled and eager, yet basically lacking in business expertise and awards on the wall. That's okay! Use this to your advantage; the payoff is in the big picture.

It's time to fully assess your fixed list. Make certain that every expenditure that is the same from month to month is included. Total your monthly expenditures and multiply by twelve to obtain a yearly figure. Now, add your desired, objective salary amount. If you're having a difficult time establishing this amount, begin with the starting salary for art directors in your region; obviously, if you've got years of experience as an art director, your salary should be commensurate with your experience. The grand total of your annual fixed list (expense) dollars plus your desired salary is the income you need to generate from the services portion of your business. Unfixed expenses are usually directly attributable to your projects. That list will be used to help you determine appropriate rates to cover those variable expenses.

Burn Out or Burn On

There's nothing like starting a new business, motoring along on the latest razor scooter of a dynamite project that you can't believe you landed. This baby is huge! They even gave *you* the budget. You'll make so much money you don't even need an hourly rate; they never asked. You go buy the latest computer, the latest handheld PDA, the coolest sound system, and an Armani suit for the presentation. You're flying high for sure. So, the big job gets done, and it's a beauty, and then you're back to Mr. ABC client, who nickels and dimes you until you feel like day-old toast. The bills pile up. Maybe your credit card company calls you to see if you've forgotten this month's payment. You're lucky if you can pay it *next* month.

Don't burn out this way; there is simply no excuse for it. Learning how to determine the right hourly rate—and sticking to it consistently—will get you through the toaster and back out into the "fresh today" section.

Obviously, the higher your overhead, the higher your rates will be.

But this doesn't mean that you can increase your prices every time you purchase a new piece of equipment or hire a new staff member. First, I'd like to share some of my experiences in how to view those big expenses—stuff like salaries and rent. Then, I'll give you a couple of really good formulas for setting your own hourly rates.

Recently, I saw my profits go *up* by hiring a summer intern from the local university. (To see the relative importance of this move, keep in mind that salaries are going to be your single biggest expense, unless you're working strictly on your own. Note my list of fixed expenses on page 7. Prior to hiring this intern, I had been paying $50 to $75 per hour for freelance help that always seemed to be problematic; we were using a good freelancer, but our client was quite particular about many quirky little things. Without having the freelancer at our beck and call all day long, we found ourselves spending a substantial amount of time correcting work that she had accomplished. Having a summer intern in our office meant that we paid him much less than a full-time designer, plus saved the time of our other staff, since he was more available to fix or change his work. We saved money, and he got some nice samples for his portfolio!

Another thing that goes hand in hand with determining your rates is your studio or office rent amount, another fixed expense. Working from home keeps this figure low but can quickly drive you crazy with the distractions created by the neighbor's barking dog and your mom who calls to chat every day, since she knows you're "home." On the other hand, a more elaborate studio space comes with a high monthly price tag and its own set of utility and maintenance bills.

Since your rent will be one of your biggest single expenses after salaries and taxes, you might think that finding a cheap work space will keep your rates down substantially. In the overall scheme of things, it doesn't improve your rates by more than a few dollars an hour. You can prove this easily by plugging different rental amounts into your fixed list as you use the second formula given in the next chapter.

The American Institute of Graphic Arts (AIGA) recently published some very interesting, comprehensive information in *AIGA/Aquent Survey of Design Salaries 2000*, which provides results from a survey of our entire industry. The prior survey was published in 1998, so, hopefully, they will continue to provide this excellent information every two years. Salaries are reported by geographic area and then also in three statistical levels: the twenty-fifth percentile, the median, and the sev-

enty-fifth percentile. More detailed data on the survey instrument itself and the composition of respondents is available on AIGA's Web site at *www.aiga.org*. Seventeen position descriptions, such as solo designer, owner or partner, senior designer, web designer, etc., are featured.

This study, while containing a disclaimer in the front as a warning for the information to "not be viewed as a nationally representative statistical sample of all graphics professionals," is the most detailed industry analysis I have seen yet. I believe it to be very highly reflective of what is going on in our current salary structure nationally. I have design colleagues in almost every geographic region represented, and I believe the information to be quite solid. It also includes benefit information ranging from costs for typical medical coverages, types of retirement plans offered, retirement plan contribution stats, and much, much more.

■

How to Determine Your Hourly Rate

Before we get into the actual processes of determining rates, you need to make some important decisions regarding whether or not you should be a graphic design business owner:

Things to Consider Before Starting Out on Your Own

- Do you crave independence and a lack of routine?
- Are you self-motivated?
- Do you like to take risks?
- Are you outgoing enough to enjoy talking about your work and "selling" with your portfolio?
- Do you want to freelance for other firms and agencies? If not, do you have enough contacts that could support your studio by hiring you directly to produce creative work?
- Do you like wearing different hats?
- Are you generally optimistic?

If some of the above questions are difficult to answer affirmatively, think twice about striking out on your own just yet. Take part in some small-business workshops and start searching for a mentor or two who can help you decide when the time is right.

Assuming you feel good about the last set of questions you

answered, move to this next set and determine if your strengths will lie in going it alone as a freelancer or establishing yourself as a full-service firm.

Do You Want to Be Full Service?

- Do you like being completely in charge?
- Are you a team player?
- Do you enjoy doing many things at one time?
- Do you have an extensive knowledge of prepress production and printing?
- Do you enjoy sourcing new suppliers?
- Do you like troubleshooting?
- Are you familiar with several respected copywriters?
- Have you written professionally? Do you feel comfortable with spelling, grammar, and punctuation?
- Do you like to negotiate?
- Do you like to establish schedules for different people and follow through with them?

Answer *yes* to at least eight of the above ten questions and you can count yourself a great candidate for supplying full service to your clients. Six or seven positive responses will find you a great freelance candidate, but as a full-service supplier, you might have some serious challenges ahead. Any questions having a no answer should be looked at as deficiencies and corrected to a yes answer as soon as possible if you want to survive in the fun, yet challenging, full-service market!

Any fewer than six yes answers—forget it! Sorry.

Pricing

Now you're ready to pick the right pricing formula for your business. After getting through this chapter, don't stop reading the book and think you know it all. There are some great pricing options in chapter 8 that you will refer to—and use—often. The important thing to remember is that no one formula is perfect for every project. This is a starting point. Often, pricing for projects is determined by your flexibility and your knowledge of different approaches to pricing. And don't forget the most important piece of this: profitability!

Many formulas exist to assist you in establishing an hourly rate. The simplest formula is to multiply all the salaries you're paying out—don't forget to include your own!—by three. The theory here is that one-third of your expenses represents the actual outlay of salaries, one-third represents the overhead, and the final one-third is left over for profit. Pretty easy, huh? Actually, the smaller you are—and especially if your studio is in your home—the better this down-and-dirty formula can work.

The Master Formula

A much better and more comprehensive formula follows. Albeit more complex, it works a lot more efficiently and makes more sense logistically as you are computing it. So, get some paper and a pencil with an eraser; you're going to have the perfect hourly rate in less than fifteen minutes!

Remember the fixed list? You'll need this detailed list of all your fixed expenses for its important totals. I'm going to use the following example for matters of simplicity:

THE BEST DESIGN FIRM, INC. ANNUAL FIXED COSTS LIST

Salaries (owner + 3 people) .$188,000
(3 people = 2 designers + 1 print/production artist
 or 1 office person)
Studio Rent/Maintenance .37,000
Company Car/Maintenance/Insurance8,100
Health Insurance .6,480
Equipment Loan/Lease Payments .6,000
Business Insurance .1,200
Accounting Fees .4,000
Telephone .2,200
Heating/Air Conditioning .2,400
Electricity .1,000
Dues/Subscriptions/Awards Entry Fees2,500
Payroll Taxes, City/State Taxes, Social Security Taxes (FICA)
 (Multiply total salaries by 25%)47,000
Personal Property Taxes .2,000
GRAND TOTAL .$307,880

Now, look realistically at the total billable hours you can obtain from your salaried staff. First, we'll divide your total salaries by those billable hours, and that will give you a rate to charge just to cover salaries. Next, we'll add a percentage based on the rest of your expenses to cover overhead. Finally, we'll add a percentage so the business itself can actually make a profit for all this work!

Billable hours are simply those hours which you can directly bill to a client. Unbillable hours reflect time that cannot be attributed to any specific client's job. These are hours spent on general things like cleaning up, backing up your computer, or peeling bananas. Our office manager-receptionist at Real Art often performs unbillable tasks—answering the telephone, ordering supplies, general accounting tasks. Her hours are mostly unbillable.

So, out of a total year's worth of hours for four people—52 weeks × 40 hours × 4 people = 8,320 hours—suddenly, The Best Design Firm, Inc., needs to deduct 2,080 hours for their office manager-receptionist. That leaves them 3 billable people and 6,240 hours. Everybody gets two weeks vacation, so 3 billable people × 80 hours subtracts 240 hours from the company's total. Typically, allow five days for each person to have as sick days or personal days off, so that's another 120 hours. Real Art gives everyone on staff one week of paid vacation as part of their holiday bonus between Christmas and New Year's. If The Best Design Firm wants to offer this bonus, that means subtracting another 120 hours. Don't forget our seven legal holidays—it's typical to extend these into an additional day off for four-day weekends—so 14 days × 8 hours × 3 billable people is another 336 hours to subtract. The subtotal currently stands at 5,424 billable annual hours.

Last but not least, no designer is in any way billable for an actual forty hours per week. Time-consuming tasks such as surfing the Internet on company time, cleaning up for that important client visit, running errands, and backing up your system can quickly add up to about an hour a day per billable person. That's a painful subtraction of 690 hours of downtime (5 hours per week per billable person for 46 total weeks of actual work) for a realistic grand total of just 4,734 *possible* billable work hours. That's if everything runs smoothly all the time.

Now, add the total salaries and related tax expenditures, for a total of $235,000, divide by 4,734 possible billable hours, and get an hourly rate of $49.64. For the sake of simplicity here let's round that

figure up to $50 per hour. But remember, this rate does not yet include total overhead. So far, you've only covered the salaries portion of the fixed expenses list.

To determine what percentage to add to cover your other fixed expenses, divide remaining fixed expenses' total by the total salary and taxes amount. In the Best Design Firm's case, the total fixed expenses ($307,880), subtracted by salary and taxes ($235,000) leaves remaining expenses of $72,880. This remaining amount, $72,880, divided by the salary and taxes amount of $235,000, equals 31.01 percent.

Again, we'll just round this off and make it 31 percent. Okay, okay, this is a bit like algebra, but at least I'm giving you the answers—just fill in the blanks with your own totals, and you'll get your percentage! Now, take the hourly rate that you computed to cover salaries (in The Best Design Firm's case, $50 per hour) and multiply it by the percentage you've just established to cover your overhead (in this case, 31 percent). The $50 hourly rate multiplied by 31 percent equals an additional $15.50 per hour Best needs to charge to break even on additional fixed annual expenses. So, $50 per hour to cover salaries plus $15.50 to cover all those other expenses establishes that The Best Design Firm needs to charge at least $65.50 per hour (let's just say $66) just to *break even* on everything.

For you algebra whizzes out there, sure, you can arrive at your hourly rate simply by taking your total overhead number—in The Best Design Firm's case $307,880—and dividing it by total billable hours for a quick hourly rate. It comes out the same, right? Correct, but it is very important as you grow to know what percentage of your business overhead is salary-based versus other fixed expenses. Right now, at Real Art, our salary overhead is about 50 percent of our total fixed costs.

You might think that making a profit over and above your total fixed expenses is simply icing on the cake: nice, but not really necessary. If so, you're not alone. A lot of people think that everything left over at the end of these calculations is theirs to keep. Don't make that grave mistake of not having anything left over for a rainy day or to cover the occasional slow-paying client. Small businesses close their doors every day because of these far-too-familiar dilemmas.

Remember, we've made no allowances here for slow periods, downtime, equipment failure, scheduled pay raises, or the nice gesture of distributing bonuses for jobs well done. Peruse the contents of your unfixed expenses list. Costs for things like postage, maintenance, and

education (design conventions are wonderful) that are seldom attributable to a particular job need to come from somewhere—your bottom line. You could easily go in the hole if your hourly rates are not bumped up enough to cover these variables.

A common percentage of profit in our industry begins at 15 percent and can go up to 25 percent; my firm averages about 19 percent. Adding 19 percent to The Best Design Firm's $66 hourly rate equals an additional $12.54 (round up to $13), making their adjusted base rate for profitability $79 per hour. My firm actually charges up to $250 per hour for certain tasks, which will be discussed later in this chapter.

Enough already with the calculator! Just remember one thing: The hourly rate that you originally established (before adding a profitability percentage) covers only the itemized subjects on your overhead lists. Each job you produce will have contingencies that you must not forget to include in your budget planning and estimating execution. Details do matter; every day, every project is different.

There are other formulas to determine hourly rates, of course. I find this particular formula the most comprehensive, reliable, and easy to compute.

Your *average* hourly rate should remain very close to your base rate—The Best Design Firm's being $79 per hour. Once this base rate has been established, it's easy to go in and refine it or to try other rate methods.

Hourly rates reflect not only the end product that a client receives, but also the years of experience, skills, and intuitive talent that a creative team offers. Ultimately, our clients expect and deserve a results-oriented piece that will increase their profits by enhancing their image, promoting special offers, educating their consumers, and so on.

Interestingly enough, and to my surprise, the geographic location of design firms I have interviewed in the past did not really affect hourly rates. I thought New York City or San Francisco rates would certainly be higher, but found that not to be true at all. Rather, rates changed according to the size and experience level of the firm and the success and notoriety level of the principal. The aforementioned *AIGA|Aquent Survey of Design Salaries 2000,* as well as the recent *HOW Magazine Salary Survey*, do challenge my finding by comparing geographic areas (AIGA includes size of firms also) instead of experience levels. I would still bet, however, after reading these surveys, that the

higher salaries are being acquired by the more experienced individuals and firms; it just makes common sense, but is not proven in any of these surveys.

The Graphic Artists Guild publishes a *Handbook of Pricing and Ethical Guidelines* that can serve as a handy reference guide while you are establishing your rates; an updated edition is published every two years or so. This handbook includes the latest information on how to price design, different ways to price projects, how design and artwork are commissioned, standard contract terms, business management tips, and discussion of ethical issues that arise daily in our industry. The publication provides indispensable reference material that I have not found anywhere else in our industry, and it should be a part of your business book collection. However, the average designer I most typically talk to agrees that the dollar rates the Guild quotes for specific projects profiled in their handbook seem high.

Per-Task Hourly Rates

Not to complicate things, but most firms—including mine—use their base rate to establish per-task hourly rates. This simply means that for scanning time or time spent typing copy into the computer, we might charge only $40 per hour, while design and illustration time are billed starting at $125 per hour. Much of my personal time is billed at $250 per hour. Certain multimedia tasks and intricate Photoshop time are also billed much higher.

Determining per-task rates is essential when a one- or two-person studio grows into a multiperson firm. This rating process enhances the billable efficiency of senior people within the firm; it provides for their not doing menial tasks when they could be more profitable and better appreciated doing something that reflects their experience level and abilities.

Check out the per-task rate list I've provided from my firm. Notice that the tasks requiring more technical experience are billed out at higher hourly fees. Also, make note that these rates were established to use as a comparison factor when pricing certain task-heavy projects—for example, illustration-heavy jobs. First, we usually price a project using our "master formula" hourly rate. Then, we check that result against our per-task hourly rates to help us refine our estimates. The

following rates are beginning rates. Depending on the type of illustration, Photoshop work, or new media work, rates may go higher than those shown.

REAL ART DESIGN GROUP, INC. PER-TASK HOURLY RATES

Meeting time . $75
Design . $85
New media . $150
Copywriting . $125
Illustration . $125
Photoshop . $150
Production . $85
Proofreading . $85
Revisions . $85
Research . $85
Art direction . $150
Clerical . $85
Travel . $85
Client service . $85
Proposal prep . $85

Value Rating versus Hourly Rate

While design firms have an established base hourly rate, most of us also put a great deal of emphasis on "value" rating. Value rating means that after you determine how much time an assignment will take to design and produce and multiply that time factor by your hourly rate for a project total, you objectively think about what the project itself is actually *worth*.

A great example of this is a logo design. Some logo design solutions come to you in a flash, while others seem to drone on into oblivion. Many times, my staff and I have sat down and literally designed a logo within an hour's time. Even though *five* of us sit around doodling and brainstorming for an hour, multiplying five times our design hourly rate is still only $425. If we billed a Fortune 500 company $425 for a logo for a new product, the client would: (1) expect to get logo designs any time for that mere pittance, (2) have no idea where we are coming from when our next bill charges them $2,500 to refine the logo to

camera-ready status, and (3) begin a downhill slide of losing respect for us, because any firm that is twenty-two people large with a sixteen-year history would be selling themselves and their colleagues short by offering such a significant task for such a minimal fee.

So what is a logo worth? Now is a good time to pull out your Graphic Artists Guild *Handbook*; it shows all kinds of pricing structures

you can adapt to your specific situation. But the biggest thing this book can't tell you is what the project is worth to *you*.

Maybe the client is an energetic entrepreneur who has a great idea and is giving you carte blanche on design. In this case you can't charge him $5,000 for a new business start-up logo; but you can charge him a minimal amount, do a great award-winning design, and agree that you will be paid an additional $1,000 per quarter for a year after the company gets on its feet. Or you might agree to be more fairly compensated for future collateral pieces that the company will require in its growth mode. This is value rating.

On the other hand, if a huge Fortune 500 company asks you to design a logo, graphic standards, packaging, and direct mail literature for a new product that is going to hit the national market, your best bet would be to refer to the Graphic Artists Guild *Handbook*, discuss the budget constraints directly with your client, and then take a quiet moment in your studio to look at the value this immense project will bring you. With the Guild's pricing suggestions in mind and an idea of the client's budget expectations—if they have been shared with you— it's easier to assess for yourself what projects are worth to you and your staff. Value pricing not only allows you to be flexible with people you want to work with, it also allows you to triple your normal rates when you know that a client is difficult to work with.

This pricing method is great also when a client is gaining a benefit far beyond what your normal hourly rate would reflect. For example, a logo for a new product we recently named and developed for a toy manufacturer took us a combined hourly total of thirty-four hours to brainstorm, compose, and execute. Thirty-four hours at The Best Design Firm's hourly rate of $79 would only equal $2,686 for this significant project, which is actually valued at around $10,000 in the Guild's pricing book because of the annual revenues of the client's company.

Chapter 5 gets into a lot more detail about value rating and what it can and can't do for you. And don't forget to check out chapter 8 for more great pricing options.

■

Starting Out

You've read the formulas and some other procedures for establishing pricing. How close are you to establishing your own rates? An important question you have hopefully answered for yourself at this point is whether you want to be known as a one- to two-person studio, an actual design firm, an advertising agency, or a freelancer. The services you provide and the number of staff people you have to provide those services greatly affects the way you will value upcoming projects.

What's Right For You?

A *one- to two-person studio* typically services its own accounts. Some are full-service, which we reviewed earlier in this book, and some aren't. Ongoing client lists are usually very short with studios of this size, and they generally produce a lot of one-time projects.

Being a *design firm* basically means that you have some sort of staff—a group of people who support your efforts in one way or another. Team players in a design firm usually include the owner, who generally acts as creative director, at least one or two designers, and an office manager. Larger design firms have account representatives, production or traffic managers, an art director or two, many designers, new media programmers, and often more than one owner.

An *advertising agency* not only supplies graphic design services and writes copy for print materials, it also writes, produces, and purchases time for television and radio commercials. Ad agencies also "place" other media—they purchase billboard and magazine space and develop and implement comprehensive marketing strategies.

Many people in our industry refer to design firms as "agencies" quite inappropriately, misleading potential clients and sending the wrong message of "higher overhead," which goes hand in hand with a real agency. Agencies are always full service and usually have very large staffs.

Freelancing quite simply means that you work on an "as-needed" basis for other design firms and advertising agencies. Basically, you're a can-do-it individual and end up filling in during a company's busiest periods or when their own designers are on vacation or out ill. Many freelancers specialize in a few niches or styles, so that their work becomes recognizable and, thus, popular in a particular region. Freelancers often work in-house at a particular agency or design firm. The latest trend is for freelancers to work from their own home offices, since many times their employer won't have an extra computer on hand for them to use. Increasingly popular is the capability for free-lancers to post their progress on a job to a creative director at another company for review on the Internet. This saves a lot of driving time in bigger cities and meeting time in general.

The next big question you've answered by now is whether or not you want to offer full service. It's like going to the soft-touch car wash: Do you want only the outside of your car washed? Maybe add the wheel cleaner and the rust-inhibiting underspray? Or do you want the works, including the deluxe vacuum, special rain-repelling coating, and the squirt of fragrance that will always remind you of sipping piña coladas in Bora-Bora?

Full service can be accomplished best when you have established yourself as a design firm or advertising agency, with many smaller studios that provide a wide range—but still not full—set of services. It is almost always impossible for freelancers to be full service because they usually don't have established credit with color separators and printers, nor do they want to handle the paperwork and responsibilities or the substantial amount of coordination required.

Full service means that you are responsible not only for the graphic design, but also the copy, production, photography, color sep-

arations, printing, and delivery of most projects. Realistically, you and your staff cannot personally fulfill all of these obligations (how many design firms do you know that contain printing presses?); however, your expertise in coordinating all the details of a project is paid for by your client.

When determining value rating and per-task rating, full-service firms have a longer list of extras they are able to provide to their clients and can be reimbursed accordingly for those assets.

Full-service firms charge a higher rate for their projects because they are providing more services. Most of the time, this rate is reflected in the estimate as charges for the various itemized services. A higher percentage of average profit is also expected by being a full-service firm. Freelancers or studios not providing full service will have a more difficult time acquiring larger projects, even when their rates are comparable to full-service teams.

Other items that might affect your rates when starting out are:

- *The quality of the pieces in your portfolio.* If you aren't established in the area, have won few awards, and know that you can do better work, but have not yet had the opportunity to prove yourself, it will be important to set a fair rate that will attract clients and give you a chance to show what you can do. In this case, a slightly lower "introductory" rate may be implemented until you have achieved a few successes.
- *How much equipment you have.* This becomes part of how high your overhead is, which is directly reflected in your hourly-rate equation.
- *Networking opportunities in your area.* How many people do you know, or how many friends could give you names of friends that would be potential buyers of your services? Even if you are a great designer, way ahead of your time, if people in your job market don't know you, it might be difficult getting started. Networking is simply a way of avoiding the cold calling that most of us dread. Networking doesn't get you the project, but it does help you get in the door to show off your work.

Now that you have absorbed all there is to know about setting your rates, just do it! You've done your homework and deserve to go forward with confidence that the rate you've established for yourself is

the right rate for you. In the long run, clients will respect you more if your rates are objective and if you feel good enough about them to quote them as being your own.

How Do Your Rates Compare?

The easiest way to discover that your rates are too high is to lose jobs that your clients are obtaining at a better price from other firms. Still, make sure that you're not *too* hasty to lower your rates before considering the old adage about apples and oranges—are you comparing apples to apples? Lots of times, my firm will lose a job to a smaller studio whose overhead is obviously much lower than mine. I've gotten into the habit of informing clients in a positive way that if they are asking smaller studios for bids, ours is seldom the lowest one they will receive. Then, I proceed to explain the many reasons why. I also inform them that we will not enter a bid if they are shopping only for the lowest price. To me, it's anathema. Who needs it?

The best way to discover if your rates are competitive is simply by asking. Talk to your existing and prospective clients about other firms they use. Make sure they are firms that provide services comparable to yours. Have this conversation with someone you trust, with whom you can share a frank discussion about rates. Sometimes, this is more easily done in a casual atmosphere, like over lunch. But I can guarantee that you won't offend anyone by being directly concerned and receptive to your client regarding rates if the subject comes up in a business meeting while reviewing a specific project.

I can also promise you that as time goes on and you gain more confidence and competence being your own businessperson in the design industry, you will become less and less rate sensitive. You can trust that established firms will endorse my practice of first determining the value of a job before even thinking about dropping rates to accommodate a budget. We'll discuss this in depth later in this book.

The more time you spend in the business, the more likely you are to come across a client or two who will complain about how high your rates are no matter what you charge them. I have a client who always reminds me that our prices are so incredibly high, as high and sometimes higher than his advertising agency, of all things. How can I charge him so much? I usually respond to him by laughing like he is making this big joke. I do think it's pretty funny. He is actually one of

my favorite clients to do business with because he gets so crazy excited about the creative process. When his conversation turns to our pricing, I have learned to say "yeah, yeah" to myself. His rhetoric used to make me very defensive, and when I asked him what he would like to pay for a project, I invariably would lose money on it.

If you can't stop obsessing about how your rates compare, do a simple questionnaire in the form of a mailer to clients, vendors, and other people associated with your industry. Ask them to respond to questions regarding pricing issues. Make it user friendly, with just a few "yes or no" boxes to fill in and perhaps one question that requires a written answer. Use your design skills to make it a nice direct mail sample in itself—you never know where your next client may come from! Give them an incentive to respond to you, like a free T-shirt or something more creative. You can design and produce a cool gift for just a few dollars. Count on getting a 5 to 10 percent response rate if you're giving something away, then write off the expenses as a self-promotion.

It's interesting to note that most firms charge a higher hourly rate for the principal or owner(s) of the firm. For several years after starting my own firm, my hourly rates were the same across the board. Basically, if our cleaning woman delivered a set of film to the printer on her way home, the charge was the same as if I had done it. As the business has grown, I find myself needing to be very selective about my time, and this is reflected in a higher hourly rate for my work. Many clients prefer and even ask for me to be present during all phases of our projects together; but this simply is not humanly possible. What I have found is that I need to expose my senior designers to our clients more often. Upon doing so, other people on my staff became more credible to my clients, making it much easier to justify our hourly rates.

When to Raise Your Rates

Raising your rates is not nearly as difficult in practice as you might imagine, and the same rules apply for freelancers, small studios, and full-service firms. Obtaining an affluent client list, winning awards consistently, or achieving recognition by designing public or community pieces will all help your business volume grow and will result in a reevaluation of your rate structure. By "affluent client list" I mean clients who are respected—businesses that are prominent in your area,

Very seldom will any client actually ask you what your hourly rates are. When they do ask, simply share your per-task hourly rate *range* with them. In my case, I don't hesitate at all to offer the fact that our rates start at $75 per hour—on the low side for a firm Real Art's size—but I am quick to offer a short aside on my "value theory" and the fact that we use our hourly rates to back up our original estimates, mostly for internal purposes of monitoring productivity. This conversation has appeased every client who has questioned me about rates.

The following are summaries of the roles of, and national average billable hourly rates charged by, principals of design firms, senior designers, junior designers, and freelancers.

- Principal—Typically acts as creative director. Usually has well over five years of specific design experience. Shares a lot of diverse marketing capabilities and expertise with clients. Manages entire staff. *Average hourly billable rate: $200.*
- Senior designer—Many times carries the title of art director. Has two to five years of experience. Often interacts with clients. Delegates some work to others. *Average hourly billable rate: $125.*
- Junior designer—Entry-level position. College or design school graduate. Minimal prior experience. *Average hourly billable rate: $85.*
- Freelancer—Works independently. Usually has minimum of three years prior design firm or advertising agency experience. Has flexibility and usually a computer at home. *Average hourly billable rate: $40–75 (depends on experience and market).*

The rates listed above are averages based on my personal informal inquiry of my national client base as well as other design firm owners. As I mentioned before, I believe that the more experience one has, the higher the rates. Typically, design firms do not want to be singled out with published rates because of the confidential nature of the subject matter. My true belief is that the reason is fear and paranoia of disclosing our rates to clients. Trust me, they know anyway!

like Fortune 500 companies, or even the city itself. Many small firms (including mine) have grown by doing great design work for local theater, dance, opera, and other arts organizations.

Changing from a one- to two-person studio to a full-service firm with more employees can mean charging higher rates; so can new services you provide. For example, it recently became evident to me that my firm was starting to supply more and more new media services (while five years ago, Photoshop work was the big billable task), which required a ton of additional gigabytes, more software, and an incredible new assortment of pricey hardware. I was forced to separate new media time from design time on my per-task hourly-rate sheet.

As your business increases, so does the caliber of your clientele and the types of projects you are asked to work on. Rate increases can usually be passed along to your new clients without any discussion at all, because they have no previous history with your billing procedures. If a client does think we're expensive, I always respond with an analogy they can relate to. For example, when my architect client recently whined about our logo rates, I asked her if she was the cheapest architect in the city. She was offended; I had counted on that. I then asked her if she didn't think she was worth the extra money to her clients because of her attention to detail, her on-site location work, attention to contractor, finished quality, etc. Of course, she was worth it. So suddenly my pricing becomes a moot point.

With any business growth comes the need for new staff members and additional, often expensive, equipment. Reviewing your fixed list twice a year, as suggested at the beginning of this chapter, will help you determine whether or not you need to increase your rates. Rework your hourly-rate formula at this time as well. If your cost of doing business has jumped dramatically, it may mean having a face-to-face discussion with your long-term clients about why you need to raise your rates. The goal is to inform them of your growth and what this means to them in terms of new capabilities with your updated equipment, new illustration styles from the new staff member, and so on. Always point out the benefit for the client when you are announcing any change in rates. Significant growth always deserves to be discussed and promoted.

Prior to your meeting with them, a nice, upbeat letter to your entire client list announcing the new additions, with perhaps a sample of your latest, hottest-designed piece will act as an icebreaker for your appointment. Always share the new benefits and services that your

client will receive. Make it seem as though your new services and staff are worth way more than your minimal price increase.

You can start your personal conversation with something like, "Did you get our letter about our new capabilities?" Once again, never apologize for your increase in rates; simply justify them factually. Clients like to work with winners, and your rate increase can be turned into good news for them in the long run.

After the letter goes out, don't forget that you promised to call them soon (which you should include in your letter). Never send out more letters than you can properly follow through on, and save the discussion of the rate increase until the face-to-face meeting. Your meeting will invariably turn into a sales call, with your taking home an armload of projects that need pricing, estimating, or budgeting.

If you've started out with a healthy hourly rate from the beginning, you shouldn't have to raise your rates very often. Raising rates by just a few dollars an hour to cover new equipment will probably never even be noticed by your clients. Many times, the addition of new equipment will happen after your original equipment is paid off. If you keep that monthly dollar allotment for equipment on your fixed list at all times, your rates won't be affected at all.

My friend and business partner, Chris Wire, uses a phrase for which we cannot find the origin or the author: "Quality is long remembered after price is forgotten." It's a really beautiful saying that could transfer to just about every business on earth!

■

The Client's Budget

M any factors can affect the way you price various projects. Some of those factors relate to what you might gain from doing the project (other than money!), some relate to what your client can afford, and then there are factors that you just can't control, like changes in the overall economy. Do some homework before giving your pricing. Can the project elevate your standing as a designer within your community? Is your client a smaller businessperson who has a lot of growth potential? Is the economy in your area a little slow? These are all reasons to think strategically about how you can and should price a project.

First: Do Your Homework

Why does the word "budget" seem to reverberate from the darkest, meanest corners of the world, ricochet from the earth's highest cloud ceiling, and come back to hit us all in the head? Really, someone should come up with a better word. More often than not, I've found that the most dreaded budget—the one that some executives sat up all night establishing, subtracting from, adding to, and pulling their hair out over months ago—is not as bad as it seems after all.

The most important thing to know about budgets is that it's okay

to talk about them. Many designers choose to ignore budgets, when indeed a budget can become your best friend! (Well, maybe not, but certainly a worthy ally!)

The second most important thing to know is that your client is just as intimidated by the "B" word as you are. The sooner you break the budget barrier down, the better for both of you!

It's simple: Ask. If the client has a budget in mind and shares it with you, the outcome can only be one of two possibilities—there's either enough money set aside for your specific project or there isn't— and either way, you can show your professionalism by jumping into the driver's seat and making everybody, including yourself, happy!

Taking the lead on the matter gives your client confidence in your capabilities. If not enough moneys are set aside, it's your responsibility to educate your client as to why the amounts are insufficient for what they want. And on the rare occasion when the budget is higher than you expected (those occasions do indeed exist!), use it to create a high-end, awesome piece that you and your client can be proud of.

Established Fortune 500 companies who are experienced in buying creative services generally understand fee structures and are most often prepared and forthcoming with monetary information. Often, these clients are required, by company policy, to obtain three bids for the same project. Rarely are they obligated to take the lowest bid. This is not the case with government or non-profit organizations. When they ask for multiple bids, they are usually shopping for the lowest price. Ask. It is very typical to discuss what the pricing or bidding parameters are before you get started.

Many times, smaller clients will ask you to assist in the budget-making process. This is a great sign of their trust in you, and often, they will use your estimate as their budget. Know that you are doing *their* homework in this case; make sure that you carefully review each element of the project, and don't try to go for the high dollar. This isn't a gambling casino; it's your career! I'm always reticent, however, to help a client establish a budget if they are then going to go out and get bids from other firms.

Establishing trust between you and your client is imperative for you to offer competitive pricing and budgeting—and also for you to create a dynamic, creative piece. It's a sad day when your client asks you to establish a budget, and then, after several days pass by without a return phone call, you finally get him at his desk, and he announces

that he's given the project to someone else. Darth Vader? Might as well be. You've been duped, and it's a discouraging and crushing feeling. It happens to the best of us, and it will happen to you, too.

Just make sure that you've learned what to do next time you're faced with this type of situation. I spend a lot of time role-playing critical communication issues like this. It's tough to think on your toes when a client delivers information that you were not expecting. Get yourself one of those little handheld voice-activated recorders, and talk to yourself. I do it all the time while I'm driving the highways—more like getting stuck in gridlock—in Los Angeles.

Sure, people look at me weird; but who cares? I'm role-playing. What could be more important? Play the tape back, and really listen to yourself. Do you sound apprehensive? Do you stumble around with um's and oh's while you're trying to get your message across? Do you make sense? Is your vocabulary concise and intelligent sounding? You are your worst critic. If you're anything like the typical perfectionist designer, keep on talking until you feel like you're ready to make the call or appointment. You'll be glad you finished your homework!

When the Budget Isn't Big Enough

There will be occasions when there simply isn't enough money in the client's domain to pay your rates or to produce the project to the height of design you originally had in mind. One of the hardest things to learn is how to gracefully, but emphatically, say "no, thank you." Saying no will probably close the door to future endeavors with this particular client, but it comes with its own set of advantages—it shows that you are serious about your rates and the services you provide, and it also gives you the opportunity to refer a friend in the industry who might have lower rates and be an excellent fit with this client's needs. What goes around always tends to come around, you know!

If you stay within your current community for a long period of time and are committed to business growth and image, clients whom you turned down often roll back around to your starting gate. Your client will either grow his business or change career tracks and go to work for another company you are already servicing. You could end up working on a civic project together or some other nonprofit community endeavor. You never know where Mr. or Ms. Client will show his or her face. So, if you bow out of a project because a budget is too low,

make sure you don't burn any bridges. Your "cheap client" today could be your stepping stone to bigger and better projects tomorrow.

Your other option when a budget appears too low is to say yes because the project offers you the potential for a great portfolio piece, or because this may be a new type of client who will enhance your firm's flexibility by adding diversity to your growing client list. If you decide to proceed with a budget that you know is not high enough, it is very important that you set parameters with your client up front. You may decide to produce the piece in your firm's downtime—thus taking a longer period of time than normal to complete the project. Or you may suggest that the client become more involved in providing elements of the project, such as photos and copy.

The important thing in dealing with an under-budget job is not to build resentment because of the money you are not being paid. After all, you did say yes, and it wasn't because Bruno was twisting your arm. Take responsibility for your actions, and be as professional and efficient with the matter as you would with a big-budget job. The payoff is in the end product: the smile on your client's face and the next job you get as a result of this one!

Your Vendors Can Be Your Biggest Allies

Taking on an under-budget assignment may also be an opportunity to work with a new, perhaps smaller, vendor. Perhaps you have had a printer calling on you that you really want to try, but you haven't had the right project until now. Be very honest with your new vendor when you ask them to work with you. Don't use a new vendor unless you sincerely want to establish an ongoing relationship. You don't want the reputation of being a carrot dangler!

Maybe an established vendor has a new process that they might be willing to invoice at a lower rate. For example, I had this happen when a printer that I had been using for years installed a "screenless" Crystal Rastor printing operation within their facility. The printer wanted a highly-designed piece to test and subsequently distribute as a sales sample of the new process. It just so happened that a prestigious paper company had contacted me about designing a promotional piece for a new line of paper; but their budget was extremely limited. The result was a piece that made everyone—printer, client, and us—very happy!

The aforementioned story about the prestigious paper company who asked us to design a promotional piece without a hefty budget may come as a surprise to you. You know those phenomenal paper samples we always get that show the latest eye candy designed lusciously using all the latest trends, and you'd just do anything to get that tasty, lip-smacking job for your portfolio? Well, they usually don't pay you enough to go out and buy a case of candy bars. Really? Truly.

If the client is a nonprofit entity, many vendors will price their participation in the project accordingly. Some vendors will even donate their services if asked or if given a generous lead time in which to turn the project around. It is wise to have your client do the asking for favors such as donated services. Encourage them to tell vendors that they will receive credits on the printed pieces for items that they donate. Once again, your reputation is at stake, and you don't want to be known as the design firm from the freebie-asking kingdom. Save your favor-asking for the times you will need those favors to cover yourself! Vendors will have a harder time saying no to a nonprofit client that is producing a job for a worthy cause than they would saying no to you.

Wants versus Needs

A major factor to consider when dealing with an unrealistic budget is the matter of what the client may want versus your professional opinion of what the client really needs. Many times, I have met with clients who think they need a full-blown capabilities brochure, when in actuality they have a new product that requires only a simple product sheet. Another example of clients' wants versus needs may be a new corporate identity program. If the budget just isn't there for a new logo and all the goodies, maybe a logo revision is in order for now.

Another alternative is offering to tier a program for your client. Perhaps you design a product sheet now for the new product; after sales generate a sufficient amount of capital six months from now, plan to do the capabilities brochure. Same thing with a new identity program: Start with the basics—letterhead, envelope, business cards—and then, as your client's supply of other identity materials (new product labeling, for example) runs out, produce and print these on an as-needed basis. This way, you don't overwhelm your client with one big invoice that they may not be able to pay. Setting priorities in this manner shows your client that you care, that you understand budget constraints, that

you are interested in teaming up with them to better their image, and that you want a long-term relationship. It also puts you in that omnidesirable driver's seat!

Don't forget that different-sized businesses require you to think a different way about pricing. For example, an identity system for the new corner deli cannot possibly cost as much as a new identity program for, say DaimlerChrysler. At first, the thought of charging different rates for different clients may seem unethical, but this is not the case. Think of this practice as being a close companion to the value rating method discussed earlier in this book. This methodology is recommended repeatedly in the Graphic Artist Guild's *Pricing and Ethical Guidelines*.

Consider the following scenario: When a large Fortune 500 company recently asked my firm to design a new logo for a new product, they also asked me for a budget, including a poster for the product's introduction at a big trade show, a direct mail brochure, and a couple of postcards to be used to enhance their promotional program for a new, highly targeted software system. My estimate requested $12,000 for the logo alone, while just a few weeks prior to that, we had produced a logo system for a start-up business for only $1,500.

The Fortune 500 project required countless meetings, extensive research about the specific target audience, strategic marketing study analysis, and the development of printed collateral for a simultaneous public relations campaign. On the other hand, the new business identity system was easy by comparison—one client meeting, a general audience, and no market research—plus, the owner was a new neighbor near our studio. You never know when you might need to borrow their snow blower!

Again, as with budget-driven pricing, think about what's in it for your firm when establishing rates for smaller clients versus larger, more-established clients. Consider the visibility for your business of the pieces you design at lower-than-Fortune 500 client rates. Also, possible barter situations or extended payment arrangements may once again surface with the smaller client. We'll go into detail on more pricing options in chapter 8.

While you should be careful not to interrupt important cash flow by adjusting your rates downward for smaller businesses, these types of projects might actually be scheduled for production during slower periods, which could help you in the long run. And don't forget the poten-

tial for that small start-up business to become a full-fledged corporation sooner than you think.

Dot.Com Syndrome

I don't think there's a designer or design firm out there today who hasn't gotten burned yet by a promising, up-and-coming dot.com company. These guys are everywhere, aren't they? Unfortunately for everybody, the nonpaying dot.coms have become the typical stereotype to graphic designers. At first, they appear very attractive. Most of us are learning new media techniques and enhancing our client services by designing Web sites and DVDs containing streamlining videos and cool animation. So, when a dot.com comes to us for identity, printed collateral, or any number of needs that new start-ups have, it's always appealing.

After producing a couple of projects in the Midwest for some supposed high-tech dot.com start-ups—and never receiving payment—we were asked by a client of mine at Universal Studios to meet a friend of his who was starting a "very high-end dot.com." They were just getting their funding, and everything was hunky-dory, howdy doody, or whatever the phrase might be. You get the picture. I took the time to meet one of the new owners, who had impressed my credible client enough to impress me. This dot.com was on the West Coast after all; that's where all of them are, right?

Turns out, I really liked the president and owner of this new dot.com. He was very sharp, well-dressed, incredibly articulate, and had a decent list of clients already. His funding was just around the corner. He needed new identity and a graphic standards program for his Web site. He had plenty of programmers, but the actual graphic design on his Web site needed some help. This was a project with which we could be exceedingly creative and proficient.

Chris, my partner and Real Art's creative director, was brought in to meet the owners. They all clicked right away. The president was very honest with us. They had less than $5,000 cash—probably $3,000. But he was willing to lend us one of their programmers on occasion to help us out with some much-needed new-media programming experience. My partner ended up spending several hours (unheard of for such a low budget project) with this person.

We did a great logo for this company. Our first clue that some-

thing was going wrong was that, after revising the artwork to the client's liking, we didn't hear from him for a couple weeks. Repeated efforts to call and mail from both Chris and me went unanswered. Even my big client from Universal tried to call on our behalf. He was supposed to be on their newly-forming Board of Directors, and he was embarrassed that he had introduced us. Everyone was perplexed, but giving the new start-up the benefit of the doubt. They just seemed so credible—how could all of us be so wrong?

Turns out we weren't really wrong. After two months passed, the president finally called Chris to tell him that the company was going under. The interesting factor here is that the company players are still credible business people. They are astoundingly creative and have an excellent business concept. The plain and simple fact is that they never landed their big financing support. These grassroots companies hope and cross their toes and work their butts off until they get so burnt out themselves, they can't go anymore. The idea is still great. They just couldn't sell it to venture capitalists.

Shame on us for letting this happen to us again. We should have been very systematic about requesting credit information from this company—their banker's name and phone number and several companies who were already extending credit. Even new businesses have established credit with phone companies, power and light companies, and other basic-needs support services. We could have—and should have—taken the time to ask the right questions, check out their wherewithals before moving forward. We have no excuse. All the intuition in the world on all of our parts did not pay off. We even have a full-time (non-billable!) office manager to whom we delegate these types of tasks! Geeez.

If you do accept a job at a lower fee, it is not unusual to ask a client if you can add a byline to the piece and receive a substantial amount of printed samples to do your own promotion. Many times, your mailing will enhance the client's visibility to your specific audience, which probably is not included on your client's mailing list, thus adding some possible nice residual benefits for them.

Consider Your Options

There are always more options to consider when the client's budget isn't big enough. Use your intuition. I know this sounds ethereal to lots

of readers, but we all have intuition inherent to our own beings. Go out and buy a book on how to tap into yours if you think you don't have any; you do. Check your gut, and ask it if this client is worth you going out on a limb for. After your gut says yes, ask the client for some credit references if they're a small business or start-up.

Then—you're creative—roll up your sleeves and have a brain-storming session with the client and figure things out. Set up a payment plan for your client that you feel comfortable with—perhaps on an ongoing monthly basis. This could help both your and your client's cash flow. Eliminate costly full-color comps; provide informal, less costly presentations to your client. Technology has rewarded our industry with the ability to provide beautiful hi-res, brilliant, comprehensive artwork that appears finished to our clients—and it's expensive to get to. Try going the old-fashioned way, with some sketches and a verbal walk-through of your concept, using idea boards that show things that look like what you're going after design-wise. Make sure you get the client's buy-in before you jump into the costly act of true-blue production.

Try replacing location photography with stock photos, or use typography creatively and have no photos or illustrations at all. Rely on basic graphic design for a change. Design a great black-and-white piece—or a two-color piece instead of a four-color piece. There is nothing quite so beautiful as a well-done spot-color piece. You might also choose a lesser grade paper stock for the finished piece; ask your printer to help you on this one. Many printers stock floor sheets that they buy in huge volume and on which they print most of their bulk work. Surprisingly, these sheets can be quite nice and very cost efficient.

Use budgets as a stepping-stone to better client relations, to increase your own knowledge, and as a reference for future projects. The more input you bring to your client regarding a budget, the better for both of you. The biggest thing to remember about budgets is not to be intimidated by them, but to embrace and accept their reality.

■

More on Value Rating

Introduced value rating in chapter 2 of this book. Just like the prior chapter on the client's budget, value rating deserves a lot more discussion in greater detail than I gave to it in its introductory phase. There can actually be a considerable amount of value for you in value rating—from a profitability standpoint even. Most of the pricing we do at our firm these days is based on value rating. After we assign a value to a project, however, we always go back and divide our value rate by the amount of hours we believe the project will take to determine whether or not we are close to our computed hourly rate described in my master formula. Invariably, we are ahead of the game when we do value rating, but until you get a very clear idea of what a project can and should go for pricing-wise, it is smarter to stay with your master formula.

Prepare for the Unexpected

Current events play an extremely significant role in fee structuring. During our latest national economic downturn, from 1990–1992, many design firms and advertising agencies literally went out of business because they were not flexible enough to respond to the dramatic drop in work flow.

Keeping up with national news is vital to every business, but keep

in mind that professionals in the marketing industry often suffer the most when times are tight. Why? More often than not, Fortune 500 companies sever their marketing budgets first and go into reprints of old materials until financial times turn around. If you keep informed of the latest happenings, you can tighten the belt buckle on things like overhead, new equipment purchases, and employee hirings while bracing for the storm. Eventually, the weather clears, and you find yourself busier than ever. Everything's a cycle, after all.

Another dilemma that you can never be fully prepared for is natural disaster. While the national economy may be humming along, and you have stacks of local and national newspapers to prove your willingness to stay informed, a matter of seconds can bring an unexpected situation. If a hurricane, earthquake, or other natural disaster hits your area, you can be assured that it *will* affect your business in some way.

Unfortunately, even personal accidents occur. I was happily on my way to play a round of golf on a prematurely summery day in March 1991. Business was great, I was laughing with my best girlfriend about some type of nonsense, and seconds later found myself more than dazed and confused, with a memory only of crunching metal and breaking glass. Our auto was hit from behind, leaving me with a bulging disk in my neck, over a hundred days off work for physical therapy, two years of working in pain, and a new-found litigation attorney I was forced hire to settle the matter and recoup losses.

The economy had nothing to do with the resulting business loss. However, I was forced to face some pretty heavy overhead issues that resulted in some restructuring of rates and the way business was done in my absence. At that point, almost any job coming in the door offered some value, because I was our primary salesperson. Not so smart.

The Graphic Artists Guild's *Pricing and Ethical Guidelines* contains a considerable amount of information regarding value pricing for projects related to their actual usage. "Usage," in this case, refers to whether or not your design(s) will be used or distributed nationally versus a hometown circulation. It covers matters such as the exclusivity of the target audience for your designed piece—is the audience master widget experts, veterinarians, or vegetarians? A wider audience will typically make your piece more valuable to your client, and thus command a higher price for you. Pricing is very rarely based strictly on usage, but should definitely be influenced by it. Logos and their specific usage are especially applicable to this pricing application.

Again, it's your decision to assess the final pricing and the actual value of the job. Don't forget the residual profit benefits that expanded usage of your design provides your client, and don't hesitate to price your project accordingly. If you're not sure what the end usage will be, ask!

Self-Promotional Value

Another reason you might decide to try value pricing is because the project has the potential to reward you with some self-promotional value. Perhaps it's a series of posters for your local ballet or opera company. These projects are usually award winners or portfolio pieces—but they're generally low in budgetary allotment. Deciding whether or not there is any real self-promotion value in a project is pretty easy. Always stay focused on your big career picture when you are making this decision, not allowing yourself to get caught up in "should I do this, but they need me to do this, or what if I don't do this" types of scenarios.

Pro Bono Work

If you thought pro bono only applied to law firms, think again—and think hard! Once you've opened your doors as a businessperson, the favor-asking follows close behind. Accepting jobs for no fee needs to be done very selectively, while making sure that doing so does not disrupt your cash flow or place too great a significance on pro bono jobs over paying clients. Finding the right balance of when to say yes to such projects can be difficult—especially if you're one of those types that never says no.

If you know that you are indeed one of those people who can never say no, you're probably giving way too much work to many outstretched hands, for the wrong reasons. Know that this can possibly result in great, ongoing grief for you with your peers. It's tough to give something for nothing. You must be a master at finessing creative control, talking and presenting (typically) to a powerful board of directors, and savvy at obtaining criticism constructively from a group such as this. Doesn't sound like much fun, does it? Most established graphic design firms stay far away from this practice completely and totally, leaving some space for those starting out to endeavor to take the reigns and ride into the night.

WHAT'S IN IT FOR *ME*?

- Does the project allow any kind of growth for you? If you are new to your community or if you are a new business start-up yourself, this may be a great way to make yourself known.
- Is it a new, possibly ongoing client opportunity? Keeping with my example of a local arts organization (e.g., a ballet or opera company), many times these organizations have some nice set-aside funds for their annual report or their annual fund-raising campaign, but they need a series of posters to sell their season.
- Does it involve a new production technique that you would like to try? Perhaps there is a chance for you to try something you've never done before, and thus an opportunity for experimentation on a real process, while simultaneously getting educated. Sound like a win-win?
- Does it provide any networking opportunities for future sales potential within your client's organization? Translation: Are there important members on your local opera's board of directors who could be potential corporate clients?
- Will it open new doors for you because this is a new type of client that you have never serviced before? I don't know how many times I've shown our portfolio to a client in an industry we have never serviced before, and they won't hire us only because we've never done work for the widget-crafting industry—or whatever business they happen to be in. You and I know that good graphic design is just that—it doesn't matter what the subject is. But the more uneducated creative-services buyer doesn't have a clue and wants to see something pertaining to their industry in your book.

Requests for pro bono work should always come from nonprofit entities. I cannot stress the significance of my last sentence enough. Small businesses starting out, or otherwise "needy" companies or clubs, will not—I promise you—respect your process if you are going to give away your goods for free. They will dime and dollar you to your creative demise, and you will ultimately regret your generosity. You will also certainly set a precedent for being a "cheap" designer, and when you go to charge your real hourly or value rates, you'll be questioned and ridiculed because "you didn't charge us that much on the last job we did."

- Will the end result be portfolio quality? It would be great if every job could be a portfolio job—and there is no reason not to go for it—but realistically, we all know that every job is not. So, if you'd love to sink your keyboard into a specific project, this might be your magic moment.
- Is the client willing to give you credit for the design and agree to print this credit on the piece? If the client allows you to print a mouse-size credit on the piece, you're golden. Ask the printer for extra samples to send to your mailing list. You might have to pay a minimal amount for overruns . . . but it will be worth it.
- Is it a direct mail piece that your client may be mailing all over the place with your name on it? If your client does let you include a byline, think realistically: How many units are being printed, and how many will go into the right buyers' hands—quite possibly, graphic design buyers' hands. It can either be a masterful marketing success for you or a huge waste of your time. You've got to have the instinct to choose between what is right and what is wrong for you; use it, don't abuse it.

Answering yes to any of the above questions can be sufficient for your affirmative decision to design a value-rated piece, possibly at a lesser rate than you might normally charge. However, only you can make the final decision, which will usually depend on just how busy you are (or aren't) when such an opportunity arises.

In my opinion, pro bono is a necessary evil for the design community to embrace and accept. How many times have you been on an airplane and the flight attendant asks if there is a doctor on board? Designers are the communications doctors for organizations like your local performing arts groups or disease-research fund-raisers. They all need well-designed print material to support their efforts. Many of these projects are things like posters, season brochures, or T-shirts—the fun stuff we all love to design. Ironically, these projects are usually big award winners in our industry because it is typically understood—and if not understood, it is up to you to make the fact known—that if you

are not going to charge for your fees, the creative direction of the project (within reason) is yours.

There are a number of nonmonetary benefits to providing your services at no cost. Consider some of the following issues as you make your decision:

- *Giving something back to your community.* We all want to give something back that we can feel good about. Good intentions of donating cash to causes we feel are worthy don't always translate into action—there never seems to be enough left over after the bills are paid. Pro bono work is a way to share your expertise by creating results-oriented design, thus providing actual value to causes near and dear to your heart in lieu of cash.
- *Portfolio potential.* Most pro bono clients should agree to give you free reign creatively and are pretty much at your mercy to provide them with a good design to fulfill their needs. It would be unethical for them to ask you to do something for free and then tell you how to do it. Unethical, yes, but believe me, they'll try. Make sure to lay at least the groundwork for your creative freedom before entering into any agreement.
- *Networking.* All nonprofit groups I have worked with have influential businesspeople on their board of directors. When word reaches them of your generosity, they will most likely be inclined to meet with you and help you make contacts within their own companies, which could mean nice new sales opportunities for your firm. This opportunity will present itself as your project unfolds. You will probably meet certain "committee" (i.e., marketing or design committee) board members who will influence the entire board's final decision as to whether or not to accept your work.

 Ask to be the presenter at the "big board meeting." This is an invaluable experience for you and the right time to make yourself known. If you are unaccustomed to presenting to large groups, what better format with which to gain the experience than one with a lot of decision makers, earnest to learn from your presentation? You can't make a mistake; you're there for free. It might help you, as you introduce yourself to this group, to thank them for the opportunity to provide your services (it's the perfect time to crack a joke about their lack of budget). You might even say

that this experience is a win-win for all of you, because you are gaining something from it yourself, i.e., presenting to a large group, presenting while using a microphone, etc. Use this time to educate the audience; you're the expert—that's why you're up there. Make sure they know it by the time you're done.

- *Self-promotion.* Since your pro bono designs will be portfolio quality, ask for enough samples to distribute to your own mailing list. On more than one occasion, pro bono work we designed was mailed to our mailing list as part of our agreement—at no cost to us. Most nonprofits have a healthy mailing expense budget. If you can show them that your own firm's mailing list might include potential investors or donors, it may well be worth their while to include your mailing list with their own. As with all pro bono work, it is very common to include a printed "design by:" at the bottom of the piece so that everyone who receives it will also see your name.

Alternatives to providing projects totally free include charging a discounted rate, or bartering for things like season tickets or recognition as a corporate sponsor in the organization's program. In some cases, I have asked the client to pay our regular fees; on receipt of their check, I agree to immediately write my own company check back to their organization. Then I post my check as a promotional expense and can take the amount as a legal tax deduction because I am indeed using it for my own promotional purposes.

Unfortunately, to date, the IRS does not consider time spent (even when translated to a dollar amount or hourly rate) in providing graphic design services to nonprofit entities as a legitimate tax deduction. Real Art typically requests that a nonprofit entity pay for our services, then we immediately refund their money with a same-day check written back to them for the same amount, sometimes more. This legally allows us to take the contribution as a tax write-off (even though we must declare the income) but, more importantly, allows us to publicly announce our donation.

Rule the Competition

Value pricing gives you a tremendous opportunity to stand out against your competition. And not always in good ways. My favorite client

WHEN TO SAY YES OR NO TO PRO BONO

- **YES.** When you are interested in the subject matter or support the cause of the organization asking for your help.
- **YES.** When the client gives you creative control and promises not to art direct the piece.
- **YES.** When the client is actively involved in the organization of other free aspects needed to complete the job, like color separations, printing, and paper. You should *not* be expected to ask your vendors for favors, but you can refer your client to vendors who you think might help.
- **YES.** When the client offers to give your firm credit for doing the piece via a "design by:" footnote on the piece.
- **YES.** When a client offers to introduce you to board members and key people within the organization.
- **YES.** When it has the potential to be an award-winning or portfolio-quality design.
- **NO.** When the client seems hesitant about any of the above.
- **NO.** When a client does not agree to pay for your outside expenses, like high-resolution output and supplies.
- **NO.** When you're way too busy and already into overtime with your current projects.
- **NO.** When Intuition 101 kicks in and you get a bad gut feeling.

always reminds me that "Real Art is expensive. You charge me as much as my agency does." These types of comments always made me cringe in the early days of owning my own business. Luckily, he usually ends his comments with something like, "but you're good, you always come up with something new, and I like that," quickly followed by, "but I can't use you for everything."

Honestly, there was a time when I wished that every client I had would use me for everything. A one-stop shopping design firm, yessir-ree. You want a billboard? We'll do a billboard. You want an annual report? We love annual reports. You want a flyer to put on cars in parking lots? Well, we don't really do those, but what the heck, sure, we'll do that, too!

Perhaps you can get some insight here into where I'm going with

this dialogue. When I founded Real Art, we were a little-known organization. I was offered some high-visibility projects and called on companies close to my studio in downtown Dayton, Ohio. Slowly, we were recognized. Sixteen years later, my client at Universal Studios Hollywood is telling me that my prices are as high as his big Los Angeles agency. What's wrong with that picture? The answer is, What's all right about that picture?

Any time a potential client asks me who our competition is, I answer their question unfalteringly. "We really have no competition," is my consistent answer. They look at me quizzically to hear my going on about the fact that we create work that specifically answers our clients' needs, not our own. Not only are we in the graphic design business to get results from the visual communications we create for our clients; we're also in the business to get the clients' repeat business. This means that our clients are ultimately happy with our pricing structure in turn for the value of work they are receiving. There is no better reward to us than a repeat client.

I think this philosophy is important to any size firm or studio. Your "competition" might have the coolest Web site, the slickest salespeople, and the biggest expense accounts, but at the end of the day, the "right" clients for you will be the ones who like you because of your work, not because you drive a nice car or you go out to fancy lunches.

Consistency in your pricing structure is a significant priority. Especially within a large company like Universal, don't get fooled by the fact that the advertising department is in building 1102 and the merchandising group is in building 418. Everybody talks and compares—especially if you're doing your job right. You should never take the chance of pricing one way for one group and another way for another group unless you want to do some serious explaining and hula-hooping in front of a large crowd some day.

Let's face it . . . awards do get us attention. I can say to our staff—and I mean it—that our greatest reward is a repeat client. But the ultimate is a repeat client for whom you win awards! Ruling the competition also happens gradually as your work becomes recognized by the industry trade magazines and local and international design competitions. It's always a treat to not be one of the big kids on the block (read: advertising agencies), and then leave an art director's or ADDY awards program with a big box full of accolades and handshakes.

Entering design awards programs can be incredibly expensive. Set aside a certain amount of money within your own firm's budget every year to make sure you have the cash to enter. Look in your favorite industry magazines for competitions sponsored by paper companies. Some of them, such as Mead Fine Paper's annual Top 60 program, have a great following that is quite prestigious and well-known. Other paper companies put together traveling shows (modeled from the Top 60 format) that give you generous national exposure and a somewhat different venue in which to win and be recognized.

Don't make the mistake of not caring about awards programs and taking an aloof attitude. Tooting your own horn may be the most difficult thing for you to do. It's really hard for some personality types to actually go up to the podium and graciously accept an award. I remember the first year I partnered with my now-partner of ten years. He was recognized for a wonderful accomplishment and given a significant reward. On his way up to the podium, he seemed embarrassed, looked down at the ground, and practically made an excuse for himself when he accepted the reward at the microphone. The crowd is watching you at these events; learn to say "thank you" with meaning and clarity, even if it is simple. Enjoy the moment standing before your competition; sometimes your clients are in the audience, too.

Appearing overly humble will lessen the reward in the viewers' eyes. They might question why you received the reward if you did not believe in the work enough yourself. They will invariably make assumptions about you or the project that are wrong. Give everyone a reason to look up to you by showing that you believe in yourself. Everyone likes to go with a winner.

■

New Media Pricing

The incredible plethora of demand for graphic design created in one of the seemingly countless new media formats is crushing. A couple of years ago, few people were on the Internet—let alone shopping for goods and services via their nearest online junkie screen. Plus, it was a man's world. The quantity of male users crushed the ratio of women users. That's all different now. More women than men use the Internet for information, shopping, and sourcing.

Staying in Control

Our first new media projects were taking our Fortune 500's PowerPoint presentations and making them "more creative" by adding unique slide show functionality and maybe some music, along with better-looking typographical design. Today, a staggering amount of software and programming savvy awaits the dreaded rose-colored-glassed designer with, alas, more to learn, more to read. Just what we wanted. And how in big brother's creation are we supposed to even begin setting a price for this stuff that no one has ever bought before, let alone tested for efficacy, accuracy, and consumer compatibility? Too many questions, too little time is what it all pinnacles up to. I say "up" because if you're going to offer new media within your menu of design services and you're not

up on the latest and greatest software and applicability, you're toast, simple as that, burned toast.

We have a joke amongst the sales staff at Real Art: Don't talk about the Internet, Web sites, multimedia presentations, online catalogs, or anything at all that might connote to your client that we are designers and producers of new media. But nevertheless, without exception, one of the first things that a potential new client will say, even before we sit down at the conference room table is, "Hey, do you guys do multimedia?" My first reaction is to make a joke out of it: "'Doing' multimedia?" I'm trying to get them to blush or change the subject. It doesn't work—they're serious. So the answer is, "Yes, we 'do' it."

Unfortunately, demand far outweighs our ability to produce it at this point. This is such a difficult time for our industry, and I don't see it lightening soon. The fact is that there are too many clients who want—or think they want—multimedia projects designed for one reason or another. The unfortunate part of it lies in the realization that there are not enough programmers in the design world to go around. Not enough colleges are offering strong enough programming educational support, combined with a higher sense of graphic design. Programmers are having problems crossing the lines between being tech heads and frustrating their graphic design colleagues who can see it in their minds but who don't have the programming knowledge to make it work on their monitors. How many of us designers have lived vicariously as we watch our illustrator compadres make the magic that we could only envision but never get down on paper? The same analogy lies within the enclaves of designers' brains now with regard to their programming colleagues' capabilities.

We're all on a learning curve, clients and designers alike. This is a relatively dangerous place to be together. We are accustomed to being in control, making recommendations, and wowing our clients with the latest and greatest. None of us currently have a tremendous portfolio in the multimedia arena; so, suddenly, competing for new media projects, juxtaposed by the lack of programming skill set among the design masses, presents a unique challenge for us. We are vulnerable in both budgeting for the unknown and clearly communicating relevant information to our clients.

The answer then comes down to price and selectivity in choosing projects that best fit your realm of knowledge. Choosing projects that define themselves as having good profitability potential is also critical

at this time of demand versus availability. Often, we are pricing multi-media projects at value pricing, beyond actual typical value. We are doing this for two reasons: (1) We are understaffed in comparison to the great demand for our services in this sector and cannot find enough well-educated, experienced people to employ in this category; therefore, we can command a higher price because of demand/availability, and (2) The technology incessantly surpasses itself with new software constantly entering the market, changing the dynamics of our services and causing more stress and training time.

This training time must be accounted for in our hourly rates. Usually, we are self-training, as the software is so new that actual creative support is nonexistent. Clients really need to commit to a partnership with this medium right now and for the foreseeable future. We must educate them on the unknowns and the challenges we face. Schedules are more nebulous with this medium, as are final budgets. When a client is willing to pay the price, however, we'll dive in and search the bottom of the pool for all the gold coins we can find.

Most of our clients do not know how to budget for new media or the actual value of multimedia projects for them. They see on a regular basis the high visibility Web sites, the fabulous things that can be done via CD-ROM and DVD. They see it on programs like CNBC, experience mega-amounts of eye candy as Internet users while simultaneously getting bombarded with e-mails and faxes from Web designers working out of their basements advertising twenty-page Web sites for $500. Ultimately, this results in clients not realizing how much effective visual communications on a multimedia platform should really cost.

Remember when the Macintosh revolutionized our industry? Real Art was the first design firm in Dayton, Ohio, to make a big investment in the technology. I remember ordering an SE30 for my office manager and the first big-monitor work stations Steve Jobs had to offer, all totaling $12,000. The year was 1987. It was such a big installment that people from Apple came to visit our studio and congratulate me for my smart investment. Meanwhile my colleagues were still using tech pens, and probably most of our printers couldn't even take a disk.

Shortly thereafter, "desktop publishing" took off. Everybody and anybody had little SE30 workstations on their desks. Many of our clients started to take their design work in-house in an effort to save costs. Everyone, including their mothers, became graphic designers. I

became alarmed that we were going to lose work because technology was so accessible to everyone. Well, we all know the end of that story, and let's be thankful for an ongoing ending instead of the end of the graphic design industry. Good design prevailed. Our society became even more permeated with graphic imagery in everyday life. People began to expect a good icon to explain functionality, a nice font to represent their thinking. Terms that were once a designer's domain have become commonplace.

The same thing is happening with Internet design and multimedia projects. Everyone expects something bigger, more beautiful, with multiple functionality—and, while you're at it, how about some video, 3-D enhancement of the product line, and a customized musical track playing in the background. Your typical $500-per-Web-site designer cannot begin to offer these expanded services. And although technology may be getting more affordable—heck, I've got some very nice multimedia capabilities on the affordable new iMac I just bought for my kids—the role of graphic designers as visual communicators has never been more serious or more substantive.

We are in the foreground of a huge masterpiece, seeing neither the beginning nor the ending. Here and now, it is up to us to be in the present moment and become experts in this high technology. Pricing, budgeting, and estimating in our industry have never contained more depth, more variables, or more customization possibilities. We are the experts.

Hub and Spoke

One of the first terms I used in explaining the pricing of this technology to clients was "hub and spoke." What I meant by this term was that on a typical CD-ROM or Web site, a smart way to begin the design process was by creating a hub—a core of graphics which cradled the foundation of the forthcoming information—followed by spokes—the different buttons or areas which could be visited by the viewer as the multimedia experience was realized. Clients seem to grasp this analogy very easily. It was also very simple for us to explain that while, perhaps, a client ultimately wanted their entire product line, sales videos, links to their suppliers, and virtual trade shows as a part of their new media endeavors, it might be more realistic price-wise for us to begin with the hub design and then prioritize the various spokes in order of impor-

tance. This term still works for us to some degree as a starting point for our pricing discussions.

However, there is still the problem of our clients not understanding the difference in costs between actual production of new media versus manufacturing. Clients seem to have the perception that new media is more cost effective than print. This mysterious fallacy is enhanced by the aforementioned basement media designers and free Internet offerings. In actuality, the development costs are much higher than traditional print because, in addition to designing, the production process takes much more time, with an entirely different skill set being billed out at a much higher hourly rate. The staffing required to produce this work is more difficult to find (let alone attract, hire, and maintain without attrition) than your traditional print designer. On the other hand, your clients do save a lot of money in the manufacturing if they have a large volume of products, for example, and place them into an online catalog or CD-ROM instead of a printed piece.

The other pricing fallacy we are facing from our clients is the desire to standardize the medium. There was a time, for example, that a certain type of video might typically cost $1,000 per minute to produce. Clients became savvy about that number and knew just enough to be dangerous. Now, they seem to be looking for a formula that might synchronize with their existing knowledge of, say, "a twenty-page Web site costing this much" or, "It should cost this much money per page."

In reality this concept does not work at all. Two different Web sites with exactly the same number of pages can result in dramatically different pricing. One Web site might cost more because of the functionality within it, such as connecting to a database, linking to purchasing options, or other multilevel applications. Secondly, Web site design has moved beyond the limiting environment of "pages." The word "pages" was introduced with this technology early on as an analogy to the pages of a catalog; it is a term everyone was comfortable using.

There are countless dynamics that determine pricing, that affect both the amount of time spent in creating a new media piece and the ultimate value to the clients' consumers of this information. Determining these dynamics and variables before starting a new media project is probably the most significant obstacle in establishing a good budget in this medium. A few of these determinations are whether or

not the project contains DHTML (Dynamic Hypertext Markup Language), CFML (Cold Fusion Markup Language), and ASPS (Active Server Pages). All of these different technologies were designed to enhance the user experience and efficiently deal with changing content while giving the viewer enhanced options of usability. They all work with HTML (HyperText Markup Language) to add functionality, but they add to our pricing dilemma because they involve tricky, time-consuming programming.

Most Web sites just a few years ago were static HTML pages—very text-based with few graphics. Now, everything is dynamic, with active server pages linking us to something else, changing the navigation, using Macromedia Director and other more sophisticated design applications, which virtually take away the concept of pages, forcing us to price a project as a whole while taking into consideration all of the functionalities.

The irony is that these functionalities are the reason why multimedia has become increasingly useful, ever changing, and entertaining. It's fun to surf, even if you don't know how to swim with the sharks! Customizing each viewer's experience, depending on their clicking habits, is now a typical underlying feature within the web of information we should include on an effective Web site. Viewers' browser capabilities also become relevant to our multimedia design. Providing the capability, for example, of browser detection to determine whether or not the viewer is using Flash, and providing a link for a free download of the software so the client's media is more effectively used, is becoming more commonplace.

Options abound for Web-based graphics, CD-ROM, and DVD applications, with the latter being more volatile because of the lack of industry standards within the design and implementation of support hardware. Especially with regard to training and instructional information, this medium is becoming more significant to our industry. A viewer can now interact directly with what is happening on the monitor. If the viewer is learning how to do something, tests can be layered into the medium for subsequent tracking by the company headquarters at a central database. Entire new product lines can be launched without print collateral, by feeding small bits of information—hype first by employee introduction and sales training, followed by partner channels, and then direct public relations and media distribution, feeding each sector more effectively than any other medium can provide.

Technology combined with strategic methodology within the design industry has made many communications processes incomparably more cost effective than doing it in any other manner.

Big brother, big sister, and everybody else are watching, and the way you price these projects goes way beyond our traditional ways of thinking. People are just now realizing the capabilities of this incredible medium; it is growing beyond any value that I can foresee for our industry. Print-based technological development is static compared to the daily changes taking place in new media. Design tools typical to our industry, like Adobe Photoshop, Adobe Illustrator, etc., directly correlate to this medium. You can save to HTML pages, you can save out to PDFs (Portable Document Format files), you can optimize directly for the Web. The final deliverable itself in this medium is changing about every six months. It is phenomenal and frightening at the same time. Trying to forecast at this point could make me a total fool, but I believe it is quite apparent that our industry is due for a major overhaul created by this incessant, higher technology. The forecast at Real Art is that, by the year 2003, our multimedia revenues will be over 50 percent of our total. This year, 15 percent of our revenues will be derived from new media. I make this point specifically because we are a traditional, full-service, print-based firm, not a new media specialty house.

Live and Learn

The more experienced programmer-designer realizes it is quite possible to cut and paste programming created for one project into another. This has created a flurry of stock software in many categories—from the creation of multimedia kiosks to templates and various functionalities for Web sites. This is not a threat to us creatives, but a validation that the medium is here to stay. There will be the "desktop publishers" of this industry, along with corporate in-house capabilities, which require these off-the-shelf products.

Therefore, it will be important for you to note in your contract with more sophisticated projects something like, "The source code created for this project remains the property of The Best Design Firm." Many times, your clients will require you to relinquish that code to them so that they will have it as well. A common mistake you will want to be aware of is that you do not want to relinquish the rights of their actually using that code again on another project. This is totally simi-

lar to buyout rights for photography and illustration. If your client requests your source code, you need to charge them accordingly and be prepared to explain the ethics of their request. You should own the rights to the usage of any source code you write, unless your client is forthcoming with the budget to buy you out.

One of the most effective methodologies Real Art uses to bypass the many frustrations associated with pricing versus expectations is splitting our new media projects into phases. Phase One is the Alpha. This term goes back to programming more than anything else. Beginning at the Alpha, we provide a site map, whether it is a Web site, CD-ROM, or whatever. A flow chart, or wire frame, is required to show how the viewer is going to get from where to there. The overall look, feel, and navigation for the piece is developed at this phase also. Standards for imagery are created at this point. Essentially, this first phase is analogous to the comp we show for a printed project—things don't really work, they're not built correctly, we use a lot of stock photos and canned images to show the overall direction. So much of what the client wants depends on these initial offerings. Questions will arise while you are presenting this wire frame, and your client will become aware of the depth of options and communications opportunities by seeing the two-dimensional format while you discuss possibilities for the format's applicability. The primary goal for Phase One is to totally establish what the piece is going to be like when it is finished. Client sign-off at this phase is critical to your moving on.

Providing a price for Phase One is relatively easy. No programming is involved; it's almost like a comp. We use our multimedia hourly rate for this phase and make sure we have enough hours in the budget to brainstorm every possibility. Value pricing at this point is nebulous. We would rather get the client started and ready to embrace the technology than try to suggest to them at this point that it has any particular worth. Many corporate clients who have in-house programmers hire us to produce this phase only. This keeps us in the loop with regard to setting a standard for high-end graphic design and results-oriented visual communications. We can better police the usage of any established graphic design standards connected to their corporate logo or mission statement than the typical in-house programmer. Often, we are then asked to participate with their programmers in art directing of sorts, working cohesively with their in-house people to maintain the integrity of our original design. This is wonderful because it allows our

print-based designers to immerse themselves into the programming experience by sitting side by side with the techies. They realize the parameters, limitations, and consequences of their ideas within this new media.

Do not move on to Phase Two until you have clarification on the content. Phase Two is what we call the Beta. Clients love being a part of this programming lingo, and the project begins to propel itself from conceptual infancy at this stage. If there is video or voice-over required, we begin and complete production at this phase. Here, we start assembling the content and breaking it down into its various pieces of the application itself. Now, we start working with the analogous flat pieces of paper, building our pages, sections, screens, whatever. Your client already has in their mind from Phase One what the piece will look and feel like.

The Beta allows for the client to view it in a working format and make changes because we have not yet built the document into an unchangeable format; we're still in the production phase. It is important to get client to sign off once again on the content and navigation of this Beta. This is the final proofing stage for imagery selection, text, sound, video, etc. Clients often do not understand that changes made after this stage are like making changes after a piece has been printed and delivered; the entire structure of the piece needs to be revisited and redone. Do not get caught up yourself in the excitement of presenting this most fun phase of a multimedia project without making this fact very clear.

Pricing for the Beta should be based on a combination of your multimedia hourly rate and the ultimate value of the finished work itself. If you are introducing a new product that features a new logo, online catalog, sales training, and distribution methodologies, make certain that you charge a fair price for the logo itself, along with all of the peripheral functions of the finished piece. It's very easy to cut yourself short and overlook the actual value because the format in which you are presenting is different than our traditional modes.

Phase Three, then, is the actual programming. Everything is assembled and converted into absolute working functionality. When the client views the project at this point, it is 95 percent functional. After client sign-off at this phase—a final Beta, if you will—the piece goes into testing. A final release version is prepared after every possible user platform and applicability is tested on a variety of systems. Sign-

off is once again required for approval of manufacturing. It is important to include a statement that removes you from any responsibilities if a new problem should arise that was not found in the multiplicity of testing that you performed and the client approved. The statement should include that the piece has been virus-checked with a specific virus software. It is prudent to include, in detailed writing, the actual testing methodologies that were performed on the Beta and improvements that were subsequently made. This shows—and should stipulate—that you have done everything in your power to protect the piece from problems. However, should problems occur, you are not responsible.

I like for Phase Three to be priced strictly on an hourly basis, with a projected estimate signed off by the client, including an allowance for time overages. Programming time is very difficult to predict. It's hard to get clients to sign off on paying hourly rates with unknown endings. But if you can be fairly specific about a range in programming pricing and honest about your billing procedures at the end of the project, most clients will go along with the gamble of saving money this way, as opposed to your giving them a flat programming price.

Finally, spell out the exact deliverables on all of your pricing and budgeting paperwork involving new media. Be incredibly specific with regard to what target system the project is being developed for, the target through-put (bandwidth), the software, and language with which it will be developed. There are multitudes of issues that should be detailed, many of which may not even be discussed in your client meetings. You are required to provide an education to your client and be responsible for establishing a precedent. Will any of the images need to be downloadable? Printable? Will several Web sites need to be built, for example, for AOL users, Netscape users, Internet Explorer users? You must determine the end users' capabilities with regard to the type of hardware they are using, the software they might be running, the speed with which they are receiving or downloading information.

Spell it all out to the point of irritating your client. Often, your clients will not have the answers to these questions. They want you to get started right away (thus, Phase One!); they want immediate satisfaction. The advent of higher technology has become a nemesis to us graphic designers. Everyone wants everything last month, it's not even about yesterday any more. It is up to you to charge them for it and explain the differences.

At the time of this writing, there are so many unknowns in our own industry with regard to the ultimate relevance of the dominance of multimedia projects within our revenue stream. While it is most intriguing and fun to produce, the medium still has higher costs and more risks than traditional print and video. There are still too many unanswered questions with regard to copyright law. We're all—users and developers alike—immersed in this wild, wild west. As new software is designed and better compression algorithms are created and improved, so will our services and pricing evolve with the revolution. It promises to be an interesting and educational evolution!

■

Some clients are notorious for changing their minds for all the wrong reasons and at all the wrong times. You *can* charge the client for changing their minds a million times! A first round of changes to the original design and copy concept is acceptable, at no additional charge to your client; build this into your quote. Sometimes, even a second round is required; for these clients with changeling faces, I know to add what I call a "revisions allowance" in their quotes. Any changes after that mean either that you are not communicating with your client effectively, your client has multiple personalities (and many of them do!), or your client is making their decision by committee—and the committee is too big to agree on anything.

The Changelings

If you have the unfortunate history of experiencing most of your clients constantly making changes, then a personal assessment is certainly due. More often than not, however, if a client is given carte blanche to make changes, he or she will do so. Set the rules up front. One idea may be to design a "Change Order" form. This form might be a simple confirmation of the client's desired changes, along with a new cost for this revision and a place on the form for them to sign off. It could be as simple as setting up a template that can be printed on your let-

terhead. Review this form and procedure with your clients before starting projects, thus warding off their desire to make alterations.

Clients, justifiably, are allowed to change their minds. What we as designers need to realize is that, most of the time, client changes are not meant to bruise our egos or to point out that we are uncreative or totally off base. Remember that many times client changes come not directly from your client but indirectly from your client's boss. When changes come from a higher echelon that seems as invisible as the Wizard of Oz, it is important to remember that eventually the Wizard surfaces, and, just like in the movies, he may not be such a bad guy after all.

The truth of the matter is that the client most often *does* know his or her product or service better than we do and should ultimately have the final say. Keep in mind that there is a time and place for client changes, and it is up to you to set those ground rules proactively while you are establishing the schedule for the project at your initial master meeting. Discuss up front the issue of possible changes that your client may want to make. Be specific about what these changes could possibly be. Give your client reassurance once again that while his or her involvement is key to the success of the finished piece, revisions should be made only at certain incremental stages of the project, which you establish and agree upon together. Changes at any other stage of the game (after color separations, for example) will wreak havoc with your estimate.

Don't let unreasonable revision charges build up until they become a towering inferno of disaster. You don't want to absorb these charges, and your client must acknowledge them if they are to be made at all. Many times, when clients are informed of the costs they will incur to make a significant change at the wrong stage of their project, they will change their mind (again) and leave the project alone.

For as many times as a client may think he wants to change his mind, there are as many occasions where a simple dialogue with you might convince him otherwise. Acknowledge the concern, but point out how such a change might be costly beyond any possible value to be derived from it (if this is actually the case) and, more important to you, how the change may actually be undesirable from a design standpoint. Sometimes, clients want reassurance that they have made the right choices along the creative way. Lots of times, they are charting unexplored areas, and their decisions are being scrutinized not only by their customers, but usually by superiors as well. Your sensitivity to these issues, along with an ultrasignificant patience factor that has been

deemed necessary to your survival in this industry, is vital to your success. A great example is when a client sees a color proof and suddenly isn't sure you've chosen the right color for the headline, only a few days after he said he loved it and it was perfect. Your answer should sound something like, "You know, I had the same concern about that red myself as soon as I saw it, but then I realized it was the best choice because of the daring message we're trying to deliver and also because the red matches the color of your product perfectly. I can't think of a better color to use here." Most of the time, your client simply wants acknowledgment and validation of his concern. Your explanation then gives him ammunition if someone else (perhaps his superior) decides to challenge him regarding the same issue.

Your delivery of these dialogues will get better and better with practice, and once you have the satisfaction of observing a client go from wanting to change the course of things to seeing it your way, you'll know that you can achieve the desired results—you just can't expect to do it all the time.

Some ideas follow on how to handle a client's unreasonable change requests:

- Listen very carefully to what your client is saying—it may not be as bad as you think.
- Be objective. Review your proposal (if you did one) for an outline of the project's goals and objectives. Do the client's changes concur with those goals and objectives?
- Validate your client's concerns by simply acknowledging them. This does not necessarily mean that you have to agree with them.
- Discuss the issue and endeavor to mutually agree on what the next step should be. Most often, the next step will be for you to research additional costs and discuss them with your client as soon as possible.
- Communicate additional costs in writing to your client, and have them sign a form that acts as an agreement to cover the surcharges.

Billing Protocol

Providing services that you can't charge your client for is sure to dishearten you. Your efficiency, and that of the staff members you have

chosen to slurp up your overhead, is of constant, utmost importance. Everyone makes mistakes; just don't make the same mistake more than once, and you'll be on the road to more profitable, enjoyable self-employment. Typical taboos that you cannot ethically charge your client for are things like fixing typographical errors you have made, not inputting client changes, not having your computer files set up properly for your printer or color separator to output, using faulty disks or CDs, suffering the dreaded "fatal error" computer bomb, not backing up or saving your computer work, and misdirecting a vendor or freelancer you have hired to help you complete the job.

A very difficult task is to train your staff members to take personal responsibility for their mistakes. The advent of the computer as a design-production tool in our industry has added a significant amount of responsibility to the designer's already heavy load of multitasking; thus, the opportunity arises for more mistakes on the technical side. Employees should constantly be updated on new ways of doing things, and also be monitored for costly errors that reduce the firm's profitability.

I have found that biting the bullet and paying for employees' mistakes without disclosing the monetary amounts to said employees results in even more errors. A staff member can quickly prove his or her loyalty, efficiency, and worth to the firm by reducing the frequency of mistakes once he has been enlightened about the occurrence and how much it cost the firm. An idea I have recently put into place is rewarding employees with a small bonus every month that goes by without their making errors that cost the firm money and time.

The old adage that hindsight is 20/20 comes into play in yet another arena: You have a hunch that adding more to the project will please the client and pay off. Often, you'll be right, but your thinking will be wrong in some of those cases, and you really can't charge the clients for things they didn't ask for or agree to.

But it can be great when you take the risk and it *does* pay off! There have been several occasions where I quoted a client a price for a specific project and decided on my own accord to enhance the project by adding time and, on occasion, even money to make that project better.

A perfect example is some package design that we recently created for a large grocery distribution company. Our original quote to the client, prior to client approval of the final concept, included two-dimensional designs. Once I saw our two-dimensional presentation

boards, I realized that creating three-dimensional prototypes might actually sell the idea to additional departments within their huge corporate domain. I was right! Having tactile samples to fill with product and do test displays gave other department managers the opportunity to think of items in their own areas that could be uniquely packaged with the company's own "signature" art and design. Putting some extra time and money on the line was a lot more strategic than throwing dice on the table in Vegas, and the payoff for us was a job that literally quintupled itself in volume and profitability.

Another example is an incentive program we created for a large paper distribution company. Our original quote and presentation were for a more conservative design with minimal production work. When my art director got into the project, however, he had some great ideas that required a literal ton of multimedia development time, not to mention a few thousand dollars. The client liked the idea and agreed to pay for the extra photo images, scans, and color separations that ensued. Because of budget constraints, however, we could not charge the client for the tenfold time required beyond our original estimate. Also, at the time we were really in the learning phase of using Macromedia Director to its true potential, and we couldn't fairly charge them for our learning curve.

The payoff in this case was a multiple-awards-winning project, new portfolio pieces, and the acquisition of two very large, intense multimedia projects from two new clients who were very pleased to finally find a local firm that could produce high-end, new-media techniques.

There is a tendency in our industry for egos to get in the way of practicality and reality. The introduction of multimedia as a design and production tool presents a perplexing problem. The incessant, looming question is, What specific services and supplies will we provide to our clients? Most clients have the comical perception that if you have a computer, you can just "change this and that and move this here and change this color there and animate this," on and on into oblivion. Theoretically, this may be true, but the real world comes back with a bucket of cold water in the face, reminding us that we can't be everything to everybody, like we sometimes imagine in those omnipresent rose-colored glasses! The answer is simple: Don't make it hard on yourself. Do what you do best, and do it all the time. If your strong point is graphic design and only graphic design, provide your client with *only* that service. Talk to vendors about your weaknesses, and at least edu-

cate yourself enough to offer a referral service to clients who need to buy services that you don't provide. Refer to the full-service concept earlier in this book, make your decision about what services you do and don't want to provide, and move on. You can always add services to your list; it's harder to take them away. Realizing your strengths will reward you not only with profitability but also with a great reputation.

There are five common faux pas that you should take responsibility for and never charge you client:

1. Typographical errors that appear on a dylux, or printer's proof, that were not corrected by you or your staff after a client asked you to make the changes. This includes not only misspelled words, but any copy changes that your client indicated to you when you reviewed the final proof with him before sending it to the printer.
2. Inadvertently changing the color of something that your client specifically requested.
3. Accidentally changing the position of something that your client requested, such as transposing a couple of paragraphs within the copy or swapping some photos or illustrations. Be careful with this one, especially if you are using freelance help or entry-level designers for a project. Invariably, people with less experience will make decisions on issues like this when they really shouldn't.
4. Requesting the wrong ink or paper colors from your printer. It's easy to transpose PMS numbers or read the wrong item from your paper swatch books, especially if you are transmitting this information over the phone and have no documentation to back yourself up. (If such a mistake is made, is it the printer's fault or your fault? It will ultimately fall on your shoulders in your client's mind.) Always confirm these details to your printer in a written purchase order.
5. Having the final printed materials delivered to the wrong address. Don't laugh—this happens often. To avoid arguments and incurring additional freight costs, have your client confirm the delivery location(s) to you in writing.

You Gotta Be You

Owning your own graphic design business and developing your personal ethics systems are a huge challenge in their own right. Don't be

too hard on yourself, but always be true to yourself. Living under false pretenses is very stressful and can literally make you sick. You must know your own process and that of your staff members to be truly productive and profitable. Dealing with money and issues regarding pricing is delicate subject matter. Money is a weird figment of our society. It's very intimate, and everyone handles it differently and has different concepts of right and wrong. The entire process is a very individual one, and this book was designed to open your own awareness of what might work for you.

Situations will occur when a client says, "I spoke with such-and-such design firm, and they can do my project for $3,000 less than the estimate you gave me." Your first response to this matter should be a question as to whether or not your client is comparing apples to apples, but never ever put yourself in a position or frame of mind to appear defensive. If you are a multi-person firm and you are being quoted out against a freelancer or small studio, your rates will obviously be higher, and you can't be expected to compete in such an arena. If your firm was quoted out against another multi-person firm, comparably talented, and you feel that you properly assessed the requirements of the project before submitting your estimate, then tell the client they have a good deal going with the other firm, and you'd like to see how the project comes out, thank you very much!

If you decide to lower your price point-blank, you are setting a dangerous precedent. You will always be expected to lower your prices with that particular client, and you will get a reputation all over the place for doing so—clients talk, you know! Protect yourself. Don't feel like you have to get every job you estimate.

It comes down to the simple matter of who the client really wants to work with and your own capability to look at the matter strictly professionally. Don't ever take these situations personally—if you do, you will be committing yourself to straitjacket city in a matter of months!

Time Management: Key to Your Survival

Another mandatory aspect of being you that makes every right-brainer cringe is accepting the concept of time management. "That's for accountants!" you say? I used to think so, too. I'm not going to frustrate you with loads of information that you probably won't take the time to read anyway! Just please know that time management goes

hand in hand with project management and that discipline thing, so difficult for us designers to commit to.

I finally found the one time management tool that totally changed my life—I mean totally—when my dear colleague Kathy Madden forced me to buy one of those day-planner things. Before I joined the multitude of users of those calendars-in-a-spiral-notebook, I had piles of stuff on, shoved in, and stacked knee-high around my desk. I thought those planners were for geeks—certainly not graphic designers! And why would I want to spend over $30 for some notebook pages that I would never use anyway, and another $100 for a leather-bound carrier that I didn't like the looks of? Dear Kathy practically bound and gagged me as she ever so patiently showed me my new apparatus and how to use it.

Ten years later, I am a reformed and better-organized woman. I go absolutely nowhere without my day planner. You will find that day planners come in many different sizes and name brands, and you'll also find that one name brand's carrier is not compatible with the holes punched in the other name brand's calendar pages. Getting over this initial frustration will be easy once you are able to open yourself up to the wonderful world of pre-organization.

That's right—someone else has already figured it out for you! There, before your very eyes, are sectioned-off pages that include every hour of the day for your appointment reminders, plenty of space to take notes (and draw pictures!), other goodies like last month's and this month's calendars in full view, and any month within a five-year period at your fingertips.

What about the infamous electronic PDAs that are everywhere, with people beaming each other up and on and into mega-information, games, stock quotes, and e-mail messages? I think they're great. As a matter of fact, I had one and plan to get one of the latest models as soon as I have enough time to research the perfect model for myself. Really. But the fact that I *had* one—past tense—lends itself to the fact that an electronic PDA will not withstand the pressure of a 145-pound woman stepping solidly on it in the middle of the night with steel-toed work boots on. Nor will it tolerate falling off the roof of your car as you're zigging down the street, late for an appointment. It also lacks resistance to things like Crazy Glue and Play-Doh. Then, there's the time when I had an important meeting and looked down at my PDA to realize, in horror, that it had translated my text into nothing better than garble. Need I say more?

Look, I am not getting paid one red cent to endorse these paper planners, and I won't even give you my favorite name brand, but I can promise you that a planner will change the way you do (or don't) organize yourself, your clients, your vendors, and so on. It will be a tremendous aid in your master meeting and for determining project schedules as well as personal schedules. Everyone on my staff has one now, and it has made a big difference—everybody knows what is expected and when. Ultimately, putting these deadlines and other details in writing in a calendar format—especially if you actually take the planner to planning and creative sessions—opens up your own creativity. You're not bogged down with all that left-brain stuff, because it's all in your book!

Know Your Work Process!

Another significant factor in the world of organization is knowing your work process—how you get things done. If you know your own methods and can use them to your advantage, organizing yourself and others will be substantially easier. A lot of our work processes were taught to us in design school or college by professors who set up class assignments with schedules that suited *their* work processes. You may not have given it a second thought until now, but do so with me, and you'll see what I mean.

Realistically acknowledging your answers to the sidebar questions on the next page will be a great help in setting up your projects' schedules in the future. You will learn to know yourself better and plan the sequence of necessary events that you establish with your clients around what you've just learned. If you have a staff, ask them these questions as well. Know that if you are going to require someone's help to complete a project, you will have to set up the schedule accordingly, to fit a work process (or style) that may be very different from your own.

This whole work process thing came to me while teaching at the University of Dayton several years ago. My own work process is mostly that of diving right in and creating a visual theme before I get the copy. So, when I assigned a portfolio-type project to a group of seniors, requiring only five thumbnails before moving on to the design enhancement and production phases, I heard this huge resounding sigh of relief from about half of the class. I thought five thumbnails sounded like a lot. It turned out that my colleague down the hall, who taught another

Answer the questions below as specifically as possible to learn more:

- Do you like to do a lot of thumbnails before you begin a project? If so, how many, and how much time do you like to spend on each one?
- Do you like to do research before you begin designing to get a true and accurate sense of who your target audience is?
- After you have been assigned a project, do you like to let it twirl around in your head for several days before you begin?
- Do you like to have the copy written before you start designing so that your visual design can fit the meaning of the text?

Or:

- Do you like to start a project right away, spending little time on thumbnails?
- Do you get frustrated when a client asks you to show more than one concept?
- Do you find that you have an intuitive sense regarding many different kinds of target audiences and what will appeal to each of them?
- Do you like to come up with a visual idea first and then have the copy written to match your visual theme?

No answer is right or wrong. Answering affirmatively to the first four questions and having these methods appeal to your sense of how to be productive simply shows that you come at design from a more practical, fact-oriented basis. You're the type who likes to turn over every stone before you pick one up and hold it for awhile. The methods suggested by the last four questions appeal to design types who get frustrated with a lot of preliminary tasks and who like to dive into a project immediately.

portfolio-level design class, required a minimum of thirty thumbnails on his projects.

My first inclination was to panic; I had never taught this level of design students, and I felt that maybe I was not pushing them enough. What I soon learned was that the students who needed to do more than five thumbnails did so on their own before they could move on. About half of the students did just fine with only five thumbnail con-

cepts. Grades and the quality level of the finished projects were not impacted at all by how much planning or "predesign" work went into a piece. My colleague's students' projects were no better than my students' projects. It simply boiled down to two different methods—or work processes—of performing the same tasks.

You'd think that this teaching experience would have shown me something about scheduling projects for my own staff. But I hadn't really learned my lesson. Very shortly after this scene played itself out, I had the great fortune of being able to hire a very talented illustrator-designer who had recently graduated on an art scholarship from a well-known university. I had seen his portfolio about six months previously but did not have any job openings. A significant growth in accounts offered me the opportunity to seek out this young man and offer him a job.

About two months after my art director and I had enthusiastically agreed that this young man was the perfect member to add to our team, we began to have second thoughts. He seemed to have trouble meeting deadlines and all of a sudden seemed unsure of himself. The quality level in his once-incredible illustrations and designs seemed to drop way off. We were frustrated, and so was he. The straw that finally broke the camel's back was when we gave him the opportunity to draw some illustrations for a new client's capabilities brochure. He worked solidly for one week and then over a weekend, with very little to show for his time. We met him on a Sunday (the project was due for the client's review on Tuesday) and couldn't believe how little we saw. I frantically called in two freelancers, who responded appropriately, and we got the job done on time.

This employee was really depressed, and so were we. When my anger and disappointment had subsided enough for me to talk with him about what had happened, the skies suddenly parted and light shone down into my blinded eyes. We soon were all relieved to realize that it was a simple matter of his having a different work process. While my art director and I have a quick-go-to-it process, this staff member likes to plan with a lot of concepts and especially needs to have copy, or at least a comprehensive idea of what the final piece is going to look like, before he can really get started.

This story is a great example of just how important it is for graphic designers and their employers to understand the vast differences in individuals' needs in regard to getting the most creative output from

them. When you look at graphic design as you would a manufacturing process, it's easy to see how different methods of operation will affect not only the end product but the efficiency within the production process as well.

Project management from a creativity and organizational standpoint can benefit greatly when the principal (or principals) of a firm oversee all the projects. This doesn't mean that you will have to over-encumber yourself with work tasks—quite the contrary. By overseeing projects, I mean that you should approve each project at every significant stage of the growth process—read through copy and make any suggestions for improvement to your client or copywriter, review and approve the initial concept (if it wasn't yours to begin with), approve all images (photos or illustrations) before they are scanned or included in the piece, and approve final production before it is set up or prototyped for the client.

By overseeing projects in this way, you will better understand what endeavors went into each phase of the design from a time-creativity problem and solution standpoint. You will be more respected by your associates and your clients if you have a general overall knowledge of each element of a project. If you're the principal of a firm or studio, your capabilities for discernment are more developed than those of your support staff. If you become out of touch with a project, you will also lose control of it, and the end result may be something that is not up to your standards.

As your firm grows, it will be exceedingly difficult for you to oversee each and every project produced by your firm. The challenge will be to find that special someone you trust enough to give authority similar to your own. To this day, the most difficult task I have ever faced as the owner of a firm was to find just the right person to help me take on the most significant task of overseeing projects.

It's more than *like* a marriage; you literally give someone the trust to make important decisions in your absence. You learn immediately that if they don't do things just like you do, it will be hard to accept their decisions, and you learn how to stand up to clients in situations where you personally had absolutely nothing to do with the issue at hand. I know that some principals never find just the right person to accomplish those ultra-important tasks. After having my firm for nine years, I had the great fortune of meeting the person who is now my trusted partner and creative comrade.

Now, either Chris or I oversee every project that comes into our studios. It can get really crazy at times, but we both know that it is imperative for one of us to approve projects internally before our clients see them. The ultimate outcome is that each project will have benefited from more than one creative eye (that is, it will be seen by the designer who actually created the work and either Chris or me), and, perhaps more importantly, it will have been organized and managed within the discipline of the internal system we have created. Consistency in how we produce and present our projects has been the key to our firm's "signature" within our market.

Your Client Is Your Partner

Treating your client somewhat as you might a business partner will help both of you create successful projects. None of us like to feel that we are being controlled by someone else. Simply offering comments like, "I'd really like to know how you visualize this piece before we get started," or, "Your input is really important to the success of this piece," psychologically makes your client feel like a significant contributor to your design solution.

Even if you don't really like the client's ideas, make sure you listen carefully without interrupting when your client is voicing an opinion or presenting an idea. You will make your client feel great whenever you *can* offer, "That's a great idea!" If you would like to change or add to their idea, or offer an alternative, try to add something like "And it would also be great to blah, blah, blah." Words like *and*, *also*, and *in addition to* are inclusive of the client's ideas. Don't use words like *but*, *only*, or *just*; they are negative. You can more readily get your message accepted by using positive words.

Develop a System That Works for You

Knowing yourself and your staff's processes will be the foundation for the type of project management system you need and will also depend heavily on the size and complexity of your business. If it's just you, or you and one or two other people, it's easiest to implement a simple system; I recommend the "job-jacket" system outlined below. For a larger group of people, you'll want to involve everyone in devising and implementing a system that works for all the individuals involved. (*Why*

group involvement is much more important than the details of the system you eventually decide to adopt is further discussed on page 113.)

The best system I've found for small groups—which I define as you working alone or with one or two other people—is the job-jacket system. A job jacket is simply an oversized envelope that holds every element belonging to that particular project. The external job jacket itself can be reused many times until it falls apart—your clients will never see it!

The outside of the job jacket usually has a clear pocket of some type that you can use for the job's log number, the project name, a list of everything that's inside, and client information, such as name, address, and phone number. Or this information can be written directly on the envelope itself. Inside the job jacket you should keep: hard manuscript copy; disks containing art, text, and other relevant parts of the project; all photos and illustrations; purchase orders; time sheets; and anything else that your client originally gave you when you accepted the project.

Job jackets should always be kept in a central location where everyone can access them. At the end of the day, all items should be put back into their specified job jackets. The next morning's work can then be started by either the same person or a different person without wondering where certain project elements may be. This simple but effective system works great and is the most common organizational system used by small studios.

Seldom does a firm open its doors with a huge, award-winning staff, crème-de-la-crème clientele, and an overflow of working capital in the bank. If you decide to start a studio, and it grows until you need to hire several full-time support staff members and then several more, you'll need more than the job-jacket system to keep things organized and flowing comfortably.

This may sound odd, but the best way to create a strong project management system for a larger group of people is to get everyone involved in both the creation and the establishment of the system. This is at least as important as what kind of system you eventually establish! By getting everyone involved, everyone takes ownership of the system, and everyone has had a say in its development. Work processes of all types will be acknowledged when a group makes a team effort in putting together a project management policy in which every member will participate.

Five time and project management tips follow:

1. Consistently maintain time sheets.
2. Plan your days so that you can spend at least two hours at a time focusing on design and production tasks. Fragmented time is counterproductive.
3. Make and return your phone calls at the same time every day; try initiating calls first thing in the morning for an hour and then returning calls between 1:30 and 2:30 in the afternoon. You'll find greater success in reaching your parties at these hours, resulting in some nice blocks of time for planning or productive sessions. Don't set up appointments for yourself during these periods, and inform your staff that you are not to be interrupted at these times.
4. Be aware that job burnout occurs more often in our industry than in any other. Encourage staff to take planned vacation days, consider giving an extra day off on holiday weekends, and think about closing your office or studio for the week between Christmas and New Year's.
5. Set realistic schedules for projects, and stick to them. Hire freelancers or approve overtime hours to keep projects on track. Falling behind will result in a domino effect of being behind all of the time and becoming notorious for missing deadlines with clients and vendors—a really big no-no in our industry!

When the boss tries to put the so-called "perfect system" in place, the support staff tend to hold grudges or find excuses for why it isn't working. But when the support staff teams with their leader in a joint effort, a clear winner emerges—the group itself as a whole!

Once you and your group have established a project management system that everyone can assume some level of ownership for, it should pretty much be left to run on autopilot. You should have checks and balances set up along the way so that you or another key authoritative person will be overseeing or approving projects as they pass through the phases you have deemed necessary for such review and approval.

Ongoing clients will become a part of your project management system through osmosis. They will know from experience when and how to expect things from your firm. You will have developed a con-

sistency that you, your staff, and your clients will become familiar with. Good staff morale will ensue because you have allowed everyone to be a part of building the machine that will drive the team's organization.

I know it all seems like a lot of work, especially when you can't possibly see yourself being this detailed or this organized. I totally understand. But trust that your professional and personal lives will be much better for it all. Picture this monster inside of you that is the bad, disorganized, and out-of-control guy. Then, picture the calmer, more productive, in-control person. You might not be even the slightest bit aware of the second option. Now, you have the tools to meet that awareness face to face.

■

know you have spent a lot of time and energy in establishing your
hourly rate and learning about value pricing. But creativity in your
pricing structures can be just as important as the creativity in your
portfolio when it comes to operating your own business.

Brokering

I'll never forget exactly when and how the idea of "brokering" in my
business came to fruition. After my car accident and the subsequent
restructuring of my business, my soon-to-be husband, Joel, and I were
brainstorming on my recent lack of profitability. Since I was the pri-
mary salesperson at the time, reducing my overhead because of lack of
volume was mandatory.

Joel's closer scrutiny of my books showed some months with huge
sales and other months with less than 10 percent of those sales. I
explained to my pragmatic, numbers-crunching, attorney guru fiancé
that the huge months were reflecting jobs that resulted in equally huge
printing and color separations costs. "Well, that's simple," he replied
unnervingly. "Why don't you act as a broker for those services?"

I began to silently wonder why I had ever agreed to marry such an
uncreative, left-brained kind of guy. Not only had I never heard of bro-
kering in our industry, it sounded like a dirty word that was filled with

pinpoint oxford cloth shirts shouting indiscernible words on Wall Street. Little did I know that it was soon to be one of the most creative ways to generate consistent profitability and peace of mind.

Joel encouraged me to call a close friend of mine who was also a printing sales rep and discuss the possibilities of brokering. The idea was to work like this: I would continue to offer full service to my clients by providing printing management, coordination, and quality control (which was very important to me). I would still obtain quotes from printers and color separators and include their prices in my client's estimate, with my normal markup fee (which we'll go over next in this chapter).

The only difference was that the printer would bill my client directly, include my markup fee, and then send me a check for my marked-up amount after my client paid him. The beauty of this plan is that all at once, your printers and color separators owe *you* money! Suddenly, your books are consistent every month, reflecting your actual billing performance more realistically. And you don't have to worry about your client paying you on time so that you can pay your printer on time.

This system also leaves you absolutely no opportunity for the occasional temptation to spend moneys collected from your client for your huge printing bills on something other than what they were intended for. Too often, businesses of all types get into "robbing Peter to pay Paul" and fall dangerously behind in their obligations to Mary, even though they had every intention to make up the difference through increased revenues or better cash flow management. Don't ever let this happen to you.

Of course, there are individual clients and situations where you will want to absorb the paperwork and details of significant outside costs. Some large companies issue only one blanket purchase order for a project, and if you claim to be full service, you may need to be responsible for the entire project, including hefty printing charges. But 90 percent of the time, the brokerage concept has worked *very* successfully for me.

Quite surprisingly, our vendors love it, too, and most of them are now encouraging other firms and agencies to operate in the same manner. It's an efficient way to handle large amounts of money and be able to look at your business volume more realistically. Vendor trust is an absolute must, but to this day—seven years later—I have never had even

the smallest problem with the implementation of this system. As a matter of fact, every printing vendor we use has its own company brokers, making it easy for us to be objective in our selective process.

Most clients will welcome receiving the printing invoice separately from their design services invoice. Printers usually bill at the end of the month, and in many cases this will extend the payment period for your client, because your invoice should be in their hands shortly after you have sent your files to the printer. Typically, I tell clients that we prefer billing them for our services while asking the printer to do the same. I explain to them that we do quote two to three comparable printers and always choose the best printer for the project depending upon price and quality. Disclosing the actual brokerage procedure is usually not necessary. If clients ask, I certainly tell them that the printer discounts the work and uses us as a broker—which is true— and it has never created a problem. Generally, the client wants and appreciates the full service.

If the client wants us to bill the printing and carry complete administrative and supervisory management of all outside services, we add a project management fee to cover our production manager's billable hourly rate as well as the typical markups discussed next in this chapter.

Markups

Everyone knows the concept of retail markup. The corner grocery store buys lemons for a dime apiece and sells them three for a dollar. Your favorite department store buys Levi's for $16 and sells them to you for the everyday low price of $34.99, and so on. Well, every business has their own markup standards, and the graphic design business is no exception.

Consider the substantial cost of supplies required for a packaging presentation, for example. Or, if you are buying your own printing, color separations, high-res scans, or whatever, you need to be aware that there is a universal standard of marking up these costs. I had my firm for almost two years before I came to this heightened level of awareness while having lunch with a business mentor. Hopefully, you're finding out about this earlier in the process than I did!

The most common markup in the graphic design world is 15 percent; every firm I interviewed used that amount as a base and went up

or down from there. On smaller projects, many firms (including mine) charge a 20 percent markup to their clients for outside costs. This simply makes it all worthwhile and recoups some of your unbillable office manager's time for all the work like invoicing and purchase order management for the necessary supplies and vendors required to complete the job.

Usually, the only time markups go down is when the quantity of a press run (the actual quantity being printed) is so large that it is totally unreasonable to charge 15 percent, because it places the entire project in jeopardy of being monstrously over budget. The perfect example of this is a company's annual report, catalog, or packaging items. Run sizes that exceed a quantity of twenty thousand fall into the lowered-markup category, most often hovering in the 3 to 7 percent markup range. Once again, the value theory comes to light, and it is necessary for you to make the final decision. Sometimes, putting even a quarter of a penny per unit onto runs can increase your profitability substantially without taking the client over budget on their unit cost.

Management Fees

There are pros and cons to letting your client be the one to manage the printer and other large outside suppliers. Sometimes, clients want to manage things like who will print their project, who will shoot their photos, who will provide the final film, and who will perform the major tasks that bring a project to its final peak (or demise!). While some clients really *do* know how to buy these services, others know just enough to cause real trouble. Your job is to discern among the multitude and decide accordingly.

Since some clients will be adamant about managing these matters, your challenge is to decide whether or not this control scenario is agreeable with your own process. If the vendors the client wants to use are your own vendors, then there is typically no problem. Sometimes, clients who buy their own services will even respect your suggestions and referrals. In any case, you should ask for a management fee to go through the proofing and quality-control phases of your project. After all, if your clients respect you enough to hire your design services, they should want your blessing on the photos they've chosen or the quality and integrity of the final printed piece.

If you're full service, don't be afraid to say no to a client's project

Markups are a great way to make a nice, ethical profit margin, especially on jobs that are produced on a regular basis. Use the following checklist to remind yourself of typical things to mark up while you're doing your estimate or projected budget:

✔ Printing fees
✔ Color separation charges
✔ Supplies needed to complete a job—special presentation boards, colored papers, and laminating
✔ Any outside service bureau fees—high-resolution outputs, color lasers, color copies, and oversized outputs
✔ Laser copies from in-house equipment
✔ CDs or other hardware required for backup of client files
✔ Photographer or stock photo fees
✔ Supplies and materials needed for photo props
✔ Copywriter or other freelance fees
✔ Anything that you are buying to complete a project

that won't pay you a management fee to go on the press proof or allow your input on photography or color choices. Both you and the client are asking for trouble when it comes to important quality issues in the final piece. Many good designs rely on finishing techniques, such as varnishes, tints, duotones, and other production techniques that simply cannot be proofed until the final stages of a job. If an alteration needs to be made in the color-proofing stages or on press and you are not present to make the decision of what gets changed and how, chances are your design will be sacrificed unnecessarily, to your total chagrin.

Page Rates

Quite often, a new client will ask me what our per-page rate is. I became very familiar with this term long ago while working for a large department store. Catalogs featuring the latest fashions were being produced in some form nearly every day, and freelancers were paid by the page—one per-page fee for design and layout, another per-page fee for production. If you were really efficient and could design two pages in

an hour at $50 per page, you could make a lot of money really quickly (hey, this was 1980). To be quite honest, this per-page deal was the deciding factor several years later when I decided to quit a production supervisor's job in a corporate advertising department to join the ranks of per-page-rate freelancers!

While the "per-page" term won't be heard on a daily basis, clients who produce catalogs frequently or who deal with newspaper or magazine ads will freely use this expression and expect you to respond to it.

Working on a volume project that has a per-page fee attached to it can be quite profitable and rewarding. Since this appears to be the age of catalog production (everybody's doing one), getting a few under your belt as examples will give prospective catalog clients the green light to hire your services. Catalog design and production is always a good way to keep cash flow going and staff people busy all the time. It is the butter and bread of many design firms.

The best way to determine your per-page rate is to ask clients what they are used to paying. I have found that 75 percent of the time, clients in this category are willing to pay more than I would have asked—so, in that case, you've got a win-win situation and everybody's happy!

If a client is reticent to give you a rate, you'll need Intuition 101 once again. First, decide on the value of the job. Then, use your newly-found algebraic skills, and try to determine how long the project will take you to produce and multiply that by your hourly rate. How does the value assessment compare to your hourly determination? I tend to use a combination of both rate methods until I'm comfortable with the outcome.

If the client thinks your per-page rate is too high, share your difficulty in establishing this rate with him or her and see if you can come to an agreement that you both feel good about. Don't let yourself get backed into a corner; but the sooner you can find a comfort level for discussing money issues with your clients, the better for both of you.

Newspaper and magazine ads are also often quoted in per-page-rate terms. A newspaper will have its own specific grid and column inch requirements—a one-third-page ad in a Chicago paper might be a quarter-page ad in a Phoenix paper. Make certain that you are familiar with this particular sizing before you quote prices. Some newspapers are

even set up in tabloid versus broadsheet size, which could also make a substantial per-page rate difference.

Giving a correct price for a magazine ad will also require knowing which magazine the ad will be placed in and what the size of the publication is. Hardly any magazines are the same size these days—approximately-the-same doesn't count—and asking the right questions up front will get you more respect and confidence from your client.

Knowing these different possibilities for sizing as they pertain to your per-page rates, even in approximate ranges, will be an asset in initial client meetings, where you might be asked to discuss rates on the spot.

There are often opportunities to design ads for publications themselves. In this case your per-page rates may vary with the nature of the periodical or its circulation quantity and advertising rates. Smaller publications tend to pay less, but it is a great way to meet potential clients and get some work in your portfolio, especially if you are just starting your own design business.

Retainers

Retainer pricing means that a client pays you a straight monthly fee for services you provide. In actuality, the client is retaining your services for a consistent fee based on your annual volume of work production for them. This pricing strategy is quickly losing its popularity for reasons I'll soon discuss.

Retainers were primarily devised for full-service advertising agencies by clients who would buy radio and television time on an ongoing basis using an annual media budget. The retainer fee would be used essentially like a revolving credit card for the agency to book future media time for the client while paying for the prior time used. On a monthly, quarterly, or annual basis, the entire account required an intense review to determine whether the agency was overpaid or underpaid, what exact services were performed at what rate, what projects the client had added unexpectedly, and so on.

Many large agencies and some large design firms still use this billing procedure for large, ongoing accounts, but its feasibility is quickly waning. The biggest problem is that many times the firm ends up owing the client money. Most firms simply don't have the cash flow to "pay back" money that they've already used for something else. *Every*

client I have spoken to about retainers over the last ten years has been burned by them.

Another problem with retainers is the legal descriptions, contracts, and attorney fees that ensue with such an entanglement before you can even get started working with the client. Not to mention the paperwork and accounting nightmares that suddenly face your office manager.

If a client suggests a retainer program to you, however, don't cower in abject fear. That suggestion means there's lots of work coming your way!

A great advantage of retainers is certainly the consistent cash flow that will prevail, as well as a guaranteed level of work. Retainers are a great way to grow your firm because you can assign a staff member to "manage" the retainer account while hiring new staff members to either dedicate to that account or work on new projects. Make certain to have a contract stating that the payments are not refundable and that the account will be reviewed quarterly by both you and your client (to make sure that you don't "owe" your client too much work, or to bill additional fees to your client that were not covered in your original retainer agreement).

The biggest negative thing about retainers is that they *are* contractually binding, usually for at least a year, if not longer. This can be a good thing for you if all is peaceful and smooth. On the other hand, it can be a living nightmare if, for example, all of a sudden you lose rapport with your client or the person with whom you work directly gets replaced by someone with whom you can't work too well. Make succession plans for your business for the impending loss of cash flow if either of these things happens, forcing you not to renew the contract when it expires.

Quick Billing

A creative alternative exists to the monetary tracking hassles that retainers require. Why not suggest a simple pay-as-you-go concept to your client instead? Billing can be done on a weekly, biweekly, or monthly basis (depending on volume) for the work done within that period; the client could agree to pay you within a week of receiving your invoice.

You might even give a 2 percent discount as an incentive if payment is received within ten days, five days, or whatever you decide is fair. Involving your client in this process shows your business acumen and also shows that you are serious about proficient service.

If you and your client agree to a quick-pay or other creative billing program versus a retainer, also ask for a ninety-day-out agreement. This could be a simple letter of agreement outlining your request for ninety days' advance notice should your client decide to terminate your ongoing services. Outline these ongoing services as explicitly as possible so that the volume of work is apparent. Your signature and your client's signature on your letterhead outlining your agreement quite simply suffices for a legally binding document. The ninety-day agreement will give you time to plan when a client does terminate your services and will also remind your client of his or her commitment to you.

Leasing Your Work

The idea of leasing design work was a new concept to me until I talked with Bruce Turkel several years ago for the original version of this book. Bruce shared this unique billing method with me, and I thank him for sharing this concept with my readers during that enlightening interview more than a few moons ago.

The basic concept of leasing your work is a simple one. Let's use logos as an example. Smaller clients are usually overwhelmed by how much it costs them to have a logo designed; even many corporate clients underestimate the importance of this significant mark and complain about the fees required to produce it.

Bruce's concept is that if you want to charge $8,000 for a logo (which is not out of line in most circumstances), then you should do so. But rather than billing the client for the entire amount in one lump sum, try the following: Negotiate a fair amount up front with your client, say $3,000. Then, make a payment plan to receive another $2,000 in six months, another $2,000 after one year, and the final $1,000 a year after that. The payment arrangements can be whatever you and your client agree is fair and reasonable.

Another alternative in the leasing program is to charge your client a flat fee for every year that your logo is used. Billing would be done on the anniversary date of the original logo approval. The idea here is to

show your client—especially the smaller, entrepreneurial client—that you believe in them and in their product. In essence, you're willing to take the risk with them and their new venture.

Per-Project Pricing

Countless times, I've been asked questions by clients like "How much would you charge me for a two-color, 8½" × 11" self-mailer?" or "What are your fees for a 9" × 12" full-color pocket folder?" These types of questions are frequently asked by new clients trying to get a feel for your rates.

As previously discussed regarding per-page rates, it's a good idea for you to have some idea of how to answer these questions. You don't want to be intimidated into quoting a lower price because you're being asked to think on your toenails. If you're not sure what you would like your answer to be, simply respond that you need more specifics, that each job is certainly different, and that you will provide a rate that afternoon or tomorrow or whatever, to make it clear that you are not simply skirting the pricing issue. Self-confidence is key here in your communicative rapport. People can pick up on your weaknesses quickly and use them to their advantage if you're not prepared with an answer.

After you have completed several two-color, 8½" × 11" self-mailers and several 9" × 12" full-color pocket folders, you will have a good idea of what these types of projects entail cost-wise. Things like newsletter, letterhead, envelope, and business card design—even eight- or twelve-page brochures—will soon develop a history of sorts within your invoice files.

It's a good idea to try to immediately share a range of fees that the client can expect. I've noticed that if you reply by saying something like "Design fees for 9" × 12" full-color pocket folders usually run somewhere between $2,800 and $9,000, depending on the images used," that's enough to temporarily appease the client. It's also a great segue to *your* next question, which is, "Do you have a specific folder requirement coming up that I could quote on?" The broad range of pricing given, while it certainly can be vague, should be realistic, and your client must understand that you need more specifics before you can provide a confirmed estimate.

Bartering for Profit

Bartering is indeed a way to make a nice profit of a different sort. Surely, you remember your *Weekly Reader* as a kid—it often described exciting trade journeys from the far corners of the world. Bartering is just the slang word used for trade, usually referring to trade on a somewhat less grand scale, i.e., between individuals or small groups.

I have designed many fun and creatively rewarding projects for clients who didn't have a lot of money but had something nice to offer in return. A very popular local restaurant in my old hometown is a great example of this. The Winds Cafe & Bakery is owned by a couple of friends who work hard and get rave reviews from critics all around the state of Ohio. I happen to enjoy eating their unique Mediterranean-style and nouvelle cuisine dishes. The Winds needed a logo—and sub-logos for their carryout bakery, coffee beans, and wines—but they didn't want to spend thousands of dollars for design and production. We agreed that they would pay for their fixed costs—the money required to print new menus, letterheads, business cards, envelopes, matches, and T-shirts, for example. Fees for design services and production would be bartered. So, everybody was happy—I ate great meals once a week and entertained friends and clients at no actual dollar cost, and The Winds got nicely designed promotional items, many of which have won design awards.

Another example of a successful bartering arrangement concerns a very talented furniture builder whose display window I had marveled in front of on countless occasions. Through an unusual chain of events, I was introduced to this man, who immediately discussed his need for some design services. Business was brisk for Glen, but he wanted to be doing more highly designed, custom pieces. The tradeoff here was a design for some direct-mail literature in exchange for an incredible conference table that playfully emulates a grand piano. Although we really needed a meeting table for our offices, we would never have been able to actually spend the money on an item as lavish as a faux grand piano. Glen and I decided that he would make the table during his down periods, and my staff and I would design his brochure in the same manner.

Since I have a staff and am actually paying someone their salary to work on barter accounts, I have to be very careful that we are busy enough with actual paying work to generate cash flow to pay for that

particular staff member's time. I am also very careful not to have too many barter accounts in house at any time.

The best barter situations are those that: (1) specifically fit your needs when an exchange is established, (2) affirm your need for a loose schedule so that you can fit them into down times, and last but not least, (3) retain a very high level of respect from your barter client for the type of designs you produce. The last thing you want is to trade any dollars' worth of your time with someone who will make content and format alterations that could leave you biting the bullet and unhappy with your agreement.

Flexibility in pricing options shows your clients that you care not only about the creative process but about their bottom line and budget constraints as well, and the beauty of offering these options can mean enhanced profitability for you as well.

■

This chapter will prove to you that estimates will be the benchmark for most projects you produce. Whether you are operating as a freelancer, a small studio, or a large design firm, an estimate shows your client that you are indeed a professional, that you have a good understanding of the client's expectations regarding creative needs and budget constraints, and that you know how to get the job done proficiently. An estimate is your primary starting point for good project management and for healthy client relationships. Never underestimate its importance!

What Is an Estimate?

A good estimate acts as a blueprint for a successful project and a satisfied client. This is truly the stage of a project that determines the quality of the end result. Goals for the finished project should be established and shared with your client as you review your estimate together. Your client will appreciate your thoroughness and understanding of the project when you provide a cohesive, concise estimate. You will benefit by gaining a client who shares your vision of the job.

An estimate is an evaluation or appraisal of a specific project in terms of creative and technical specifications and the fees required to implement these specifications. The estimate ultimately places an actual

value on a project—not only from a cost standpoint, but from a creative application vantage as well. Basically, there are two types of estimates: detailed, itemized estimates and simple, lump-sum estimates.

Your estimate will often become your contract for a specific project, so it's important to do your homework until you're comfortable with the information you're providing your client. This will also give your client the confidence to proceed with your services. Last, but not least, it will open the door to your own creativity when you can (finally!) get started on the design, knowing in advance the parameters you will be working within.

On many occasions clients will inquire about a project and request an estimate, only for you to find out later that the piece is stuck in a large black hole called "budget allocation." In this case a client may be putting together a budget for an entire campaign—or even for next year—and is merely looking for an approximation of money to allocate for that specific purpose. There will also be times when clients *think* they need a project done right away, only to realize when they get estimates that they don't have enough moneys allocated for it.

Creating preliminary estimates will appease both you and your client in these cases. A full-blown estimate takes a long time to prepare, and most clients who are familiar with buying services will understand and appreciate that fact. A preliminary estimate should be defined as such in your estimate's headline. You should then prepare it as you would a range or "not-to-exceed" estimate, which are both reviewed later in this chapter. This procedure will save you time, while giving your client the information needed for allocation of funds.

Patience is imperative when you prepare estimates and, more importantly, when you submit those estimates for approval. As you process more and more requests for estimates, you will be better able to assess: which projects are actually hot prospects waiting to be produced; which ones are "maybe" projects, depending on how much they are going to cost; and which ones won't be produced for months. One of the first questions you should ask while reviewing a project for estimating purposes is, "What is your time frame for having this project completed?" Once you have the answer to this inquiry, you can discuss with your client which type of estimate will best suit their immediate needs.

Let me warn you about assuming that your clients—new or existing—know how to establish realistic budgets. A few months ago, a good

friend asked me to give him an estimate on a very exciting project. Since we were friends and knew a lot about each other's processes, we skipped a lot of preliminary fact-finding and dove right into his needs. This piece was to be the equivalent of the best project we had ever produced. It rang with possibilities, sang with promises, and soared beyond eagles. You get the picture.

Well, about six weeks after we submitted our estimate, my dear friend freaked out because he had set aside about $20,000 to do a project that we estimated costing $85,000. He embarrassingly had to go back to his superiors to get more money approved and explain to them why he didn't know it would cost so much to produce in the first place. This guy is a very talented corporate real estate developer, but really does not have a clue about how to buy design services or how much they should cost. He did know that he needed a highly technical, polished sales brochure for a huge company and a piece of real estate that will sell for millions of dollars!

He knew the target audience and all the relative information that I needed to know to price the project.

Had I been more inquisitive and perceptive, I could have helped him by providing him with my doomsday information right from the start. Had he been more inquisitive, he would have had my firm provide him with a preliminary estimate before he presented his original budget to his superiors for review. The moral of this story is, shame on both of us. Take the opportunity to be proactive with your clients about budgeting and providing them with realistic numbers for upcoming projects. Providing this service enhances your clients' perception of your business knowledge and puts you first in their minds when the time comes to assign the project. It also gives you a first foot in the door to follow through on projects you know are coming up.

Preparing an Estimate

I recommend providing your client with detailed, itemized estimates, especially for special, one-of-a-kind projects or until you have a long-term relationship established. The advantages of providing a more detailed estimate include protecting yourself against possible false expectations, showing a real "bottom line" or total cost, and having a "legal" document should you face the unfortunate circumstance of needing one. A signed estimate actually doubles as a legal contract and

Six main questions to ask yourself every time you prepare an estimate:

1. Who is the estimate being prepared for?
2. What is the name of the estimate? Give it a header like "Estimate for 2001 Mead Corporation Annual Report" or "Estimate for Ohio State University Alumni Quarterly Newsletters." A complete name will clarify the project for you and your client.
3. How is the overview of the project to be defined?
4. What are the technical specs for the project?
5. Who will do what?
6. What are the fees?

requires your client to pay you for services and products outlined within. After working with a client on an ongoing basis, you will discover how to tailor your estimating process to achieve maximum efficiency.

You will need to know and use terms like "in-house services," "outside costs," and "outside suppliers." "In-house" simply means those services your firm generates completely while using equipment, staff, and knowledge that you physically have in your studio or office. "Outside costs" are generated by "outside suppliers" like printers, service bureaus, freelance photographers—any service you require to complete a project that you don't originate from under your own roof.

Use the list of questions provided earlier and the more detailed checklist below to help you devise an appropriate format for your estimates. Also, consider using an estimating worksheet so that you don't forget anything. This is a form designed for internal use only (clients never need to see this form), common as a guide in the estimating process. This form can include some of the questions I've outlined here as well as questions that you find to be appropriate to specific projects. The important thing is to find a format that speaks to your own sense of organization, and to cover all the relevant details. I'll review the between-the-lines information you'll need to know about preparing estimates throughout the rest of this chapter.

You may use "TBD" if the exact specs have not been decided yet. Make sure that when you have a conclusion on any loose ends, you do a revised estimate to obtain sign-off on any TBD items.

Detailed checklist of items to include in your estimates for print projects: (See chapter 6 for information on inclusions for new media estimates, but refer to this checklist as well, since some items below are applicable.)

- ❑ A brief description of the project
- ❑ Finished size(s) of the piece(s)
- ❑ Number of pages
- ❑ Number of colors being used: Is it four-color process? Two-color? Five-color plus varnish?
- ❑ Binding material
- ❑ Paper selected
- ❑ A list of what you will provide and subsequent fees. I call this "creative development" and list design, illustration, production, and all other tasks we are providing directly using internal skills and equipment (all in-house costs).
- ❑ List of what the client will provide (for example, manuscript provided electronically, any photography, logo)
- ❑ Supplies and materials required and their costs (for example, black-and-white and color lasers, outside service bureau items, Zip disks or CDs, presentation boards)
- ❑ Photography required and subsequent fees, including your art direction
- ❑ Color separation specifications and fees. (Include number of four-color subjects to be scanned, duotones, tritones, etc.)
- ❑ Any special circumstances, such as die cutting, embossing, etc.
- ❑ Printing quantity, paper variety and weight, and subsequent fees
- ❑ Travel expenses
- ❑ Delivery or freight expenses
- ❑ Payment terms
- ❑ Your signature and a line for your client's signature

Preparing an accurate, thorough estimate depends on your ability to obtain the essential information required. Never be intimidated by your client or feel like you are asking too many questions. When a client informs you of a project that needs to be produced, set up a meeting so you can go over the project elements face to face. As mentioned earlier, you may find simpler ways of accomplishing the

estimating task as rapport is established with a client; but initially, face-to-face contact is important in gaining trust and perceiving expectations.

This important initial discussion with the client will set the precedent for all future client rapport. Be ultra-organized for this meeting, and be on time! Take a calendar, and after you have the necessary information, plan a schedule with the client that you will confirm in writing after the estimate is approved. Discuss the project's process with your client: what happens first, next, and so on, step by step, to make sure the client understands the significant role they play.

This first meeting is the "master" meeting, where you must gain your client's confidence and have them relinquish control of the project to you willingly. You will have great success if you keep your client *involved* throughout this process; everyone likes to feel needed and important. I have found clients to be far less meddlesome in the design and production phases if I involve them heavily in the planning phase and maintain our agreed-upon schedule.

Use this meeting as a review of exactly what services you will provide and specifically what the client will be providing for you to accomplish your great feat. If the client is providing certain elements, like copy or photos, ask to see a sample of how these will be provided to you. Will they provide manuscript compatible with your computer software? Are you expected to input copy from a manuscript they will provide? Are typical photos or comparable pieces available for your perusal to assist you in determining client expectations of finished quality? Assessing the quality required of your finished product is of utmost significance now; if you're talking Ferrari and your client is talking Hyundai, you're both in trouble! Educating your client may be very necessary in this meeting. (see chapter 12 for more on educating your client.)

Don't be afraid to ask for what you want. If your client is providing some of the project elements and you are not pleased with their quality, ask if you can include within your estimate the fees required for their possible revision. All a client can do is say no and offer an explanation of why not. I've found that, for the most part, clients are very open to constructive comments and generally receptive to receiving an education of sorts, after you have gained sufficient confidence to present these matters objectively and are sure that you won't be putting anyone on the defensive. There's always the case where a client's

daughter designed the logo or took the picture with her Brownie camera. And there is a time and a place for everything!

Taking time to understand your new assignment and client is of maximum importance.

Be very aware of the underlying factors that influence successful projects. You may need to take some time before your initial client meeting to read up about the client, especially if it is a new one. Get your hands on their annual report or any self-promotional material they may have, and be knowledgeable about who you're dealing with. Diving design-first into projects is a serious waste of time if you want repeat clientele.

If the client is a start-up business or they don't have promotional materials to share with you, ask them about any related information you could read, like their industry's trade magazines or competitors' brochures. This shows that your attentiveness and detail-oriented manner are more than skin deep, and that you are truly committed to being *prepared*. Clients always appreciate this level of preparation and will ultimately reward it with coveted projects.

In addition to reading up on the client, you may need to become knowledgeable about the client's target audience. Usually this research can be done after your estimate is approved, but don't forget to allow sufficient time within your creative development fees to do the proper investigation. Clients will appreciate your acknowledgment of the research task as an important contribution; if a significant amount of time is required to do it properly, add it as a separate line item on your estimate. Cutting corners on research time is certain to simultaneously cut the level of respect you want from your clients.

Range and "Not-to-Exceed" Estimates

Sometimes a client simply won't make the time to meet with you, thus resulting in you not having enough information to provide a thorough estimate. In this case you might provide an estimate range, which would include an overview of how you perceive the finished project, brief specifications, and then a price range (like $10,000 to $20,000). You also want to spell out terms of payment and get an authorized signature on the range, just as you would for any other estimate. Estimates provided in ranges tend to get the client's attention, and in the case that such an estimate is approved (and they sometimes are), it protects

you by being vague in itemizations but inclusive of any possible, necessary fees.

The other option for providing an estimate when you don't have enough information is to develop a "not-to-exceed" estimate. In this case you again provide a brief project description and specifications while virtually guaranteeing to do the project for a price not to exceed the amount you are stipulating. Some clients will be amenable to this arrangement; others will be shocked to their senses and agree to give you more information and get more involved.

Providing range and not-to-exceed estimates saves you time because you don't have to sweat over the details. You also save time by more-or-less assuming the specifications. It is imperative, however, that you pad your outside costs substantially to cover the many yet-unturned stones.

An omnipresent number of variables hover above your estimate-in-the-making. Think of your estimate as the framework for all things to come: When a builder builds a home, he can't set up the framing without first looking at a plan, and only after the framework is built can the plumbing, electricity, windows, walls, flooring, and trim be added. Only then, after those tasks are finally accomplished, do you get to move your furniture in! Learn to moderate by taking one step carefully at a time.

The Estimating Process

When your initial discussion with your client regarding the scope of the project is behind you, the road is paved for you to begin your estimating process. Find a comfortable place, close your eyes, and take yourself on an imaginary journey through the creation of the entire project from start to finish. Now, either with a notepad or a minirecorder, document this scenario in detail. By doing this task you will achieve two things: The first accomplishment will be to perceive the less obvious tasks and possible variables you will encounter throughout the project's evolution; the second will be to have an image in your mind of how the project will flow. This exercise is the first step toward organized, creative project management.

Planning for things like travel expenses, long distance telephone charges, and freight charges up front will provide you and your client with the most comprehensive estimate. No client likes to be surprised

with such charges at the end of a project, long after the charges have been incurred. Remember: It's very important to involve your client in the process, so they know what it will take for you to get the job done right.

As mentioned earlier, your own mistakes and technical blunders (such as fatal errors on your computer) are not billable; however, you may want to plan now for the extra time you will no doubt need to cover or fix some of your faux pas. Knowing just how much to pad for these variables is a very tough call, and it's best to remain conservative, especially if your rates are under scrutiny.

Client revisions and the mistakes they may make *are* billable and should be called out as such within your estimate. Since you can't really plan for these particular variables and client whims in your original estimate, it is important that you allow for their occurrence as part of your billable time. Stating something like "client revisions to be billed at $65 per hour" at the end of your estimate is totally acceptable and very common. You can count on many clients getting very nervous about this note; however, it does encourage the client to give you the right information the first time around. Also, after your explanation that a typical type change or two will only take fifteen minutes or so, a client is reassured. And in the case where a client wants to make substantial copy or design revisions, you are indeed covered!

Add the time of preparing the estimate itself into your project fees. Even a simple project requires a lot of phone calls to outside suppliers, and every hour of billable time you incur should be included in your costs. You will probably want to include the estimate preparation time in your creative development fees. This will avoid any attention being brought to the matter, since it will be a small amount of time compared to the total hours spent on creative development.

Another often-forgotten variable is adding an allowance for rush charges you may incur from outside suppliers, especially if you are busy with other projects when you take on a new one. Many suppliers will double their charges for things like producing color laser output in less than their normal twenty-four-hour turnaround period. Rush charges can very quickly skim significant percentages from your profit margin.

While variables can truly cost you money, proper planning and comprehensive estimating are the real keys to profitability. Believe me, after only one project that ends up *costing* you money to produce, you'll learn the lesson that haste truly makes waste. Unfortunately, it even-

tually happens to all of us. But if you're really smart, it will only happen once.

It is not uncommon to charge your client overtime fees if the schedule is extremely tight—to the point where lots of overtime will be *required*. If, for example, your client wants a capabilities brochure designed, produced, printed, and delivered within anything less than a four-week period, you and your support vendors will most certainly spend many late nights accomplishing this task. As you become more familiar with how much time certain tasks require, you will also become more confident establishing ground rules for how much time you need to produce the job properly. A client will assume that he or she is totally in line if you don't bring the issue to the forefront. Also, you will be setting a dangerous example for how much time will be allowed for you to do future projects if you don't charge properly for your overtime.

During busy periods, even accepting a job with a normal turn-around schedule can suddenly become a crazy overtime venture—but one that your client cannot be responsible for. It's a great idea to plan for these occasions: Meet capable freelancers and set up a strong support network for yourself in anticipation of this eventual occurrence. Burnout for you and your staff members is truly devastating and can be avoided with proper planning.

Accepting a project with a tight schedule—whether it's been created by your client or your own busy period—is a commitment of many sorts. At all costs, don't get into the habit of missing deadlines. Our industry is notorious for being full of pressure to meet deadlines. If you think about it, there is a huge domino effect that you immediately become involved in upon a project's initiation. You are the middleman between your client and the other vendors required to complete the project—whether you hire them or not! Passing the buck to outside suppliers when you start to run behind on your schedule is strictly taboo. When missing a deadline really *is* another vendor's fault, you should insist that they write a letter to your client admitting that fact.

I think the most important element where meeting deadlines is concerned is to keep your client informed of extenuating circumstances. For example, if a project requires a lot of outdoor location photography, and this in turn depends on good weather, your schedule could quickly go down the proverbial drain in a matter of hours. Don't

become known to your clients or vendors for always being behind schedule. Sure, you're going to miss some deadlines eventually. But it is very important that you know how to diplomatically repair unfavorable results that will occur in these situations. If you're an infrequent offender on the running-out-of-time scene, you'll probably be able to negotiate your way out of it. Unfortunately, clients are sometimes lost because of it.

At the end of my own firm's estimates, we have a disclaimer that simply states: Final costs may fluctuate 10 to 15 percent due to actual expenses and time logged. Very seldom have clients asked me about this. The only exception, perhaps, is when I have provided not-to-exceed estimates. In this case the client usually expects and deserves not to be billed for overages, assuming that they are already built in.

We've already discussed the fact that you must build in a little extra time for unforeseeable situations. Once again, as you gain experience producing similar projects or projects for specific clients, a pattern of time requirements will most certainly emerge. Certain computer programs also allow you the luxury of comparing projects and the actual time logged on them at the touch of a button. As you develop a track record for yourself, the guessing game will turn into an actual target that is more consistently achievable.

Additional Variables

Some possible variables often overlooked in the estimating process include:

- Time needed for research, outside vendor coordination, and those moments when you're in a creative slump
- Postage, freight, and delivery costs—not just for the final end product, but for all the things that transpire along the way to a project's completion
- Proofreading time
- Client meeting time—especially if you will be working with a committee
- Zip or CD download fees for your own method of artwork storage (always important for backup and any future project revision)
- Fees for any fonts you may want to use but don't yet own

- Extra RAM fees if the project requires building a huge computer file
- Long distance telephone charges
- Travel expenses—not only for you, but perhaps for the photographer you will be using, his assistants, models, etc.
- Markups—often these fees added onto outside vendor charges become your lifesaver when you've miscalculated time requirements or other charges

Creating good estimates is a challenging task because it establishes the entire foundation of a project. Many times, after starting a project, you will get an idea that might enhance the project. Know that pursuing this idea will cost you money, since it does not appear on your original estimate. If you are notorious for changing your mind and coming up with ideas after the estimate has been approved, ask for "design revision allowances" on your estimate and explain your creative process to your client.

■

I have fondly nicknamed the official Request For Proposal (RFP) a "cattle call." This must go back to my childhood, watching a farmer friend of my dad's calling in his dairy cattle. The analogy seems quite accurate when you study the specifics.

RFPs or RIPs?

An RFP is certain to hit your mailbox one of these days. Certain organizations even have forms you can fill out to get on their RFP list. The RFP is most commonly a multipage document that details the need for designed and printed material regarding a specific subject. Usually, you will be informed of the technical specifications by this document—how many pages, finished size, color usage, who supplies what, printing quantity, and so on. Sometimes, the RFP will include a budget or a "final price not to exceed" rate, but most often, the RFP will be asking you for a budget. Many times, the RFP will require your presence at a particular meeting, where you will take notes on the extensive requirements and also see all of your colleagues who are mooing for the same project. But wait, it gets even more desirable . . .

RFPs are undeniably a drag. The most hateful thing about them is that the proposed project is usually really cool and something you want for your portfolio. You never know when and where to read between

the lines, though: Are they looking for the lowest bid? Are they looking just for a budget on a project that they will plug into their next fiscal year? Some RFPs even have the audacity to ask you to include a creative concept, prototype, or idea board with your estimate—all on spec, of course. Just how much time should you put into this nonsense? These questions can only be answered on an individual basis.

A Case Study

Quite coincidentally, I am right this minute sitting on the edge of my seat waiting for an answer from a small city close to mine that recently sent out an RFP. It's a beautiful project that I would love to get my hands on. The dreaded RFP came as they always do—regular mail, with details, details, and more details. There was a request for creative "sketches," a request for a budget, a ten-day deadline for submission of the proposal package, and a contact name.

What, in this day and age, are "creative sketches," and how does one go about acquiring a high-end job—or even being properly considered—by providing "sketches"? I phoned the contact person to first verify that indeed this job did not have a predetermined design firm destination (it happens very often—some RFPs must be issued for formality purposes, to follow the "rules" of certain organizations). Next, I confirmed that they were not looking for the lowest bid. Then, I got as much information as I could regarding the qualities that they were looking for, not only in the piece itself but also in the services to be provided.

As soon as I had enough information, my art director and I sat down to work up our presentation. Even though his billable time is higher than the other designers on our team, I knew that his capabilities and efficiency would be more cost-effective for me in the long run. The outcome was a great presentation, along with voluminous hopes that we will be granted this coveted project.

In this case, the client was forthcoming with information, was familiar with my firm, and strongly encouraged our participation. I shared with the client that it is not our general practice to do work on spec but that we were very interested in the project and would proceed on his recommendation. The deciding factors for me were his openness and the generous amount of time he spent on the telephone reviewing the project with me.

Use the following checklist to help you decide when to answer the cattle call:

- ❑ Is there a contact name or a phone number to call for further information?
- ❑ Are you familiar with the organization?
- ❑ Do they *not* have a firm or agency they seem to consistently choose?
- ❑ Is this *not* a lowest bid situation?
- ❑ Does the scope of the project lie within your realm of expertise?

Make sure you answer all five items affirmatively before going for it; otherwise, you're certain to turn your next RFP reply into a big RIP.

Since the RFP was issued by a governmental organization, I knew from experience they would not have any presentation money. I have gotten into the habit of asking quite vocally at the aforementioned information sessions if some limited funds have been set aside for presentations, simply to cover costs. This always generates a clap from the audience and probably a red circle with a slash through it going into the presenter's notebook with regard to my firm's selection. At that point I don't really care. It is indeed our duty to educate organizations who consistently ask for spec work to, at the very least, offer minimum budgets for presentations. I think word is getting around; most recently, I've noticed that fair budgets for presentations are typically assigned to the final three firms making the cut for a certain project. *Then,* the client can objectively make comparisons on different firms' creative approaches.

Your decision on whether or not to participate in a particular RFP will depend on circumstances: how busy you are when you receive the RFP, how much you've learned from Intuition 101, and what the prospective project means to your firm, not just in terms of money but in increased recognition, prestige, and other factors.

Proposals versus Estimates

Don't confuse proposals with estimates. A proposal is always necessary for larger projects and is often presented before the estimate to confirm

that you and your client are on the same wavelength regarding pertinent matters specific to the project. In some cases the proposal is included as a prelude to the estimate, or the proposal and estimate may be presented together.

Basically, the proposal outlines the goals of a project, states the objective, target audience, assignment of responsibilities, and so on. Ideally, a proposal will include all aspects of the project and may even include "sell" information about you and your staff. For example, you may want to give credentials and other qualifications of your team, such as a brief history, client list, and a list of industry awards received.

The proposal is a document in which you can outline your entire approach to the project, so the client is very clear about everything you will be doing. This is the place to put your client's objectives (as you have interpreted them) into writing. It's also the place to address your methodology or strategies, including any phases such as research, creative development, refinement of work, production, and printing. Take this opportunity to outline client responsibilities during your work together: Will the client supply all of the copy? What deadlines is the client responsible for, so the project can be kept on schedule? How will revisions and additions be charged? What terms will apply if the project is terminated after work has begun? All of these topics can be dealt with in the proposal.

Often, the estimate is included as part of the proposal. This is logical: Since the proposal is supplying information about each phase—and even each step—in the project, why not also provide an estimated dollar cost for each of these steps as they are outlined? This way, the client has all applicable information at once.

An important note: When you receive a coveted Request for Proposal, you'll want to read it carefully and respond in the exact format that specific client is requesting. Most of the time, an RFP is requesting your proposal and estimate, but many times, it is requesting a proposal only. As mentioned earlier, your proposal may include a creative prototype or sketches as well.

Going for the Ultimate

Nowadays, it's pretty simple to do an awesome proposal. We have a format we've recently created that is easy to produce and revise for different clients. We've also had the recent good fortune of being awarded

Use the following as a checklist of possible items to include in a proposal:

- ❑ A clearly defined project objective
- ❑ Goals that the end product might achieve
- ❑ Strategies as to how those goals may be realized
- ❑ Target audience review
- ❑ Any market research findings
- ❑ A list of any research that needs to be done
- ❑ Assignment of responsibilities—what you will provide and what the client will provide
- ❑ An overview of the team players, your company history, your client list, or any other "sell" information you can provide that will reinforce the client's confidence in choosing you

several projects based strictly upon our proposals—without providing estimates. Honestly, I can hardly believe it myself, but it's true. I believe the reason this is happening is that, currently, unemployment is at a historical all-time low, and clients seem so increasingly demanding with regard to turnaround times, deadlines, and unreasonable expectations—if they find someone willing, they'll take it. While I know that neither of these reasons can be totally true, I'm thankful and ready for an economical downturn at any given moment. Read: Never take situations like these for granted!

But let's spend some time thinking about this ultimate situation for a few minutes. Take some time to brainstorm the possibilities with your own staff. If you work alone, consider hiring a short-term intern from your local design school, community college, or university. Excellent students dying to sponge up your knowledge can work for you, often for little or no pay. Many college requirements include a mandatory internship that students must fulfill before graduation. Using a fresh eye and a fresh ear can really bring life to your proposals—especially if you've never done one. Great references exist for your brainstorm session. See how the award winners are doing it by buying some industry books on proposals and marketing your firm.

If you do not have professional portfolio pictures, use a digital camera yourself to take photos of your portfolio projects. Have fun with

setting up the shots, and either use props to display them favorably or shoot them on white paper so that they can easily be outlined. Print the images onto high-quality paper, and include a brief description of the project near the photo. Use these pages at the end of your proposal, selecting previously-completed projects that convey your expertise in the type of project you are proposing. Remember that in our industry quality always translates into price. The more "buttoned-up" you look, the easier it will be for you to justify a higher price for your work.

Choose an interesting paper and binding method for the outside cover of the proposal. Options are all over the place. Even if you live in a remote or rural area (I do, so I know!), paper distributors and printers in your nearest big city will be glad to keep you advised of new papers and binding methods available. This is their job and how they sell more paper, printing, etc. Take the time to ask for your inclusion on mailing lists, promos, etc. Paper reps are happy to set up an appointment and meet with you to show you the latest goodies on the market. Ask lots of questions. Ask for samples, and you can make your proposal covers from different paper samples until you find the right paper that works for you.

Within the framework of your proposal, if you do not include an estimate for pricing, be sure to include your entire process. Perhaps you might share how you will price the project—using an hourly rate per task, per person, etc. This entire proposal-instead-of-estimate ideology came from the advertising agencies with whom we so often find ourselves competing. Larger Fortune 500, corporate clients are especially accustomed to receiving a voluminous amount of paperwork when they are in the process of deciding which firm to hire. Help them make their decision by showing you are the be-all of your clients' dreams. It's easy and fun—like writing a book about why you want the project, how you're going to go about doing it, whom you'll have working with you on it, etc.

Reviewing your proposal in person with your client is a smart way to make sure they don't receive your life's work and store it away for lavatory reading or coffee table duty. I never read the copy within the text aloud—but I do review the information therein by going through the subheads and verbally telling the client what they contain. This is my opportunity to show my firm's competence to the client. The end of my proposal presentation includes a more detailed explanation of our portfolio pages.

More often than not, the person to whom you're presenting will need to go to a superior or group of people and reexplain what you've just reviewed. While frustrating for you, it is very typical. Many corporate clients are paranoid about their coworkers' involvement and want to project a sense of being in control, therefore wishing to present your information to their own peers. It is a great day when your client will allow you to present directly to the decision-making core. Credibility for both you and your client begins here.

Instead of pricing within your proposal, try explaining the different phases within the specified project. If the client is new, tell him your biggest reward is a satisfied, repeat client, and include testimonials or references from satisfied clients in your proposal. If you are a one-person studio, developing a strategy and a "look" for your proposals will elevate you tremendously in your customers' eyes. If writing and self-marketing are not your strengths, hire a freelance public relations person or a professional writer to help you establish a template for this new endeavor. Use your newfound bartering skills to trade these talented individuals for work you both need to have accomplished, yet don't have the cash, time, or patience to complete.

■

Troubleshooting Estimates and Proposals 11

N ow that you're an expert where pricing and estimating are concerned, it's time to get comfortable with how you manage projects and their budgets. The estimate that you provide your client with actually doubles as a project budget; it includes your rates, calculations, and determinations. Now, you have to produce what you said you could produce for the amount of money you said it would take!

Throughout this book we reviewed some subjects that will affect project management. The most common trauma you will experience throughout your course of owning and managing your own firm are unexpected changes, read: charges that either you or your client will need to absorb. These issues will arise time and time again throughout the estimating and project management phases of your jobs, and you will learn how to tailor my examples of solutions to your own particular needs.

Organizing for Productivity and Creativity

The most proactive thing you can do to ward off the evil demons of changes and charges is organize, organize, organize. If organizing and managing project budgets sounds like a big responsibility, it is. I can't stress enough the importance of setting up forms and a project management system that will help you realize true and glorious profitabil-

ity. Your last key to the profitability cache is to learn how to manage project budgets effectively. This, in turn, will open new doors to your creativity. Trust me, creativity comes more easily when projects and money are flowing smoothly. Creative block is directly connected to stress.

Good project management saves time and money by acting as a template, embracing all disciplinary aspects of a project. Discipline is a word that carries us all back to our childhood; it means rules and regulations and acting in some type of controlled manner. Horrors! In general, it's not a real friendly word, but I suggest you learn to love it if you want more time to focus on creativity, design, and what you do best. Committing to disciplines of different varieties (some of which are given in this chapter) will truly save time, money, and your sanity!

After your estimate has been approved, you're ready to embark on the creative aspirations that have brought you the project in the first place. In your master meeting, when you originally gathered the information needed to compile your estimate, you also discussed a typical schedule for that project with your client. This was your first step in establishing discipline with regard to the project's efficient management.

If you did not involve the client in this scheduling development, do so immediately. Put the schedule in writing and detail every event that will happen as part of the project. Include dates when you will receive pertinent information from your client as well as when your client will review everything you produce—from initial concepts to the finished piece. Reviewing the schedule together with your client before you get started will save substantial time for both of you. Neither of you will waste time wondering what the other is doing with his or her portion of the tasks involved; nor will you waste time trying to track each other down or e-mail questions in an attempt to get what you need and expect from each other.

Substantial amounts of money are often wasted on rush charges with service bureaus and same-day and overnight delivery charges, rushing things back and forth between you and your client that could have been handled in a less urgent manner if more careful planning had been done. Many of these dollars can go right in your pocket if you discipline yourself, your staff, and your client by organizing events of the project carefully before you begin. People in our industry, especially, seem "addicted" to overnight and one-hour delivery services. Upon

So where do you begin? Use the following checklist for creating discipline in project management—starting at the very beginning of the project:

- ❑ Get a signed, approved estimate; this estimate will double as your project budget
- ❑ Review a detailed schedule with your client, your staff, and your vendors
- ❑ Work out dates in the schedule as needed until everyone has agreed that it is reasonable

Next, make sure your schedule includes the following dates:

- ❑ All dates when your client will provide you with information you will need to complete the project
- ❑ A date when your client will either give you or approve the exact text for the piece
- ❑ The date when you show your client initial design concepts for his or her approval
- ❑ The date when you show your client the finished piece, either in a prototype format or in a format you have previously agreed to
- ❑ The date when you will release the project to the color separator or printer, if required
- ❑ The delivery date

scrutiny of your outside expenses, I can promise you that about 50 percent of them could be eliminated with better project management.

Get Ready, Go!

Once all parties involved in the project—clients, staff, and vendors—agree to the important project dates listed above, you can proceed to realistically schedule your own personal time that will be required to complete the project. Deliveries to service bureaus and outside vendors can now be planned by date and can sometimes be accomplished on the way to or from your workplace. Staff members are usually more than willing to make these deliveries themselves when they are on their way to lunch or even as a little break in their day.

Reimbursing your staff for their mileage expenses (the current IRS-approved rate is 32¢ per mile) is a lot less expensive than delivery services, makes the client feel like they are personally being serviced by your staff (and they are!), and makes your staff feel trusted and more appreciated by you and your clients. If you do not have a staff, consider hiring a student intern from a local design program to do your deliveries a few times a week. Students love the experience of being around design professionals; you'll be doing them a favor and at the same time saving a lot of money otherwise allotted for delivery services. Lucky you!

Never, ever begin a job without a schedule or deadlines. We get a lot of projects from one of our favorite clients that have no tight turnaround requirements. (That's why they're one of our favorites.) They'll say, "Well, we have a trade show about four months from now, and we'll need these by then." Usually, it's a project that could easily be designed, produced, printed, and delivered within four weeks. These types of projects can (and will) go on and on, with everyone perfecting and redoing little things here and there into oblivion, unless you have created a disciplined schedule. In the past, evaluating time and expenses incurred on these pseudo-eternal projects always came as a surprise—they were our *least* profitable (albeit least stressful) jobs.

The biggest roadblock to successful project management is you. Well, maybe or maybe not. But let's face it—stereotypical designers love to rock the boat and procrastinate, waiting until absolutely the last minute to get the adrenaline going to produce a dynamite piece. The only problem with this recurring scenario is that when it's all said and done, you always look at the project and say something like, "If I'd just had more time to do this" or "If I'd just had another day, I would have tried a different color palette that might have looked better." The truth of the matter most often is that you did indeed have that time (check your schedule!); you just chose to do other things.

Nobody likes to hear the self-discipline rap. I myself really hate it deep down and almost can't believe I'm preaching it. The truth is that, after all these years in the industry (twenty and counting), I really have found a balance between procrastination, with its craziness, and the real secret to creativity. You need to find a balance within every day—or at least every week to start—between the time spent adhering to your set project schedules and the time you allow yourself to run free. If you

don't, you'll find yourself on a roller coaster: The highs will be incredibly creative, but the lows will wipe you out. You may find yourself getting sick too often with colds, flu, and so on, or you might even experience the total blackness of burnout.

A huge part of project management is taking the schedule you've created and following it, not only by doing the work yourself, but also by delegating to others whenever you need to and firmly requesting that the schedule be adhered to by staff and vendors alike. Even if you work by yourself, student interns, service bureaus, and freelancers are eager to help when you're in over your head. If you have agreed to a schedule that for the most part you have directed, you are the very last person who should have trouble sticking to it. *Get help when you need it!*

Learn to do exactly what you do best all of the time, and then find a team of support people—whether they are occasional freelancers or regular staff—who specialize in tasks that you don't do so well. For example, if you're a great people-person, you love client contact, and you love coming up with ideas for projects, find a core of support people who are great at producing your ideas and another person or two who are great illustrators or photographers so that you don't have to be it all, let alone doing it all, in your peak periods.

You will be infinitely more creative, make more money, and be a lot more fulfilled once you look at project management in this way. Just remember, do what you do best all the time, every day, and find other people to do what they do best, every day, all the time. This is the key to superior project management.

As I said earlier, the type of project management system you need will depend primarily on the size and complexity of your business. If you're working by yourself or with just one or two other people, it's easiest to just implement a simple system like the "job-jacket" system outlined on page 74. For a larger group of people, you'll want to involve everyone in devising and implementing a system that works for all the individuals involved.

Once you and your group have established a project management system that everyone can assume some level of ownership for, it should pretty much be left to run on autopilot. You should have checks and balances set up along the way so that you or another key authoritative person will be overseeing or approving projects as they pass through the phases you have deemed necessary for such review and approval.

Ongoing clients will become a part of your project management system through osmosis. They will know from experience when and how to expect things from your firm. You will have developed a consistency that you, your staff, and your clients will become familiar with. Good staff morale will ensue because you have allowed everyone to be a part of building the machine that will drive the team's organization and ultimate creativity. Learn to tie those two thoughts together repeatedly, and make them your mantra: organization/creativity.

The Perils of Perfectionism

As you gather information for your estimate, perhaps the most important task will be to assess the time that will be required to produce a project. From that time assessment, you will either multiply your required hours by your hourly rate or assign a value amount to the job as described earlier. The only thing that can really throw a big whammy into your allotted time frame, or at least the only thing that you'll be able to anticipate up front, is a tendency toward perfectionism. If either you or your client are prone to perfectionism, it can really spell trouble.

If you know yourself to be the potential culprit in this case, you're halfway to changing your bad habits. Start resolving the other half by being extremely dedicated to tracking the time you spend on every task concerning your next project. When the project is finished, add up your total hours and divide that amount into the total dollar amount that the invoice gives as your fee. The resulting figure is the overall hourly rate you actually earned for that project. In many cases you could earn more flipping burgers at you-know-where!

Now, look objectively at each task within the project and determine where you spent way too much time. If this disappointing outcome happens often, you are probably the victim of perfectionism. Do you have a tendency to perform tasks over and over, or to start a project over many times before you move through it? You can only correct this problem by strictly disciplining yourself to perform certain tasks only within reasonable pre-allotted time frames. Share your dilemmas with colleagues, and compare how much time it takes them to perform the same tasks.

If you have a client who is a perfectionist, you'll recognize it during your first meeting. Typical attributes of the perfectionist client are that he will repeat the same things over in two or three different ways,

ask you to read your notes back to him, and call you needlessly every day to see how you are coming with his project. These disturbances take unnecessary time that you will log to your time sheets. Refer to the communication tips on page 158 to find ways to avoid these situations *before* you start a project. Also, it might be effective to gently remind your client that while you appreciate his need to have everything done in a certain way, his conversations, usually resulting in changes, are causing the project to be over budget. Remember, the name of the game is being honest and up front with yourself and your client at all times.

I realize this concept of "letting go" is a most difficult one for most of us. It's hard to let the kids throw toys all over the house when your actual sense of order would have it ready for a location shoot at any moment. The same analogy holds true for the way we create visual communications. They can always be better with a color change here, a modification there, some PhotoShop over the mountain. Hindsight is always 20/20. Vow to use what you learn after every piece is completed. Give yourself permission to establish a deadline, then maybe just a few hours of tweak time after the project is complete—and after you've had a chance to catch a few z's on the entire matter. If you know that you're a tweaker, don't forget to add these "few hours" into your original estimate.

There is a way to possibly sneak in some extra billable hours if you simply can't let go and wait until the next project to tweak beyond the few hours of time originally estimated. On more than one occasion, I've presented a comp to a client as-is, and at the table told them about my new, improved idea. If the client bites and likes your concept, that is the perfect time to ask if you can get him a revised estimate to include your new ideas. This leaves the door open for your client to have time to digest both the new idea and the fact that the new work is going to cost a little more. In this way, you don't proceed with the new idea until your client approves the extra costs; thus, you don't lose any money. Make a steadfast rule with yourself that you will not proceed with the new work unless funds are approved.

Bigger Problems Than You Bargained For?

When your original estimates don't hold and completing the project entails more hours than you had presented in your budget, your ability to provide accountability and a detailed, legible paper trail will help

you tremendously. Now would be a good time to review the concepts of good record-keeping provided on pages 169–181. The fact remains that good forms are necessary to build a solid foundation of account-ability. You need to develop a reputation of consistently providing services for the actual fees you quote in your estimates. Occasionally, you will need to use the 10 to 15 percent fee overage provision that you have allowed for at the conclusion of your estimates, but you certainly don't want to make a habit of it. If you do, sooner or later your clients will expect the surcharges, and your estimates will be facing some tough credibility issues.

Forms do create a paper trail, whether you're filing them as hard copies or within your hard drive. But proper documentation of time and expenses is imperative if you are to track the reality of your endeavors. If you are consistently forced to charge fees beyond those you quoted, you need to take a hard look at several factors. Are you allowing enough time to complete tasks? Are some members of your team slower than others, and shouldn't you be taking that into consideration when you're estimating? Do you keep forgetting certain outside costs that always seem to show up after the job is finished?

Be prepared for clients to occasionally ask you for documentation to justify your billing rates. While this won't happen very often, sometimes it will be necessary for you to review cost overages with clients. You should be able to source a time sheet and expense log of some type at any given moment throughout a job's history.

If you can't do that right now, this minute, just stop everything you're doing. I really mean it, just *stop*. Take today, or tomorrow at the latest. Cancel all your appointments. Take a deep breath and clear your mind, and then begin a system of logging your time and expenses. Make some forms of your own that will track everything you need to track. There is never a perfect day to perform this task. If you're a procrastinator, like most designers are, you'll never get around to it unless you cancel a day and devote yourself to form production. It shouldn't take you more than a day, and you will see immediate results.

Go back to pages 109–114, where we reviewed project management in detail. These will add a few more forms to your pile. But it is important for you to realize how closely interconnected pricing, estimating, and project management really are when you want to meet your budgets and make a profit. Remember: No profit, quick burnout. No self-employment, no fun!

The Passage of Time

You may find that your original estimate to a client is no longer realistic if a significant period of time has lapsed since its submission. On several occasions I have had clients approve projects six months to a year after I had given them an estimate. Most of these occurrences resulted from my client's original need to receive an estimate on a project simply to plug the fees into his fiscal budget, knowing all the while that it might not be produced for quite some time. This procedure is very typical for larger Fortune 500 clients, who must plan their budgets well in advance.

In your initial (master) meeting with a client, it is important for you to verify *when* your client expects to be in production with the job you are estimating. If you are indeed just establishing a budget and won't be producing the project for quite some time, it is very important to note possible variables that might arise. These variables include any foreseeable rate increases that you may be considering because of staff, equipment, or fixed-cost growth. Such an estimate should be labeled "for budget purposes" and include a simple disclosure of possible variables.

Quite often, a job will be postponed because your estimate is sitting on your client's desk and he hasn't had time to review it, or he needs his superior's approval first. To avoid this delay, always try to review your estimate face to face with your client. At the very least, review it over the telephone and answer any questions that your client may have. Then, ask the client when you can expect approval, so you can put it into your production schedule. Be very clear that the project will not be initiated until you have a signed, approved estimate.

If the promised date of approval comes and goes with no signature or contact from the client, an informal note via fax or e-mail usually does wonders. Most of the time, the estimate has moved to the bottom of the pile on someone's desk, and the client has wrongly assumed that you have gotten started. If you still haven't achieved desired results after a couple of days, you have a good excuse to phone the client, check on your estimate's approval status, and ask if any clarification of the estimate is needed. Warning: I haven't researched Murphy's Law enough to scientifically verify this, but it seems like a project that's prolonged unnecessarily often turns into a nightmare project that goes on and on and drives everyone crazy!

Items like paper prices or corrugate prices (if you're into packaging) tend to fluctuate over longer periods of time. Always verify your outside suppliers' quotes to determine how long their prices are good for. Make sure that, if your printer quotes you a cost that is good for only thirty days from the date of that quote, you share that date and disclaimer on your estimate to your client. It is very common for printers and other suppliers to have a thirty-day clause in their quotes; you and your client need to be very aware of cost overages that may be incurred by the delay of a project.

Once a supplier accepts a purchase order from you detailing their services or products at set, itemized costs, he is obligated to provide the services or products at those particular costs—another good reason for the wonderful world of forms and systems!

Ensuring Good Communication

The last thing you need is for project costs to exceed your estimate because of poor communication. There is absolutely no excuse for this because you are, after all, in the communications industry. I have students and entry-level designers stare at me in disbelief when I reprimand them and break the news to them that they are first and foremost communicators—before and even when they are designers. It's true. Your clients not only expect you to communicate with their audiences by creating good visual design but also expect (and deserve) you to be an excellent communicator on *all* levels. This is the biggest issue facing inexperienced designers and other individuals who want to start their own firm or studio.

There are several easy steps you can follow that will open the doors to good, effective client communication. (I have also dedicated an entire section within chapter 14 to this subject matter.) Remember to always be up front, honest, and considerate in terms of your clients'—and thus *his* or *her* clients'—needs. Even before following the specific steps outlined, you should evaluate your own basic communication strengths and weaknesses by having a frank conversation about this with family members and any friends with whom you feel comfortable discussing sensitive issues. This suggestion is not made to make you feel defensive; it's just the quickest way to take a crash course in self-discovery where communication issues are concerned!

Sooner or later, you will experience the uncomfortable (and seem-

ingly unresolvable) situation of a problem that isn't outlined, defined, or acknowledged in your estimate, resulting in costly changes for a project. When this happens, your client will want you to absorb the additional costs, and you will think that they've truly lost their mind this time. There will be a moderate amount of finger pointing, perhaps a voice raised beyond the decibel level regarded as normal, and a feeling in your stomach like you've just swallowed a bucket of peanut butter.

While experiencing this situation, try very hard to listen to your client's complaints without interrupting or blurting something out that you may regret later. If you are the one who is announcing the problem to your client, do so in a clear, unaccusing, concise manner, and then listen carefully as just described. After the issue has been reviewed, offer your solution if you have one. If you have not had enough time to assess who is ultimately responsible, or if you feel really angry, now is not the time to negotiate a resolution. Tell your client you will prioritize the matter today and be in contact with him later regarding the situation. Go outside, take big breaths (don't hyperventilate!), tell yourself that there really is a silver lining to all of this somewhere, and begin immediately to seek it out.

Take a good, objective look at your estimate. Does it clearly define responsibility for who does what throughout the stages of the project? Have you fulfilled the tasks that you agreed to perform in your estimate, and have you performed them accurately and on time? Has your client done the same with his appointed task list? Perhaps you are answering yes to the questions that involve you, and your client disagrees with you, or vice versa. The sooner you can agree on who or what is really to blame, the better. Sometimes it's best to just let go of relatively minor points, so you both can reach a conclusion and get on with your lives.

If you know in your heart of hearts that you are indeed at fault and the problem is your mistake, then admit it, correct it, pay for it, and move on. Should you decide to pass the buck to someone else or even try to prove that your client is at fault, expect that client to avoid you like the plague the next time you call on him for work or a referral. Mistakes can be costly, but after all, if they are your fault, you will truly gain client confidence and credibility (along with the probability of ensuring a long-term relationship) if you take responsibility for them, no matter what the cost might be to you. It might sound easy for me to say and be tough for you to read, but it's true. Set aside some

rainy day funds for this purpose. Put them into an interest-bearing account, and do something fun once a year with the interest money you've acquired (assuming you don't use the set-aside funds). I'd suggest putting $20,000 in reserve.

When the Client Is Wrong

Of course, there will be times when your client is actually to blame for something gone awry within the parameters of your project. If the client insists that it is your fault and you don't have the proper documentation to exonerate yourself, you only have six options:

1. *Do the obvious—quit.* Walk away from the project and the client, jump on your waiting stallion, and gallop away into the sunset. Of course, expect to look behind you and see the bridges of client rapport burning irreparably away. I only recommend this procedure when you have given significant energy to the next three options.

2. *Ask your client to split the additional costs required with you.* This is the quickest, most common, and usually the fairest approach to resolving a dispute of this type. It instantly shows that you respect your client and that you support him. Most problems that result in cost overages can be blamed on more than one party. When you know that you could have avoided this issue if you had just done this or that, you probably are somewhat to blame yourself. Thus, splitting the costs is justifiable to everyone. If the costs involve third-party vendors, they will usually give you a substantial discount for doing something the second time around. Ask.

3. *Confirm the additional charges in writing.* If you have really done your investigating, if you absolutely cannot afford to absorb any additional costs, and if the problems at hand were truly created by your client, I suggest using the utmost diplomacy in a written confirmation giving concise, accurate details of the events and circumstances that brought you to your conclusion. Most clients respond better to written explanations than to personal dialogue that puts them on the defensive. Do follow your written explanation with a timely phone call after you think your client has had enough time to digest the information. Hopefully, your client will agree with you, and you can promise to help him be more aware

of such issues in the future. If the letter does not work, it will, at the very least, prepare you for the next item.

4. *Get a mediator.* Your lawyer will have a list of mediators who are used in an attempt to get both parties to sit down and come to an agreement together. I have had the opportunity to use a mediator once for a situation regarding my favorite vendor. I had refused to pay a printing bill because the printer had made printing plates from another version of a project—not the version they had shown me on my approved dylux. The process was very positive for both of us. The mediator was patient, intuitive, and knew what questions to ask each of us to make our own decisions. The outcome resulted in this vendor and Real Art's ongoing, very close relationship.

5. *Get an arbitrator.* When neither you nor your client will compromise, when you've gone around and around to no avail, consider obtaining an arbitrator you both can agree on, who will do everything to settle the matter with (and for) you. When it gets to this level of disagreement, a professional arbitrator, again located through your lawyer's office, is necessary. Many times, it might seem logical to ask a mutually respected colleague to intervene; however, the chances of your colleague remaining mutually respected is slim. It's best to call in the services of your attorney and your client's attorney to decide specifically when, where, and how you can resolve this issue.

6. *File a lawsuit against your client.* This should only be done after your attempts at arbitration fail to bring a resolution. Retaining the services of an attorney to file suit is costly, time-consuming, and agonizing. Only if the amount of money you are disagreeing about is staggering *and* if you are absolutely certain that you had nothing to do with the problems that occurred should you even consider filing suit. Before you know it, your business will become everybody's business, and you'll find yourself being questioned by vendors, colleagues, and possibly your local press about what happened and why. It's best not to discuss the matter at all, even if you feel a great need to clear yourself.

In more than eleven years of owning my own firm, I have never had to sue a client. I came very close a few years ago. My firm had produced a project for a client with whom I had worked closely for over

five years. The project seemed tainted from the beginning, with the client making seemingly irrational design changes every other week after he had approved them the week before. It turned out that he was getting a lot of pressure from different committees that were involved in certain phases of the project, and he kept making the changes to appease others.

When the client was presented with a bill for what I had deemed a totally unreasonable number of changes, he balked. Immediately, I admitted that my staff had not notified him properly that he was exceeding the budget we had agreed to in my original estimate. I had been out of town when many of these changes occurred and felt responsible at least for our not communicating these overages to an established client. We both agreed to our mistakes and quite happily agreed to split the additional costs. Unbeknownst to both of us at that time, my client's boss would not agree to the additional charges or any explanation of why or how the sequence of events had led to their occurrence.

I personally met with my client's superior, with my client in attendance. The meeting was uncomfortable for all of us, to say the least. My client and I left the meeting with no resolution and both of us feeling pretty helpless. I was very angry at what I deemed to be greatly unprofessional on the superior's part. On the advice of my attorney, I wrote a very detailed letter reviewing the entire project and cost overages. I suggested hiring a mutually-agreed-upon arbitrator, and received an unfriendly letter from the superior stating that my client was not at all responsible (after he had admitted that he was) and that an arbitrator was not a possibility.

Again, on the advice of my attorney, I wrote a stronger letter stating that if I did not hear from my client's superior within thirty days, I would unfortunately be forced into filing a lawsuit. In my letter, I reviewed the project in its entirety, justifying overages and documenting when they had been incurred. I again offered to settle the matter by splitting the overages. Within ten days I received a check for the amount I had requested. The story ends ironically, though, because my client was instructed by his superior not to complete the project and also never to use my services again. The project had been conceived by my client and supported enthusiastically by his surrounding committees. It was a beautiful project that was to be displayed in a public area for years to come. It is unfortunate for me and my client that we did

not have the opportunity to produce it—the design itself had been completed.

I have seen this client socially on many occasions, and he has always been friendly to me. We have both acknowledged our disappointment and bewilderment at his superior's final decision. We are both sorry that our long-term working relationship was brought to an end by something out of our control. Ultimately, we both learned the hard way. Hopefully, this story will help you avoid similar situations in your future.

■

Successfully Establishing
and Managing Budgets

It's really important for your design skills to include a strong knowledge of production; this will help you greatly when you need to produce cost-conscious projects. There are many production techniques that you can show your clients when they want the whole world but can only afford a small state in the United States. Some designs even work better when they aren't produced to death.

Learning Cost Consciousness

Finding affordable alternatives can be a fun and interesting challenge. There are lots of ways to achieve great results without sacrificing creativity. Some of the most common cost-cutting alternatives include:

- Designing a two-color piece versus a four-color piece. Substantial savings are realized in color separations and printing.
- Creating a rich or hi-tech look for images by using duotones in your design versus four-color imagery.
- Using graphically designed or illustrated images instead of original photography, or use stock photography. (One caution: Depending on style, this could end up costing you more, not less! Choose carefully.)

- Using some of the outstanding photo and design software that is now available to manipulate or enhance existing photos or artwork the client may already have.
- Selecting varnish as a design or illustration element to enhance a one-color piece.

Of course, you could probably add twenty items or more to my list. The reason I've mentioned these possibilities at all is to get you to consider design or production alternatives *before* you consider compromising your rates. In addition, paper reps and printers are very credible sources for samples and ideas for cost-conscious design. I also mentioned earlier that tiering a client's needs into phases, or into a series of projects (such as producing a piece a month instead of twelve pieces altogether) is a great way to extend the budget and be cost conscious.

Another money-saving proposition is making certain that you use an appropriate format for comps (that is, not overdoing it), which might save you considerable time, and thus, money. Back in the estimating stage of your project, you should have decided exactly what type of comp you would present to your client to obtain approval for your design concept.

As my staff and I develop client relationships and trust levels increase, the type of comps we show tends to change as well. Our biggest client at the moment has gotten to a point of approving our design concepts based on a fax showing simple black-and-white marker drawings. This way, they usually get to see a lot more than just one idea; they get to see them all! This is a somewhat unusual case because the decision makers in their advertising department are very creative individuals themselves and have the visual sense to say "go for it" or "you guys are outa' your minds!"

The most expensive comp is computer-generated and is presented to the client in all its finished glory. You and I know that a comp of this magnitude really means that the project is at least 75 percent finished at this point; and if the client hates it and you have to start over, you've got a lot tied up that gets tossed in the trash. For those occasions when the client loves it, however, and you only need to tweak a little here and there, you can go singing and dancing into the wee hours because finishing the piece becomes a somewhat simple production task.

Showing such a finished, comprehensive design to a client is like playing Russian roulette. The upside of these great-looking comps is that, psychologically, the end product looks finished and almost as good as printed. The downside is that if you do have to start over, the client will expect another polished presentation.

A compromise between the quickie black-and-white doodles and the elaborate computer comps is what I call the "idea board." These come in handy when a client isn't sure what they want or whether they want to hire my firm to produce their project once they do decide. I usually charge a flat rate of $2,400 and show one or two boards with a mixture of sketched and higher-comped elements that will give the client a very good idea of where our thoughts are headed for their project.

Clients have been very receptive to these idea boards. They don't have to invest a lot of money up front, and they have more input into the direction in which we're taking a piece before we go too far with it. A solid 90 percent of the time, our idea boards turn into full-fledged projects. Our next presentation after these initial boards is usually a completed prototype that is not a huge surprise to the client because he has revised and improved upon our initial concepts and knows what to expect.

Upcharges can be incurred by overruns—quantities over and above the exact quantity you have specified on your client's behalf. Printers almost always print some overruns, and packaging vendors almost always produce some extras, too.

A typical overrun, which can be expected with your larger printers, is about 10 percent. The press is going so fast that, in the time it takes to shut it down, you have overruns. In addition, you actually need to have some extras to set up die cutting or bindery operations. Finally, a number of copies will be picked out due to quality problems—such as lint or dirt sticking to the piece while it's still wet. Since overruns are usually very modestly priced (about 50 percent of normal cost is standard), most larger clients will want them. A client who is watching pennies and having you research cost-cutting alternatives, on the other hand, probably won't want any extra printed or produced elements at all—much less expect to pay for them. To further complicate the matter, most vendors usually do expect to be paid for overruns, unless you specify otherwise up front.

Since overruns are a fairly conventional, established practice for a lot of vendors, but may be news to your client, it's important to always

ask your clients and your vendors *beforehand* what their expectations of overruns are and specifically how they want to handle them.

The way in which we communicate and contact our clients has a lot to do with cost-conscious design. After all, any time spent on a project means time that should be billed to that particular job, whether it's design time or client-meeting time. Clients do not need to know (at least, they don't need to be reminded with a bill for every meeting) that they are actually being billed for the time you or your staff spend with them. Remember, you budgeted time for client meetings when you prepared your estimate, so you should be covered within your total estimate amount.

I can't tell you how often clients have complained about many of my firm's competitors sending them bills for things like fifteen-minute phone calls and forty-five-minute meetings. How unthinking of them to bill as though they were attorneys! While recouping fees for the significant amount of meeting time required before and during a project's life span is imperative, how you obtain those fees from your client is open for interpretation. And it *can* be done in a much friendlier, more acceptable way! I lump what I refer to on my estimates as "meeting/coordination time" into one conservative amount. If I know going in that the client requires a lot of handholding and will not be amenable to assigning dollars for meetings, I bury the meeting costs into the creative.

Using Cost-Conscious Design

Another good point regarding cost consciousness within the design process is to think about who represents your firm at client meetings. I used to think that I personally needed to be at every single meeting, no matter how big or how small. As business has grown in other cities and states, this is no longer physically possible.

At Real Art, an art director or equivalent (I hate titles, and we don't have them on our business cards) attends every initial client meeting (that is, *every* master meeting for a new client) to review the project from a creative standpoint. As our salespersons' self-confidence grows, and as they obtain work from ongoing clients, they have gotten to a point where they can assess projects initially by themselves and properly communicate that information back to us—at least on small and medium-sized projects.

On large projects, I have found it very helpful to include a designer or two and, in some cases, our production manager in the master meeting. Doing this is more cost efficient for us in two ways: (1) It has saved a lot of time, since I don't have to explain the project to my support staff—they get firsthand information from the client themselves; and (2) The client and my support staff are given the opportunity to meet and interact with each other. This builds staff morale and client trust. It also gives you, your art director, or any other executive staff great freedom from absolutely needing to be at every future meeting or from needing to be involved in every phone conversation regarding the project. This is key if you want to avoid micromanagement.

When you're talking about cost-conscious design, client involvement at several different levels can be either helpful or detrimental. Client involvement becomes most necessary when unexpected issues arise in the creative or production phases of a project. Some significant examples of this are: (1) a new, better idea surfaces at your studio regarding format or production techniques that will be more costly than your approved estimate; or (2) after the design is completed, you realize that the paper you specified in your original estimate is not the best paper for the project after all, and the new paper you would like to use raises the final costs beyond budget. Of course, there are many examples we could list here, but these are the two most common issues that seem to arise.

Obviously, when costs are going to go up, you need approval from your client. In the two cases described above, you won't always get it. Sometimes, clients can agree that maybe you've come up with a better idea, but the budget established is one that they need to adhere to. The same thing goes for choosing a more expensive paper product after the original estimate is approved. There are also occasions when a client really wants to make the change but just can't because of increased costs.

Whenever possible, I discuss this matter with my vendors and sometimes succeed, for example, in having paper companies reduce their costs to match my needs. We've also been known to throw in some extra time and not charge the client for it if we feel that we could profit from having a better sample for our portfolio or if the client works with us frequently and they appreciate our endeavors.

It may seem a little weird for me to get on a soapbox about spending money while we're in the midst of talking about being cost con-

THE THREE BIG DS TO COST-CONSCIOUS DESIGN

1. *Discipline:* Stick to your schedules! Don't over-perfect, over-design, or procrastinate.
2. *Delegate:* Use support staff whenever possible. Hire an office manager and a traffic manager to make your firm more proficient.
3. *Direct:* Use your expertise to show others what to do and how to do it. Let your discerning eye decide what to improve upon at each design phase.

scious. But in these ever-changing, computer-driven design times, it is extremely important to keep up with what's happening in the industry. In cliché terms, sometimes you have to spend money to make money.

Things like new software or updates for software, software seminars, trade shows, time management workshops, and other important educational opportunities do take a day or two away from actual work now and then, and they do cost money. But you do need (at least sometimes) to take the time and spend the money. (That's why our discussion of fixed and unfixed expenses on page 7 included the need for such items.)

As the owner of your firm, you will have to decide when and where to spend the extra money necessary to keep things running and up to the standards you have created and, therefore, want to maintain. Essentially, you could look at such expenditures as lowering your bottom line. I know a lot of firm owners who get by with the minimum and are very negative about spending their profits to enlighten staff or expand their equipment base to the constant stream of next-level technology.

My opinion is that spending money on things like this is really necessary for me and my staff. It helps everyone stay interested, focused, and loyal to the firm. Sure, you have to find a balance of when and how to spend the money; in tighter times, you just don't do it. After having the good fortune to have my firm as long as I have, struggling as a group through the tough times (and there were, indeed, a couple of years of very tough times) only proved to me that spending money for what I like to define as "improvements" turned out to be a

great investment in my firm's future. It's almost like glue to a creaky chair or plant food to a wilting plant. You can still sit on the creaky chair for a few years, and the plant is not going to die for awhile, but both will benefit greatly from a little time and money spent on care and nourishment.

Educating Your Client

In your original master meeting you should determine your client's knowledge regarding technical aspects of the graphic design industry and how much he really understands your work process. Your estimate may contain technical jargon only understood by people in our industry, and you may be surprised at how many times you will need to explain certain processes. Great examples of this are the terms "color separations" or "needing film." Many clients think that just because we now do most of our work on computers, the printer somehow magically gets the materials for their printing plates by general osmosis.

Explaining technical processes in layman's terms will be the number one way you'll need to educate your client. Try to answer all technical questions before you present your estimate. If your client is not familiar with the processes, review the finished estimate with him in person. Then, as the job is progressing, show him the processes as they occur, and invite him to review the color proofs and the press proofs so that he can not only appreciate your expertise but also feel more confident delegating these types of projects in the future.

Does your client need (or want) a crash course in technical education? Give it to him on the spot. If you determine in your initial meeting with your client that your client is not totally competent, and he wants your help, this is your cue to develop a long-term relationship. No one likes being in the position of not knowing. And if you can embrace the teaching process and not be condescending, you'll have a client for life. A more dangerous scenario is the client who thinks he knows everything, and as you hopelessly try to explain the realities of a situation, your words fall on deaf ears. This happens way too often in large corporations, where less experienced graphic design buyers are intimidated, preferring to be bullies rather than humble servants. When you experience this type of client, let them blow off all the knowledge in their little brains and walk away. Choose your moment carefully to reintroduce the subject matter at a later date, reminding your client of the matter in a casual fashion—such as, "You know when we were talking the other day about Irises being lesser quality than digital proofs, and we disagreed? How about our talking to Mr. Favorite Printer to find the answer—maybe we're both wrong!?"

Fitting Pricing to the Budget

Deciding whether or not you can fit an estimate into a client's existing budget depends somewhat on what type of fee structure you've chosen to use. Fitting an estimate to a budget is easier with the value pricing method: You can simply determine if a project is worth the dollar amount that the client has budgeted and inform the client of your decision to move forward or move out!

Remember, you do have options: bartering, for example, or billing your client over an extended period of time so the amount better fits his allotted budget—which might be set up for monthly or quarterly disbursements. Perhaps you can creatively scale the project itself so that

A few proactive ideas follow with regard to specific educational explanations we confront often at Real Art:

- If you need a camera-ready copy of your client's logo and he doesn't know what that means, show him examples, or use other terms that may help him. Some people call camera-ready logos "slicks" because they are printed on glossy paper. If the client is at a total loss, ask if there is an internal graphics department that might be able to give you either a hard copy or a set of logos on diskette.
- When deciding who will buy film, you will quickly determine if your client has a clue as to what this means. For quality-control purposes, you will want to at least coordinate your outside suppliers. You should explain the basic reasons for your decisions to your client. For example, "Choosing a supplier depends on who can most proficiently produce the job from quality and economic standpoints," and describe some of the ways to judge this.
- Ask your client how much education she would like throughout the production of her project. Some clients want to be more involved than others. Ultimately, however, you will need to involve your client at the levels that *you* feel comfortable with.
- Invite your client to your studio so that he can see how you produce a project. It is very helpful for clients to see just how time-intensive project production really is. Your efforts will be more appreciated after he has a general knowledge of how the design world spins.

I realize these explanations might sound way too elementary, but don't ever take for granted that every client you have is aware of these common scenarios.

certain phases can coincide with given budget time frames. For example, logo revision, letterhead, envelopes, and business cards might be done in one quarter, a revised capabilities piece the next quarter, sales-specific literature in the third quarter, and so on.

My own feeling is that you *don't* compromise your fees unless one of two cases applies: Either you must absolutely have the job for your portfolio, or else you're dealing with a long-term client who has a well-

established history of giving you profitable assignments, and you're really doing him a favor.

Cost Control and Time Management

I hope I don't sound like a broken record, but once again, I'll tell you that the best strategy for cost control is *forms* (written-out figures and plans, as opposed to just an idea of what things should be). Forms are the key to controlling costs. Whether the forms are gridded into the computer template of a project management program or are developed to be used manually, they should show you at a glance how much time you have on a project, what your current costs are, and if you are on schedule for a project at any given date. The goal is for the system you establish to give you instant status report on a job whenever you want it.

So, you say, you have the information at hand, now what do you do with it? Control and discipline! You should look at the project management side of your projects about as often as you look at them from your discerning, creative vantage point.

Before a project is started, share with your support staff how much time is budgeted for them to spend on each project task. Then, as the project progresses, update yourself on the *real* amount of time spent for various tasks. If more time than you allowed for in your estimate is being incurred, you need to immediately discern why and do something about it. There are several possibilities: Someone is either overperfecting, not sure what to do or how they should be doing something, you underestimated the time needed, or the client is slowing progress in some way. Whatever the reason, appropriate action should be taken to make a positive change.

Each of the scenarios given above has been dealt with elsewhere in the book—except the issue of a staff member not being sure what to do or how they should be doing it. Reality bites in this particular example, and you can probably blame it on being too busy and fragmented yourself—thus, the communication breakdown. Chalk it up to experience, and patiently take the time to explain the task more thoroughly.

If purchase orders have been properly submitted for all outside services you will require, overages on actual dollars spent should be obsolete. In the event that you are incurring rush charges from service bureaus that you did not allow for in your original estimate, expect these overages to come out of your profit margin—*ouch!* This either

means that you're incredibly busy or you have incredible inefficiencies somewhere. Needless to say, you'll have to find the problem and deal with it.

Time sheets are really the only way to track hours spent on project tasks. It doesn't matter whether you record these manually or within a software program, but it is imperative to compare the actual time required to the estimated time allotted. Many firms only mandate the maintenance of time sheets for new employees; performance for established employees is measured more directly—by the amount of work produced and the profit generated by that work. Strategy for controlling total hours spent on projects may include a bonus incentive for your employees—the more work accomplished and the more profitable that work is, the more money there is for bonuses.

Unless you are working alone and have strictly placed a value price on a project, time sheets will be instrumental in your profitability. When I started my business, I was actually a freelancer and had a studio in my home for the first two years. I never kept time sheets and found myself floating from the studio out to the deck to get some sun, into the laundry room to do a load of whites, and then back to the studio! Consequently, I was working about eighteen hours a day. Fragmenting my studio time actually decreased my productivity level and doubled the amount of time I had originally budgeted for my projects. This became apparent to me only after I started keeping time sheets.

A larger staff requires an internal check system for hours logged to each project and for time sheets submitted on a timely basis. Delegate this check task to someone or do it yourself if you have to. It's the only way to bring balance and profitability into an otherwise timeless world that can quickly go careening out of control and into negative profitability.

What work is and isn't billable to your client is reviewed on pages 14–18. However, there are a few unique situations I'd like to point out that pertain to project management.

One fact of life is that the hours spent on project management tasks are all nonbillable hours. On pages 14–16, while we were determining your hourly rate, I noted that in no way are you or your staff members capable of billing a forty-hour week (unless you are actually working fifty-plus hours a week). We allowed ten hours a week for miscellaneous office tasks like cleaning up and backing up computer sys-

Some of my personal time management tips created especially for designers follow:

- Consistently maintain time sheets.
- Plan your days so that you can spend at least two hours at a time focusing on design and production tasks. Fragmented time is counterproductive.
- Make and return your phone calls at the same time every day. Try initiating calls first thing in the morning for an hour and then returning calls between 1:30 and 2:30 in the afternoon. You'll find greater success in reaching your parties at these hours, resulting in some nice blocks of time for planning or productive sessions. Don't set up appointments for yourself during these periods, and inform your staff that you are not to be interrupted at these times.
- Be aware that job burnout occurs more often in our industry than in any other. Encourage staff to take planned vacation days, consider giving an extra day off on holiday weekends, and think about closing your office or studio for the week between Christmas and New Year's.
- Set realistic schedules for projects, and stick to them. Hire freelancers or approve overtime hours to keep projects on track. Falling behind will result in a domino effect of being behind all of the time and becoming notorious for missing deadlines with clients and vendors—a really big no-no in our industry!

tems. Properly maintaining time sheets, filling out information on job jackets, and so on also fall into this nonbillable category.

In order to get an accurate count of hours that are truly billable, you need to encourage respect for and the honest use of the time-sheet system within your business. Falsifying time-sheet hours is totally unacceptable, and you will see where this is happening when you (or your designated staff member) review them. I've had great luck in obtaining accurate time sheets by personally discussing their importance with new staff members and instituting an overtime policy: No overtime hours are to be incurred without a simple overtime-approval form being authorized by me or my art director.

Nonbillable hours can also result from having an entry-level or inexperienced staff person performing a task that is not within his or her realm of expertise. In other words, someone who is less experienced may take twice as many hours to perform a task, but those additional hours can't fairly be charged to the unsuspecting client. On the other hand, it is important to give lower-level employees the opportunity to grow and learn. This will make them more efficient in what they do, and more of their hours will be billable. In the long run, having them spend more time now will benefit both of you.

The Quintessential Office Manager

Hiring a good office manager could be the most important accomplishment the owner of a graphic design studio ever realizes with regard to staying on budget. Hovering above the design awards, behind the glory of obtaining the "perfect" account and hiring the best creative people to support you, lies the magical umbrella that keeps you and everybody else out of the storm, safe and dry—your office manager!

This wonderful person will organize everything regarding the administrative aspect of your business. She will communicate beautifully with clients and vendors. With the touch of a button or the wave of a hand, she will show you updated status reports regarding time and expenses logged per project. A reassuring smile will ensure you that she has indeed billed the project that was finished yesterday and that there is enough money in your checking account to cover payroll tomorrow— and then some! She reminds staff that time sheets and purchase orders are necessary to complete the assigned tasks properly, and only screams at them if she gets absolutely no results otherwise.

People with these great dispositions and capabilities do exist, although they are truly a challenge to find. Without an office manager, you may find yourself totally bogged down with tasks like those I've described, and more than likely, those tasks are not what you do best. If you find yourself spending fifteen or more hours per week on administrative responsibilities, you really need to consider hiring an office manager. The amount of time you will regain and thus bill out at your own hourly rate will greatly supersede the moneys you will invest in the right office manager.

TEN TIPS TO FINDING AND HIRING THAT PERFECT OFFICE MANAGER

1. Network. Tell friends, family, and colleagues that you are looking for an office manager and what the qualifications for the position are.
2. First impressions count. If a candidate for your new position arrives at your office thirty minutes late wearing their breakfast (this really happened to me once), it's a good indication that they're not really who you're looking for.
3. Review the candidate's resume and cover letter carefully for grammatical and spelling errors. If they are careless with these all-important documents, think how they will be with the responsibilities you've outlined for them.
4. During the interviewing process be critical about articulation skills, eye contact, and levels of self-confidence that the candidate presents. These are three very crucial strengths that a good office manager must project.
5. Ask for references from prior jobs, and personally contact at least three of them. Ask previous employers about the candidate's promptness, English and math skills, and the levels of loyalty and trust the employer experienced with this person.
6. Ensure that the candidate is not overqualified for the position. There

The Traffic Manager

Traffic managers (or production managers, as some people call them) are a must when you find that there simply are not enough hours in the day to perform tasks such as buying and coordinating outside services, reviewing proof copies with clients, and making sure your staff is staying on schedule. The traffic person acts as a liaison between you and your clients and between you and your printers and other outside vendors to ensure that projects flow smoothly and proficiently. It is the traffic manager's responsibility to keep your staff within budgeted hours and to alert the sales or account person when a project is going over budget.

Acquiring the services of a seasoned traffic manager may be quite costly and will add a substantial amount to your fixed cost list, which will probably result in higher hourly rates for your firm. A traffic man-

are a lot of college graduates and otherwise-overqualified people who are desperate to find a job and think that they can get one in office management quite easily. These types will not last long in your organization unless they are challenged by growth opportunities. If growth realistically does not exist in the position you have to offer, don't hire them.

7. Don't hire a graphic designer who can't find a design job and who appears to have office management skills (lots of us do). This person will become frustrated being part of a team where they cannot express or use their creative skills.

8. Offer a competitive salary and benefits that rival similar corporate positions in your area. You want this person to enjoy a long-term working relationship with you, so you must respect their long-term needs.

9. If you're horrible at math and can't decide whether the person you want to hire is the perfect candidate or not, have your CPA or tax accountant speak with him and ask pertinent questions regarding the person's technical capabilities.

10. Take your favorite candidate to lunch. It's amazing what you can learn over a meal. Observe manners and poise, and let the informal environment help you get acquainted.

ager's time is only about 35 percent billable for the most part, but you can change that if you allow a certain amount of time for traffic tasks within your estimate. Obviously, this will cause your per-project rates to increase; however, if you've grown to need these services on a full-time basis, your clientele will probably not question you about the several hundred dollars extra that your current estimates reflect.

Announce your firm's growth and the addition of this important member to your team by sending out a mailing to all your clients and vendors. In your mailing, list the benefits your clients will immediately realize. Just like the office manager, the traffic specialist will really take the pressure off you and allow you to explore the opportunities of doing the best of the things you do best.

Successfully establishing and managing project budgets relies on several people working in tandem. It's difficult—especially for a solo

TEN KEY TASKS OF A TRAFFIC MANAGER

1. Buy all outside services that pertain to project production.
2. Assist or complete the estimate process by obtaining costs for all elements pertinent to projects.
3. Proofread all projects before the client does.
4. Ensure that the staff stays on the given schedule.
5. Update and revise the schedule for staff, clients, and vendors when necessary.
6. Obtain delivery information from the client, and relay that information to the printer or other end-product producer.
7. Review final proof copies before going to film.
8. Scrutinize color proofs and film before sending them to the printer.
9. Check press proofs.
10. Follow through with the client to ensure accurate delivery and satisfaction.

designer—to let go of control and rely on others. The sidebar information in this chapter will be particularly helpful in propelling yourself into success mode. Even if you cannot afford an office or traffic manager, someone—probably you—will need to perform these responsibilities to ensure proficiency and profitability.

■

Negotiating

There are tons of books dedicated to the art of negotiating; but I wanted to include specific tips for graphic designers in this book because I think our business in particular is very unique to the dynamics of negotiations. Constant negotiations are simultaneously taking place regarding almost every aspect of our projects. I cannot think of any other profession that incessantly finds its peers whining more about losing the core value of their esteemed endeavors, while so often falling on deaf ears.

How to Show Them You're Worth It

I tell my students, interns, and entry-level designers over and over again that they are first and foremost salespeople. Not artists, visual communicators, lovers of colors and words—none of these things; they're salespeople, every one of them. And effective salespeople, if they are going to make a profit, are good at negotiating. No one ever believes me until they show me their first finished project. Typically, any art director will ask his or her support staff questions, challenging them on, "why this blue, why that angle at the photo shoot, why that type font?" The replies given are all elements of negotiations. The art director, in turn, will be asked similar questions by the client. Answers are given by us designers in defense of our selections. There is usually

rebuttal, more questioning, and more answering. A debate may ensue. Negotiation squads (you!) are brought in. Every time we show artwork, copy, presentations, etc., we go into the same territory. Better to have a diverse stash of thoughts, words, and actions, so we can rise above the ensuing stress and get the results we want.

The first place in a project where we have to negotiate is usually when, or shortly after, we present the estimate. This is your number one opportunity to put your stars on the ceiling. If it is a new client, or one who hasn't seen your work for quite awhile, give them a dog and pony show. Before talking numbers, show your audience work that is relevant to your proposed estimate. If you don't have any relevant work, show them the latest and greatest piece you've done for a client whose name they will recognize. If you don't have this either, have a brief discussion first about why your firm is the right choice for this specific project. Seek out definitive and qualitative reasons. For example, you're a recent award winner for a piece that was heavy in typographics—like this one will be. Or, you designed direct mail collateral for a similar endeavor last month, and the client received an unprecedented 9 percent return.

Obtain letters of recommendation for your firm's outstanding achievements—quantitative and qualitative information that will give you credibility in the eyes of this new client. Show them you're worth the pricing you're asking by never literally saying, "I'm worth it, but of course." This isn't Grey Poupon. It's a competitive industry, and you need to find a reason and a way to distinguish yourself from either your competitors or, possibly, even your own history. Reinvent yourself every time you get the opportunity to present. Keep things fresh and new.

One of my fondest presentation memories has to be the time one of my partners and I presented an over-the-edge idea to a rather conservative client. The client had been our largest client for almost three years. We knew each other well; we had developed personal relationships and had great camaraderie. They had asked us to develop a totally new look for their national print consumer advertising. We're not the biggest advertising experts; we do mostly business-to-business. But we knew the client's consumers very intimately from having worked so closely with their collateral development for three years. I was coming to the point of fear, having had the account so long, however, that perhaps the client was getting tired of us and maybe vice versa.

We had a blast designing the new ad formats, developing unique

illustration styles and graphic design standards very new to the market. Prior to the presentation we sent cheapie, rock 'n' roll band–style flyers to the client's entire advertising department, with some very cheezoid graphics announcing Ban Jovi live and in concert in their conference room, at our said meeting time, in their said city and state. This meeting was for the advertising department staff only. No big VPs or merchandising people. We knew we were dealing with a safe crowd.

The day of the presentation, we arrived with a banjo, in overalls and flannel shirts, complete with karaoke equipment and a script matching the tune of the *Beverly Hillbillies* theme song. The script announced our new ideas amidst the laughter and tears of our surprised friends and colleagues. We had the guts to do something so strange and unheard-of to them that we couldn't even get finished because the roar in the conference room grew deafening. After the wildly successful presentation, we distributed souvenir Ban Jovi concert T-shirts. The noise was so loud that, fortunately or unfortunately, VPs and other senior execs were soon popping their heads into the conference room to see what was going on. Instead of waiting for their ad department to present the work to them, we got to do it firsthand to our delight and victory. It was certainly the most fun I've ever had presenting anything. And it worked! Price became the low man on the totem pole because there were too many other diversions to sway our clients from their typical focus.

This isn't to say that silly gimmicks work every time. Remember, we knew every person at that eight-person table quite well. We knew their sense of humor and could take what we knew and mesh it into our script to establish personal connections and familiarities. Showing your own clients you're worth it will come from your own individuality and creativity. The point I am trying to share with you is that proactivity and originality can enhance your performance—in presentations, conversations, and negotiations. Because ultimately, negotiations are always lurking—whether it's to challenge price, particular design selections, or finished manufacturing decisions.

Discussing Rates and Fees

There will certainly be many occasions when you will need to justify the rates and fees that you propose in your estimates. About 50 percent of the time, clients will ask me how I arrived at my figures. It's inter-

esting to note that they usually request an explanation on design fees, but not on the fees of outside suppliers like printers and color separators. I think that, psychologically, clients understand these suppliers have massive equipment housed under large roofs, so their prices are justified. They also know that there really aren't as many large manufacturers to choose from; and typically, industry standards require us to get bids from three equally qualified vendors and then use the best price we receive on our client estimate.

I have found that, more often than not, sharing an hourly rate with a client will totally freak them out. This is especially true of clients who need the aforementioned "education" and who are not particularly accustomed to purchasing design services. Usually, a simple explanation like "Well, this is a big project, and we will have it in our studio for over three weeks in the design and production stages alone" will suffice. Clients tend not to envision things going on for several weeks or months even. I also refer to similar-in-scope projects that I may have shared with the client from our samples of completed work. It's helpful when you can say, "For example, the project we did for company X, which I left you a sample of last week, cost Y dollars to produce," and so on.

If your client wants a more itemized breakdown of expenses, give it to him. Sometimes, it is a lot easier to justify project expenses in incremental stages and costs than it is to justify (or even explain) a lump sum.

A well-known on-line service recently asked my firm to produce packaging concepts for a line of customized, niche software. I gave them a price of $28,000 for the initial prototype and $3,600 for each prototype thereafter. The client is highly knowledgeable about our processes; she is an experienced graphic designer herself, who moved into her corporate design-purchasing capacity about eight years ago. I was very alarmed when she told me that my prices were substantially higher than she had expected.

I immediately responded by offering to review the project again and admitted that perhaps I had made it a bigger project than what she was asking for. I then explained that while we were asked to provide two "dummies" for two of the software products in the new line, no logo had yet been developed for either of the products—or even for the line itself. I went on to explain that my $28,000 price included designing three logos (the parent logo for the entire line and the two prod-

uct logos), a design "system" for the entire line, a packaging plan that included a format for any instructional literature to be included with the software, and an initial prototype for the first of the two products. The additional $3,600 would be for the design and production of another dummy for the second product.

Even though my client had been buying high-quality design services for years, she had not pictured so many design steps for this project. She readily agreed to pay our fees and set up a meeting for us to get started—much to my relief. We had been trying to obtain work from this client for quite some time, and I didn't want to blow it with a price that seemed out of line to them. On the other hand, I had researched my pricing carefully within its category in the *Pricing and Ethical Guidelines* book published by the Graphic Artists Guild and felt my pricing was extremely fair for the scope of work required.

The important thing here is that I was also unwilling to let her questioning intimidate me into lowering my fees until I had properly explained them to her. In the long run, she received a beautiful, first-rate presentation, far beyond her original expectations. When I explained that the project seemed more substantial after I got into the estimating process, I concluded with the fact that, in actuality, she was getting quite a lot of design for a modest rate. Her agreement gave us the encouragement to produce some great work without resentment for what we *weren't* being paid. Resentment resulting from lowering your pricing tends to build once it has begun, instead of tapering off once it has begun. It's not a desirable way to start a project.

Achieving the Win-Win

Frequently, fitting into a client's budget will oblige you to stand up to your vendors and ask for help. The easiest way to be in a position to negotiate with a vendor is first and foremost to be an important client to the vendor. You can achieve this by paying your bills within the terms noted on your vendor's invoices, by referring your vendor to other colleagues and to clients buying their own outside services, and by sending a letter of thanks to your vendor when his exceptional services got you out of a jam or his great quality helped you look good to your client. It is just as important to have good communication with your vendors as it is with your clients.

Always compare apples to apples when comparing vendors' serv-

ices. Don't expect a high-quality printer that has a new eight-color press to be cost-competitive on a small-run, two-color project. Just as you want your clients to compare you and your company's pricing and quality to someone who charges similar fees for similar quality, your vendors deserve the same treatment.

Ask your vendors to itemize. If one color separator charges more for random proofs than another, you can at least ask him why if the charges are itemized. Compare similar itemized quotes from at least two, if not three, similar vendors. This is an industry standard, and many of your clients will ask you who you quoted to do what. Don't shortchange yourself or your client. Complacent vendors who realize you're not taking the time to do comparison shopping may begin to take you for granted and not offer you their best pricing.

If you are trying to fit into a client's budget and you know that it is very tight, tell your vendors up front where their price needs to be. Instead of going to the trouble to research your project from the usual standpoint, they have the option (like you do) of taking the project for the budgeted amount or turning it down because it doesn't fit their fee structure. Estimates take a substantial amount of time to produce properly, as you know. By sharing a tight budget as soon as you are aware of it, getting the information out on the table for review, you save yourself and your vendors a lot of valuable time and frustration.

It is considered unethical to share a vendor's name with other vendors involved in the same estimating process. Even if you tend to favor certain vendors, for whatever reasons, there may be a time when you want to expand your vendor list, or maybe a client will ask you to try to work with a certain vendor, and this will be difficult to achieve because of your lack of confidentiality. After a job has been awarded to a certain vendor, you may discuss it with other vendors as necessary to justify your selection process.

No matter how big or how small your town is, it is very important to build partnerships with vendors—in much the same way you build them with clients. Word will travel fast about your work ethics, and these ethics can (and will) work for or against you.

The most important attribute of my win-win philosophy is letting go of your fear of risk. It took me well over ten years of being in business for myself to realize the confidence required to engage my clients directly, squarely, in face-to-face confrontation. I have learned that confrontation is not a bad word at all; it's actually very healthy, espe-

Some of my famous tips for negotiating with vendors follow:

- Treat your vendors exactly like you want your clients to treat you. Don't nickel-and-dime them to death, don't ask a lot of production-pertinent questions before you make a commitment to using their services (thus taking up unbillable time—remember, they need to make a profit, too), and don't pass the buck to them if you start having problems that are really not their fault.
- If you do have a problem to resolve, don't make threats or give ultimatums. If you are absolutely certain that you are in the right, make sure that you are negotiating with the right person—probably not your account rep, but perhaps the manager or even the owner.
- Always have vendors give you their estimates in writing. Make certain that all items you specified are on their written estimates. If they forgot to include something, it is your job to ask them to revise their quote before you commit a project to them.
- Don't shop for the lowest price when you don't have to. You do get what you pay for!
- Choose several vendors to work with consistently so that you can build a healthy rapport together. The stronger your relationships and the longer they last, the easier it will be to communicate your needs and resolve issues, especially when you need help saving money for lower-budget jobs.

cially in long-term relationships. Any of those popular, best-selling self-help books will validate this theory. I now actually enjoy the risk of potentially giving in to the client's demands, the risk of possibly losing some money, the risk of angering—and even perhaps losing—a client.

By embracing these risks, I can readily see the worst-case scenarios of a problem that lies before me. I am now free to approach a resolution with complete and total honesty, combined with a genuine willingness to hear and identify the client's point of view. It is important for me not to drink a lot of caffeine before I enter any sessions that require me to be smooth and easygoing. Know your own tolerances to caffeine, sleep deprivation, other stresses and situations prior to any potentially challenging negotiating meetings. You want to be fresh and

focused solely on the issue at hand, as though it were the most important moment of your career.

I always like to be proactive by opening a negotiating session first. I thank the client for their time and make an endeavor to outline the exact issues where we have a disagreement. It is a great idea to present these issues in writing, in an outlined, bulleted format. This will keep you from diverting to other issues not pertinent to the subject matter. Ask your client to help keep you firmly focused with this list, and announce that you will do the same for your client. Acknowledge that you want to leave the room on a high note together, that your goal is win-win. Say it out loud, with a smile. Smiles work wonders. Relax, have a cookie. Sweets at the table are a great way to informalize the event—who doesn't like a little tollhouse in the afternoon? Drink milk, not coffee. Be endearing, not abrasive.

The fairest, quickest way to obtain win-win resolution is to split fifty-fifty any financial differences you are having. Seldom will any reasonable person disagree with this suggestion. If you have followed some of the ideas previously presented in this book, gotten proper sign-off on estimates before getting started, properly documented and presented changes, and gotten the most important sign-off of all—at the end of a project, prior to printing or manufacturing—your negotiation tasks will be much easier. Most of us know deep down who's right and who's wrong. It's simply a matter of listening, confirming, and creatively, jointly deciding what's right.

You can validate without agreeing. You can smile and say no. You can look out the window and say you wished your mother was there to lighten the moment. You can listen and learn more about yourself and your business practices. You can ask questions that might help you avoid this situation in the future. The important thing to know in negotiating is that yes, you can.

Providing win-win solutions is very rewarding and shows your emotional intelligence. It invariably results in huge relief for both parties and is sometimes cause for celebration over lunch. You buy. It shows your client that you care about more than simply getting your way and are committed to longevity as a business owner.

Rewards and Repeat Clients

I remember sitting across the most beautiful conference table I had ever seen in my life, early on in my years as a design firm owner, talking to a prestigious architectural and engineering firm about promotion collateral. Awards spilled from their display cases. Photos of international projects lined the corridors. The building smelled better than a new car, stuffed ceiling to floor with the coolest office furniture money can design. I wanted this coveted project.

The man reviewing our portfolio was engaging and interesting—and interested. The meeting was going very well. I had founded Real Art just two years earlier and wanted this project, perhaps just a little too much, as a portfolio showpiece. With the portfolio closed, we sat and discussed some aptitudes of both of our businesses. The final question asked to me was, "Why should we give you this job?" My reply was, "Because we can win an award on this piece." I got the project, and it did win a fair number of rewards. But I will never forget my client's reply.

He leaned forward in his chair, looked me straight in the eyes, and said, "Theo, I could care less how many awards this piece gets you. That doesn't mean anything to me if I don't get any new customers from the piece. If I don't get at least a 5 percent return for my sales staff on this piece, we will never use your services again, and I will consider the piece a huge failure no matter how beautiful it is." I cowered and quivered. At that time, I did not know what the average rate of return even was for a direct mail solicitation campaign. Thirteen years later, this same firm is one of our biggest multimedia clients. The man who was my client at that time has gone on to found his own prosperous architectural firm. He taught me volumes.

Now, I always tell my staff that our biggest rewards are repeat clients, and I truly mean it. Let this be the mantra of our industry, and graphic designers will go from stereotypical rose-colored-glass wearers to the most profitable business owners of all times. Real, ongoing profitability relies on continuity, cohesiveness, and reliability. Clients who know that your rates are perhaps higher than the Bob down the street won't mind paying more if they know that, beyond your originality, you are going to provide fair and honest delivery of more than just graphic design and visual communications.

Your role as an industry expert is to rise above the typical flash-in-the-pan trends. You can present the difference by being a savvy negotiator. Learn to enjoy the entire negotiating process, and it will be evident to your peers. Rising above will result in your ability to be somewhat intimidating—but in a good way—at the tables of future sessions. Clients will learn to trust what you say and not question your authority over and over into infinity.

■

We're all in the business of visual communications; that's a given. But we've come to an age of sophistication in our society where I believe it's time for graphic designers to step up and be gratefully acknowledged. Never before has graphic design been so prominent in our everyday activities. People rely on good graphics regularly to select navigation on Web sites, create support for their presentations, validate their investments via charts, etc. The significance of what we do is at the very center of many people's daily lives, both personally and professionally.

Standing on a Soapbox

My firm is taking nothing for granted. We have known all along the values that permeate our world because of effective graphic design. I have professed since day one to my staff that we not create an individual style for the firm itself, but rather, create a multitude, an endless array of styles that are relative to each client's needs. The result is what we market as "the smart firm."

It became apparent to me several years ago that big advertising agencies were losing market share to boutique firms like my own. Articles were written in national news magazines and newspapers around the country profiling new, smaller, maverick advertising agen-

cies that were obtaining big-name, international accounts. I wanted a piece of that action for my firm too. I love to travel; and even within our own country, as I traveled more, I began to see prominent subcultures in attitude and lifestyle differing not only from one coast to another but even from city to city within the same state. This fascinated me and continues to do so today. My firm does not only reside in Dayton, Ohio. I feel it resides around the world. After all, we do work for clients who have offices, collectively, on all the continents in the world, so we needed to adapt our own mentality and raise the bar on how we look at projects both from an aesthetic perspective and, more importantly, from a content perspective.

Playing It Smart

The "smart firm" concept evolved in synchronicity with our hiring a sales development person who is well known in our region, a one-time television personality who transcended her own career from weatherperson to strategic marketing and planning. Hiring this person enlightened me with the fact that we will never again go without someone with her talents and perceptions. Our large clients who have in-house strategic marketing can now appreciate the fact that we are creating more than "pretty pictures." Even though we pride ourselves in researching projects appropriately before we start designing, the residual benefit of having a full-time "strategic marketing person" on staff elevated us in our larger clients' minds by a generous proportion. Our smaller clients need and enjoy the new services because they can readily relate to facts presented (strategically, of course) at our design presentations supporting our visuals. Suddenly, fewer questions are asked about why we chose orange or why we used photos instead of cartoons. It's all in the research!

Having a strategic marketing person on staff also made me realize that we had no actual marketing plan for our own firm. Here we are, fifteen years old, with no plan other than to try to be as progressive as possible, react to ever-increasing technological advances in our industry, and enjoy ourselves along the way. Our process within this new (to us) realm is still in its infancy, but some interesting issues have developed. First and foremost, the hiring of this person has been so effective, we need to hire an assistant for her, only one year after her hiring. Things we see our clients do—press releases, attending commu-

nity events, and getting more involved in regional business endeavors—get our name into the public domain, quickly and effectively.

One of the first things I asked our strategic marketing planner to do was to begin thinking of a structure with which we could present our firm on paper. Her first action was to write a Business Review for my critique. Within that review she identified our mission as a design firm with regard to our history, our future responsibilities, and professional ethics. She identified a myriad of services we provided, while ranking the types of clients we had attracted by overall sales revenues.

Next, she outlined attributes of the firm relative to our current size and comparatively with other similarly sized firms around the country. She then did some informal research to check how our own Real Art "brand" stood up—were people familiar with our company? Did our location help or hinder? How did our deliverables stand up to what is being done in the industry overall? What types of brand loyalties do our customers have, if any?

She then provided me a chart showing Sales by User Group for the last three years. This chart showed me trends that I had not realized were evident within our revenue paradigm. From this information, we derived segmentation information, showing a percentage of revenues coming from repeat business, extension business (cross-selling additional services with existing or recent clients), private label business (revenues coming from intermediaries or recommendations from existing clients), and new business derived from cold-calling efforts or networking.

This information gave us a very clear picture of who we were at one time and of who we are today, and it set the groundwork for questioning who we want to be tomorrow. Some strategies were devised to increase awareness among our potential customer base. Our annual holiday "promotion" was revamped to include content material featuring our latest technological and creative achievements. Due diligence before design is becoming our motto.

The result is a more energized firm. About a year after hiring this person, our most creative (at that time) art director left for an equity position at a competitor. It could have been a blow to our staff, and I believe it was, temporarily. We decided to empower some of the younger people who had been loyal employees to the firm, embracing their enthusiasm for design and complimenting them for their acceptance of this higher system of knowledge application. Now, this "new and

improved" group—having its foundation in being the same core of people—has literally reinvented itself with regard to self esteem, presentation to the outside world, and professional culture. Sure, they still have rubber band fights and silly grilling contests on their favorite George Foreman Lean Mean Grilling Machine. But they also have instituted things like creative brainstorming retreats for the purpose of creating promotion for the firm. Encouraging everyone to take personal pride and ownership of the smart firm concept has proven successful in morale, productivity, and creativity.

A personal selling strategy for the firm was then created and detailed with regard to presentation styles, proposal content, our Web site, and various other revenue-enhancing operations, with an overall effort to reduce selling costs while increasing selling content.

Getting Out to the Press

Currently in development is an endeavor to generate publicity for the firm through the media, both regional and national. Brainstorming ideas for newsworthy press releases relative to our firm's growth and capabilities are underway. Distribution channels for articles our copywriter is preparing together with our strategic marketing person are being researched. An effort to step up the quality of design competitions we enter, with a special focus on national possibilities, is in motion. We're also looking at creating a foundation for graphic design students, with the goal of awarding an annual scholarship in our firm's name.

Strategic marketing planning makes sense for us at this stage in the game. I'm only sorry that I didn't recognize its value and significance earlier, years ago—from day one, even. It has put us into a much more proactive position to think ahead, dream, and evolve from a plan instead of reacting to economic and internal situations as the norm.

The ongoing growth of our firm requires us to review our plan annually, with adjustments made continually. Just having a plan at all is a step in the right direction to committing to your firm's evolution. Our industry is especially chained to the concept of change and flexibility. Grasping for answers in a world economy that requires us to react quickly or get lost in someone else's feather duster is a lost cause. Having a vision for possibilities and a plan to build the roads to the foreseeable plain puts you up on the flight deck.

Communicating Successfully

We take communications for granted, with e-mail, cell phones, pagers, voice-mail, and who knows what's next? Effective communication in our industry lies in three very different arenas, which we usually rank this way: communicating with our clients, communicating with our support network (i.e., bankers and suppliers), and, usually last by default, communicating with ourselves and our employees. I encourage everyone in our industry to change the order of our communications priorities to the exact reverse.

First, our employees are our biggest asset. And if you're a one-person shop, then you're indisputably your biggest super-plus. Show your understanding of this value every day, and never take it anything else but seriously. By understanding your process, which I suggested with regard to devising your billable hours and rates, you can go to the next level, which is that of being good to yourself and your staff. If you know you're a perfectionist, take a day off work every time you complete a big job. If you know you're a procrastinator, set up an incentive for yourself to take a day off if you get the job finished by noon on Tuesday. A happy you is a happy staff, and vice versa.

One of the most difficult things about growing my firm was hiring the first employee. She was incredibly talented; I was very lucky. This was not her first job out of college; I was even luckier. Still, though, she required maintenance. And soon after, there was another employee, then another. Suddenly, I became a human resources manager. Design classes never prepared me for this at all. I had to rely on my instincts and my own personal motivations.

Many days went by when my own billable design time went down the drain. I seldom closed my door and always encouraged staff to come and talk to me. I still do. Now, if I really need or want to get something done, I just don't go into the office! Really—communicating with creative people is something I enjoy and am motivated to do, because through listening to them—and listening in turn to my own responses—I always learn something about myself and about managing a design firm.

The biggest challenge in communicating successfully with creatives is to listen, and listen as long as it takes. I typically find that designers are their worst critics. They are very hard on themselves and have a difficult time communicating. From a personality profile at my

firm, most of us are introverts. Introverts find it hard to be open with information. You have to ask them questions. I always try to put myself in their position and then tell them a story about myself—or another person with whom I've had experience working—and make an attempt to analogize my story to their situation. By doing this, I do not put them on the defensive. The very last place you want them to go is on the defensive.

I tell analogous stories so that they can then visualize themselves in the scenario of the narrative. Creatives have a wonderful sense of intuition and relational thinking. The stories help them by showing them what I did, or what the person in my story said, without telling them what I think they should do. I always say, "My experience with this type of situation is . . . ," before moving into the analogy. Without fail, the response is a solution coming from them, not me. Role-playing might ensue between us, where we have a lively discussion about possible scenarios. It becomes fun, and a once-serious situation suddenly has gone from a square box to an open continuum.

Having you and your staff in synchronicity is like maintaining your automobile on a regular basis. We look forward to annual staff retreats, using a Myers-Briggs-trained facilitator to discuss our personality preferences and how those preferences make us communicate the way we do. This helps us all to have a greater understanding of each other. Introverts can appear cold and unapproachable when, in actuality, they need to feel safe before they can have open discussions. Extroverts might seem obnoxious and arrogant, when they are just simply thinking out loud and need validation and feedback.

Understanding Myers-Briggs helps us at Real Art to better understand and communicate with our vendors and clients. Years of studying and comparing personality preferences among our staff has trained us to readily observe preferences in communication styles of other people who we see often. It's enjoyable to realize that we all are who we are because of things we simply prefer rather than because of a superficial compulsion to torture our colleagues! I highly recommend Myers-Briggs workshops and reading to anyone who wants to be a better communicator. Its long history and available case studies far outweigh other trendy self-help concepts.

Our support network of vendors—from bankers to printers—is too often an ignored list of people with regard to how we treat them.

Vendors are almost as important (and sometimes even more important) than our own staff. They can make or break you in more ways than one. Doing something nice every once in awhile for these folks is one of the smartest things you can do. Most of the time, these people are hearing your problems with a project, frustration with accounts payables, accounts receivables, carryover complaints from your clients, etc. Treat them to some good news for a change! Send them a letter of thanks when things go well. Don't forget them at the holidays. Talk to them with the highest respect.

Think of your vendors as your counselors. They give advice on a plethora of subjects. You need them. You need to delegate complex and often personal situations to them. We make great client presentations in our sleep; why not make a great visual presentation to our bankers when we're asking for a bigger line of credit? Bankers love financial information, and designers love annual reports. Designing creative charts supporting your request will work wonders and sometimes even get you a banker for a client. Put your professional skills to work when you need to prove a point. Show your favorite printer how much business you've given him over the last year when you're asking for some help on numbers. Design him a personal thank you card relative to the presented information.

Good client rapport begins with a simple, yet seldom-thought-of action. I always ask new clients how I should stay in contact with them. Phone? Voice-mail? E-mail? Packages of samples on occasion? Monthly meetings? Then, I make a note of their reply and follow their suggestions. Funny, I have a client who always wants me to fax her, yet she always complains that she never receives the faxes. So, whenever we fax her, our office manager voice-mails and e-mails her to tell her she needs to look for her fax. Weird, yes, but this is what the client asked for, so we steadfastly adhere to her request.

Learning Some Hard Lessons

I have had the misfortune to be the whipping post for lots of clients throughout my years as a business owner. It's so strange to have a schizophrenic client who loves you one minute and then berates you the next with unreasonable ultimatums, sarcasm, demands, and tones of voice that could curdle blue cheese. I hate to admit that, in my firm's

Other pertinent client communication tips include:

- For ongoing clients, e-mail and fax them a weekly status report.
- Make quarterly meetings with existing and potential clients to show them your recent work. It's so easy to forget your existing client list relative to your latest and greatest.
- Don't be reluctant to toot your own horn. Many younger people in our business tend to shy away from talking about their successes and think by simply showing their work, it should speak for itself. Not true. Learning how to talk about your work in relation to qualitative and quantitative performance is quite necessary in obtaining clients at the next level.
- Realize that your client has a life. Respect it. Don't call clients on Mondays if you can help it. Mondays are hectic, do-everything-you-didn't-get-done-on-Friday kind of days. Don't call them between 11:45 A.M. and 2 P.M. unless you have a lunch appointment together. Don't call them after 4:45 P.M. They're trying to wrap up their day. The best time to make calls is between 9 and 11 in the morning.
- If you have bad news, try to hold it until Friday afternoon. Fridays are usually happy days, and then you both have the weekend to think about problem solving.

case, most of these attitudes come from middle managers, usually women. When I am confronted with this type of client, I try to listen to the wrath and remove myself from them as soon as possible.

There is absolutely no possible way to win a conversation with someone who is in this frame of mind. They want to beat you up because it makes them feel superior and strong. After the bullying, and after a safe amount of time has passed, hopefully after a remedy to whatever originated the stress, I try to schedule some off-site time with them. This meeting is the foundation for whether or not this client has longevity with me. Life is too sweet to surround oneself with unhappiness. I am quick to validate their anger and be sorry they were angry. Remember, I can validate without agreeing whether or not it was right. But then, I must have a compassionate, direct conversation with them about their communication style. You get what you want by being nice,

simple as that. One can demand with gentle firmness. It is an art, but it can be accomplished through practice.

Getting Down to Basics

A review of somewhat generic communication tips follows, with specific correlations to our profession. I like to share these subjects openly at lectures I am asked to give in our industry and open the floor for case studies and feedback. Think of your own experiences at the end of every week, and, if you are of the mindset, start an informal journal of communication occurrences, good and bad. This will help you to start your own log of stories for future discussions with employees.

The basics begin with what I call the handshake versus the Hollywood hug. I come from the Midwest, where people are basically conservative, it's cold in the wintertime, and hugs are for family. When I arrived in Hollywood, I was surprised to find that a lot of my clients actually hug or do the chic cheek thing—men and women alike!

When I speak to an audience, large or small, I like to introduce myself and my lecture by walking around the room with a lavaliere mic, shaking as many people's hands as I can. Then, I introduce the concept of first impressions. Whether your subculture shakes hands (it's always the safest way to get started) or hugs (these usually come after the first job or two), it's important to do so with warmth and sincerity. Too many men loosely shake women's hands like noodles. They need to learn to sincerely shake with firm (yet not bone-splitting) simplicity. On the other hand, too many ladies want to make a statement that they're strong and have their guns loaded, and they shake too hard. Learning to shake hands well might sound extremely elementary, but try it objectively within your circle of close friends. Ask for honest critiques, and get it all out in the open. Everyone might learn something surprising.

Nonverbal communication says volumes. Posture, eye contact, vocal cues, personal space allowance, and your appearance say the world about who you are, where you've been, and where you're going to go. Think of popular people within our American culture and even your regional political figures, and you'll see what I mean. There's definitely something we say with our body language. For example, sitting at a conference table with your arms folded tightly across your chest in a negotiating session is likely to get you out the door a failure.

Learn to exert your professional influence without being over-powering. In most cases, in-person, face-to-face communication is best for clarifying, explaining, resolving issues, uncertainty, and any mis-understandings. Environment and context can also influence the success of your dominance. Choose a light, airy location for your important conferences. Be on time. Showing up late gives an appearance of arrogance and having something else that was more important taking precedence. Even if this is truly the case, you don't want to let the person waiting get this impression.

E-mailing can be a very good and, just as quickly, a very bad means of communicating effectively. I suggest using e-mail for information delivery only. I also make it a point to request a return receipt on all dated, important messages. Cyberspace has its delivery glitches. If you're going to use e-mail, commit to using it proficiently. This means you or your secretary will need to follow up on your sent messages and make sure that you received replies to time-sensitive material. Never share emotions or concerns via e-mail. Too often, our personalities cause us to write either to much or too little, too bluntly or too enticingly. Having others reading between our lines can really get us into lots of trouble, especially when what they're reading is not what we intended. Better to play it safe and stick to the facts.

Some Ideas for Improvement

Learn to role play as a means for better communication. If you have a client who constantly befuddles you, practice the possible conversational scenarios that might arise. I like to do this in the car with a mini-recorder. It's fun to talk into a voice-activated box and pretend you're the other guy and then you, all while you're cruising to your next appointment or picking up dinner at the drive-through. It's even more fun to listen to yourself later. Go ahead and amuse yourself. You're an imaginative person; that's why you're in this business. You will get better at guessing what your client is going to say the more you play this game. Just think, you're always the winner in this one!

Politics play a huge role in how well we communicate with our clients. I'm not talking about your registered voting party; I'm talking about intrapersonal issues within your clients' companies. Be a listener. Remember, you can totally validate someone without agreeing with them. This learning came to me from John Gray's Mars and Venus

books and has been magical for me. Don't get involved with who said what or who did what on that weekend, last month, or next year. Keep your knowledge of so-called political agendas within your clients' domain to yourself; it's the safest place to maintain professional integrity and client loyalty to your firm.

I have a "me versus we" theory that reminds me and my staff that, by signing a contract with a client, we are agreeing to collaborate. We are now a team. It is our challenge, therefore, to deem ourselves collectivistic versus individualistic without selling our souls. Questioning and answering what we want and what we can give in return helps to establish priorities at the onset of a new project even when a relationship has been well identified with a client. New projects mean new ways of thinking and exploring our flexibility. This is not always easy, and we need to remind ourselves of our commitment to collaboration.

Why You Charge What You Do

We charge what we do as graphic designers because we are experts. Being experts requires us to look at ourselves as much more than artists of visual communications. We are ultimately experts at communication of all varieties, at all levels. Making excuses for our pricing structure will only undermine our own authority. Being proficient in communication can come naturally to us when we embrace these concepts, resulting in better self confidence and stability.

The roles that you play as initiator, contributor, information seeker, opinion maker, information giver, elaborator, coordinator, orienter, mediator, evaluator, energizer, technician, lawyer, accountant, motivator, harmonizer, compromiser, and expediter all tie into the ultimate reasons for my having written this book. Pricing, estimating, and budgeting for our industry have their own place in Maslow's hierarchy theory. Self-actualization, followed by esteem, belongingness, safety, and psychological aptitude, all tie into our ability to communicate well—a skill that has become quite critical in our ever-changing industry. If we see each other as colleagues rather than as competitors, if we are generous with what we know, and if we are eager to learn from each other, our position and role in the business world at large will continue to grow and prosper.

■

Current Software Availability

I t's been a real chore to find software designed specifically for pricing, estimating, and budgeting in our industry. The following list is a short one, along with some editorial comments. My most objective suggestion is for you to keep it as simple as what you are 100 percent committed to managing. If there is no way you are going to embrace the capabilities of a new piece of software that has nothing to do with design, don't do it. Keep it manual for as long as you can, especially if you're a one- or two-person shop.

By manual, I mean designing forms that are easy for you to use and implement into your daily routines. Time sheets, purchase orders, change orders, approval orders, log sheets, and job contracts are an absolute necessity. You can design an entire system in one day and put it to use in either your favorite word processing program or Quark Xpress. I've previously mentioned *Business and Legal Forms for Graphic Designers*. This book makes it too easy to design forms with the handy enclosed CD-ROM, containing invaluable templates which are more than easy to modify according to your individual requirements.

You can keep your monthly bills in twelve assigned monthly envelopes—or one of those big accordion folders—and pay your tax accountant to add them up at the end of the year, applying them to the right tax formula. Better organization might include filing receipts and paid bills by category, such as those listed in the fixed and unfixed

lists on page 7. Have a tax accountant help organize you if you're in the dark. I used a manual ledger (supplied by my accountant after a five-minute training session) for three years before converting to accounting software, and it was very simple. There is too much stress meeting deadlines in our profession, let alone accomplishing the task of learning accounting software.

We're under so much pressure to automate, automate, and yet in my opinion there are no completely wonderful, user-friendly automation tools providing comprehensive service to the graphic design industry. I prefer proven, off-the-shelf accounting software for record-keeping, accounting, billing, etc. Use a payroll service to do your payroll. It's very cost-efficient and requires very little brain power. They complete your payroll tax documents and make the process totally foolproof. This entire methodology is perfect for small to midsize firms.

Larger firms can afford to hire an independent programming specialist who can design a platform better than what's available off the shelf, with specific details and direct links to your traffic management. The trouble with going this route is that you need to be very clear about your needs; it's like building a house—you have to know what you want and cannot keep changing your mind during the building process. If you use an independent software developer, make sure you get references, and make sure his pricing process compares to your multimedia pricing process. Approve the project in phases, and have enough time allotted between phases to make sure things are operating properly. You may want to use your new skills to negotiate a service contract as well.

I'm sure there are probably other software availabilities; my list goes from the most obvious to more obscure choices. I have asked literally every design firm owner with whom I've spoken what type of system they use. Larger firms typically have their own system written specifically for their requirements, as noted above. The rest are a mix of off-the-shelf to manual. None of us seem to be elated with any of the systems we're using. I believe the reason is because few of us really want to deal with this aspect of the business. A frequent remedy for a growing firm is to attract a partner to our firm who wants to operate this part of the business.

It's a huge and important responsibility. But now, you have some new ideas and skills to help you make your own decision. Consider this book a therapy of sorts. You've learned some new concepts with regard to pricing, estimating, and budgeting. You've read some case studies

and found some applications that are appealing to you. Now, it's time to try out what feels right. This is a very intuitive business. Our creativity comes from within, and we tend to manage our businesses the same way. There is no wrong and right way; whatever works for efficiency, sanity, and profitability is your winning answer. Good luck!

Clients & Profits—*www.clientsandprofits.com*

Clients & Profits is really a revolutionary product for our industry. They have a very buttoned-up Web site and customer service people on their 800 number. There are different products and modules of the software you can buy, depending on the size of your company and the functions you want it to perform. The theory behind their software application is excellent. The actual application itself is very time-consuming to learn, very tedious to maintain—it requires incessant data inputting and backing up—and, at the time of installation, throws your whole firm into a wild frenzy. It's also expensive, but around the first of October every year, they have an end-of-year sales promotion that can save you at least $1,000.

What they don't tell you up front is that you need a fairly sophisticated, dedicated file server if you don't want to be crashing every other week. Training on the software is done only by subcontractors who are contracted by Clients and Profits to represent the company, but whom you pay directly—$750 to $1,000 per day plus expenses and no shuttle planes, with a hotel room near a restaurant on a well-lit street with good spa services. Training on the accounting functions only takes an average of three days. Traffic training takes about two days. Training doesn't mean you're up and running; it's a long term commitment. Our trainer told me that we would not be fully using the software for about eighteen months after we installed. My salesperson didn't tell me that.

I have a lot of colleagues who use Clients and Profits, and there are a lot of testimonials on their Web site. Everyone I've talked to has problems but likes it for one reason or another. No one I know uses it to its full, maximum capacity. If you could have three full-time people dedicated to inputting and using every piece of the application, life would be perfect with Clients and Profits. I am hoping that they continue to improve this product.

QuickBooks, QuickBooksPro2000—*www.quickbooks.com*

The folks at Intuit really know how to design well-running, easy-to-use software. I am using QuickBooks for my family ranch and specialty food company, and I love everything about it. It comes with a very intuitive demo and is written and designed like it should be—simple, fast, easy, no guessing games. They even have special applications specifically for graphic design firms.

My biggest beef with QuickBooks is that QuickBooksPro has not been written for the Macintosh platform. I've called the company on several occasions, posing first as a consumer and then as an author, and no on can tell me when the Mac version will be out. One customer service rep promised it spring 2001, and another representative told me that it wasn't even on the drawing board. QuickbooksPro 2000 has many extended values, like automated banking and payroll built right into the system. Sales, marketing, office management, purchasing, human resources issues, and technology solutions are all features of the updated version, not available on Mac. Install VirtualPC, and you're up and running with this latest version . . . even on your Mac!

VirtualPC—*www.connectix.com*

I am in love with VirtualPC! Get on their corporate Web site, and take the comprehensive tour. This software allows your Mac to operate any Windows system software—right on your trusty Mac machine. One downside is that you need to learn some Windows functions . . . but being able to run the PC version of QuickBooksPro 2000 is especially worth spending a day and learning some new skills. There are cheap, one-day Windows classes all over the world anyway. The other downside is that you have to buy a different version of the software for different operating editions of Windows. Some Windows 98 programs will run on the latest version of VirtualPC 2000, but you need to verify each program through Connectix. Their customer service department at 1-800-950-5880 is very friendly and can answer any questions quickly and with a smile. Look for this technology to get more and more prodigious.

MYOB—*www.myob.com*

The excellence of this accounting software is unproven to me personally, but it was strongly recommended by some accounting colleagues whom I trust explicitly. I am impressed by their marketing and their Web site. MYOB is an acronym for Mind Your Own Business, and the application looks sophisticated and diverse. Check it out as an option.

Estimating Manager, Traffic Manager—*www.phippen.com*

Bonnie Phippen is a talented graphic designer who has operated Phippen Design Group in San Francisco for twenty-five years. Bonnie has designed two simple, yet effective, software tools for our industry called Estimating Manager and Scheduling Manager. Minimum system configurations required to run the programs are a Mac with 1 MB RAM (hello!) and Microsoft Excel Version 2.2 or later.

Estimating Manager is actually a customized version of Microsoft Excel for Macintosh. An easy-to-understand, eleven-page manual gets you up and running in about an hour.

Scheduling Manager helps designers streamline and simplify the scheduling process. With a single command, it sets up a blank schedule with several columns to fill in and a column of dates on each side. Weekends are shaded for easy scanning of a completed schedule, and there are even columns to indicate when someone will be out of the office. Then, all you have to do is spend a few minutes inputting data on each of your jobs—all the rest is automatic.

Scheduling Manager is just as simple to use as Estimating Manager. What I like about it is the versatility of the program: It can be used to schedule several aspects of a single job, such as design, production, and printing, or you can input schedules for all the jobs in your office for a quick overview. It's also really easy to change the job's whole schedule with a single command.

Estimating Manager sells for only $99. Add $20 for Scheduling Manager, which sells alone for $50. Such a deal, and perfect for the small to midsize firm.

■

Business Forms

The use of business forms is crucial for the smooth running of any business. The forms gathered in this appendix are intended to help in implementing the business steps and strategies discussed in this book. No form can fit all situations, but these forms can at least offer a starting point for the creation of customized forms that will be best for your company.

- The *Estimating Worksheet* is designed to allow you to understand all the costs you are likely to incur, so you can prepare an accurate estimate to give to your client.
- The *Estimate/Confirmation of Assignment* serves both to present your estimate to the client and, if the job goes forward, as the contract for the project.
- The *Project Mission Statement* is used internally to clarify how the design team will act individually and together to meet the defined goals of the project.
- The *Weekly Time Sheet* allows the tracking of time spent on the project, which can then be related back to the Estimating Worksheet to see if the project is on target.
- The *Project Expense Ledger* details all expenditures for the project and can also be reviewed against the Estimating Worksheet.

- The *Change Order Form* makes certain that the client has approved and will pay for any changes.
- The *Invoice* is used to bill the client and incorporates by reference the terms of the Estimate/Confirmation of Assignment.

The best resource for the designer to develop business forms is *Business and Legal Forms for Graphic Designers*, by Tad Crawford and Eva Doman Bruck. It offers a wide variety of forms, an in-depth discussion of and negotiation checklist for each form, and includes a CD-ROM with the forms for ease of customization. Another excellent resource is the *Graphic Artists Guild's Pricing and Ethical Guidelines*.

This appendix and the forms contained herein have been created for this book by Tad Crawford (© Tad Crawford 2001) and are published here with his permission.

■

Estimating Worksheet

Date _____ Client _____

Job Number _____ Project _____

	NAME/HOURLY RATE	PHASE 1 HOURS/AMOUNT	PHASE 2 HOURS/AMOUNT	PHASE 3 HOURS/AMOUNT	TOTALS HOURS/AMOUNT
Fees					
Graphic Designer					
Art Director					
Account Manager					
Production Director					
Computer Artist					
Other					
SUBTOTAL					

	COMPANY/NAME	PHASE 1 AMOUNT	PHASE 2 AMOUNT	PHASE 3 AMOUNT	TOTALS
Expenses					
Markup					
Percentage					
B&W Copies					
Color Copies					
Stats/Veloxes					
Scanning					
Typography					
Delivery					
Art Supplies					
Photography					
Illustration					
Writing					
Copyedit/Proofreading					
Proofs					
Printing					
Retouching					
Client Alterations					
Messengers/Shipments					
Travel					
Other					
SUBTOTAL					
TOTAL					

Estimate/Confirmation of Assignment *(Designer's Letterhead)*

Date _____ Client_____

Job Number _____ Project_____

This Estimate is based on the specifications and terms that follow. If the Client confirms that the Designer should proceed with the assignment based on this Estimate, it is understood that the assignment shall be subject to the terms shown on this Estimate and that Client shall sign on the reverse side of this form to make it a Confirmation of Assignment. If the assignment proceeds without this form being signed by both parties, the assignment shall be governed by the terms and conditions contained in this Estimate.

Project Description

Fees

Graphic Designer	_____
Art Director	_____
Account Manager	_____
Production Director	_____
Computer Artist	_____
Other	_____
SUBTOTAL	_____

Expenses

B&W Copies	_____
Color Copies	_____
Stats/Veloxes	_____
Scanning	_____
Typography	_____
Delivery	_____
Art Supplies	_____
Photography	_____
Illustration	_____
Writing	_____
Copyediting/Proofreading	_____
Proofs	_____
Printing	_____

Retouching	_____
Client Alterations	_____
Messengers/Shipments	_____
Travel	_____
Other	_____
SUBTOTAL	_____

TOTAL $ _____

1. Description. The Designer shall create the Work in accordance with the project description and the following specifications:

2. Due Date. A preliminary design shall be delivered within _____ days after either the Client's authorization to commence work or, if the Client is to provide reference, layouts, or specifications, after the Client has provided same to the Designer, whichever occurs later. The finished design shall be delivered _____ days after the approval of the preliminary design by the Client.

3. Grant of Rights. Upon receipt of full payment, the Designer shall grant to the Client the following rights in the finished art:

For use as _____

For the product or publication named _____

In the following territory _____

For the following time period _____

Other limitations_____

With respect to the usage shown above, the Client shall have ☐ exclusive ☐ nonexclusive rights.

This grant of rights does not include electronic rights, unless specified to the contrary here _____, in which event the usage restrictions shown above shall be applicable. For purposes of this agreement, electronic rights are defined as rights in the digitized form of works that can be encoded, stored, and retrieved from such media as computer disks, CD-ROMs, computer databases, and network servers.

4. Reservation of Rights. All rights not expressly granted shall be reserved to the Designer, including but not limited to all rights in preliminary designs.

5. Fee. Client shall pay the purchase price of $_____ for the usage rights granted. Client shall also pay sales tax, if required.

6. Additional Usage. If Client wishes to make any additional uses of the Work, Client shall seek permission from the Designer and pay an additional fee to be agreed upon.

7. Expenses. Client shall reimburse the Designer for expenses. Such expenses shall be invoiced at cost plus 15 percent, which additional percentage is included in this Estimate. At the time of signing the Confirmation of Assignment or the commencement of work, whichever is first, Client shall pay Designer $_____ as a nonrefundable advance against expenses. If the advance exceeds expenses incurred, the credit balance shall be used to reduce the fee payable, or, if the fee has been fully paid, shall be reimbursed to Client.

8. Payment. Client shall pay the Designer within thirty (30) days of the date of Designer's billing, which shall be dated as of the date of delivery of the finished design. In the event that work is postponed at the request of the Client, the Designer shall have the right to bill pro rata for work completed through the date of that request, while reserving all other rights. Overdue payments shall be subject to interest charges of _____ percent monthly.

9. Advances. At the time of signing this form or the commencement of work, whichever is first, Client shall pay Designer _____ percent of the fee as an advance against the total fee. Upon approval of the preliminary design, Client shall pay Designer an additional _____ percent of the fee as an advance against the total fee.

10. Revisions. The Designer shall be given the first opportunity to make any revisions requested by the Client. If the revisions are not due to any fault on the part of the Designer, an additional fee shall be charged. If the Designer objects to any revisions to be made by the Client, the Designer shall have the right to have his or her name removed from the published Work.

11. Copyright Notice. Copyright notice in the name of the Designer ☐ shall ☐ shall not accompany the Work when it is reproduced.

12. Authorship Credit. Authorship credit in the name of the Designer ☐ shall ☐ shall not accompany the Work when it is reproduced. If the finished design is used as a contribution to a magazine or for a book, authorship credit shall be given, unless specified to the contrary in the preceding sentence.

13. Cancellation. In the event of cancellation by the Client, the following cancellation payment shall be paid by the Client: (A) cancellation prior to the finished design being turned in: _____ percent of fee, (B) cancellation due to finished design being unsatisfactory: _____ percent of fee, and (C) cancellation for any other reason after the finished design is turned in: _____ percent of fee. In the event of cancellation, the Client shall also pay any expenses incurred by the Designer, and the Designer shall own all rights in the Work. The billing upon cancellation shall

be payable within thirty (30) days of the Client's notification to stop work or the delivery of the finished design, whichever occurs sooner.

14. Ownership and Return of Artwork. The ownership of original artwork, including preliminary designs and any other materials created in the process of making the finished design, shall remain with the Designer. All such artwork shall be returned to the Designer by bonded messenger, air freight, or registered mail within thirty (30) days of the Client's completing its use of the artwork. Based on the specifications for the Work, a reasonable value for the original, finished design is $_____. Original photography, illustration, and related copyrightable materials shall remain the property of the third party licensor FIX, provided that the Designer has obtained rights sufficient for the usage The above charges are only for use of such materials on this particular Work, unless purchase/reuse rights are arranged by _____. The above charges are for one-time use only.

15. Permissions and Releases. The Client shall indemnify and hold harmless the Designer against any and all claims, costs, and expenses, including attorney's fees, due to materials included in the work at the request of the Client for which no copyright permission or privacy release was requested or uses that exceed the uses allowed pursuant to a permission or release.

16. Arbitration. All disputes shall be submitted to binding arbitration before _____ in the following location _____ and settled in accordance with the rules of the American Arbitration Association. Judgment upon the arbitration award may be entered in any court having jurisdiction thereof. Disputes in which the amount at issue is less than $_____ shall not be subject to this arbitration provision.

17. Miscellany. If the Client authorizes the Designer to commence work, the terms of this form shall be binding upon the parties, their heirs, successors, assigns, and personal representatives; the form constitutes the entire understanding between the parties; its terms can be modified only by an instrument in writing signed by both parties, except that the Client may authorize expenses and revisions orally; a waiver of a breach of any of its provisions shall not be construed as a continuing waiver of other breaches of the same or other provisions hereof; and the relationship between the Client and Designer shall be governed by the laws of the State of _____.

_____ _____
DESIGNER CLIENT

Project Mission Statement

Because our work for a client is likely to take place over an extended period of time and require extensive coordination among our staff members and with the client, it is important to define our roles, goals, and the steps needed to achieve these goals prior to commencing the project.

Name _____ Date _____

Client _____ Project _____

Overall goal:

Why did you select this as a goal?

Subgoals (if applicable)

What obstacles do you face?

What skills do you have to overcome any obstacles?

Action Steps
 1.
 2.
 3.
 4.
 5.

How can your creative colleagues assist you in achieving this goal?

What will be a successful outcome of your work on this project?

What are the pricing implications of the goal, subgoals, and steps you have described above?

Weekly Time Sheet

Name _____ Week of _____

DATE	JOB #	CODE	DESCRIPTION	LASERS	TIME IN/OUT	HOURS ·	OT

REGULAR TIME	OVERTIME

Project Expense Ledger

Date _____ Client _____

Job Number _____

DATE	SUPPLIER	B&W COPIES	COLOR COPIES	STATS/VELOXES	SCANNING	TYPOGRAPHY

DATE	SUPPLIER	WRITING	EDITING/PROOFING	PROOFS	PRINTING	RETOUCHING

DELIVERY	ART SUPPLIES	PHOTOGRAPHY	ILLUSTRATION

CLIENT ALTS	DELIVERY	TRAVEL	OTHER

Total $ _____

Change Order Form *(Designer's Letterhead)*

Date _____ Client_____

Job #_____ Job Description _____

Description of change

Original Estimate_____ New Estimate_____

On behalf of the client, I confirm that we have ordered this change and agree to the New Estimate.

_____ _____
CLIENT AUTHORIZED SIGNATORY

Invoice *(Designer's Letterhead)*

Client _____ Invoice # _____

Address _____ Invoice Date _____

_____ Terms: Net _____ days

Client Contact _____ Client P.O. _____

Job Name_____ Job Number _____

For design services and expenses more fully described as follows:

Current charges $ _____

Sales tax $ _____

Current total $ _____

Prior invoices due, if any:

Invoice # _____ Date _____ Amount $ _____

Invoice # _____ Date _____ Amount $ _____

Invoice # _____ Date _____ Amount $ _____

Total amount due $ _____

This invoice is subject to the terms and conditions of the Estimate/Confirmation of Assignment dated _____, 20___.

Organizations

The following organizations either have designers as members or are of potential interest to designers.

American Center for Design (ACD)
325 West Huron, Suite 711, Chicago, IL 60610
(312) 787-2018; *www.ac4d.org*
The ACD is a national organization of more than two thousand design professionals, educators, and students. The ACD is committed to connecting its members to each other and to the research, ideas, and technologies that are continually shaping, reshaping, and influencing design and design practice. In addition to promoting excellence in design education and practice, the ACD serves as a national center for the accumulation and dissemination of information regarding design and its role in our culture and economy.

The American Institute of Graphic Arts (AIGA)
National Design Center, 164 Fifth Avenue, New York, NY 10010
(212) 807-1990; *www. aiga.org*
Founded in 1914, the AIGA is the national, nonprofit organization of graphic design and graphic arts professionals, with forty-two chapters nationwide. Members of the AIGA are involved in the design and production of books, magazines, periodicals, film and video graphics, and

interactive multimedia, as well as corporate, environmental, and promotional graphics. The AIGA national and chapters conduct an interrelated program of competitions, exhibitions, publications (including an annual of graphic design and a quarterly journal), educational activities, and projects in the public interest to promote excellence in, and the advancement of, the graphic design profession. The Institute holds a biennial design conference and a biennial business conference. The AIGA has over fifteen thousand members.

Americans for the Arts (ACA)

One East 53rd Street, New York, NY 10022

(212) 223-2787; *www.artsusa.org*

The ACA offers multilayered programs in arts education and in the study and application of arts policy; publishes books, reports, and periodicals; maintains a clearinghouse of public arts policy; encourages and supports private sector initiatives for increased giving to the arts; advocates before Congress for legislation benefitting the arts; disseminates information to improve artists' living and working conditions; conducts research, organizes conferences and public forums, and sponsors and administers such prestigious programs as the Visual Artists Hotline (1-800-232-2789), the annual Nancy Hanks Lecture on Arts and Public Policy, and Arts Advocacy Day.

American Society of Picture Professionals (ASPP)

409 South Washington Street, Alexandra, VA 22314

(703) 299-0219; *www.aspp.com*

The ASPP has a wide membership base and a number of chapters that include photographers, stock agencies, researchers, and buyers. The organization publishes a quarterly magazine, *The Picture Professional*, a newsletter, and an annual directory, and provides a job posting service for members on its Web site.

Art Directors Club, Inc. (ADC)

106 West 29th Street, New York, NY 10001

(212) 643-1440; *www.adcny.org*

Established in 1920, the Art Directors Club is an international, nonprofit membership organization for creative professionals, encompassing advertising, graphic design, new media, photography, illustration, typography, broadcast design, publication design, and packaging.

Programs include publication of the *Art Director's Annual*, a hardcover compendium of the year's best work compiled from winning entries in the Art Director's Annual Awards. The ADC also maintains a Hall of Fame, ongoing gallery exhibitions, speaker events, portfolio reviews, scholarships, and High School Career Workshops.

The Business Committee for the Arts, Inc.

1775 Broadway, Suite 510, New York, NY 10019

(212) 664-0600; *www.bcainc.org*

Founded by David Rockefeller in 1967, this is the first and only national, not-for-profit organization of business leaders committed to supporting the arts and to encouraging new and increased support for the arts from the American business community.

Chicago Artists' Coalition (CAC)

11 East Hubbard, Chicago, IL 60611

(312) 670-2060; *www.caconline.org*

The Coalition is an artist-run service organization for visual artists. Services include a newspaper, slide registry, job referral service, health insurance, national credit union, free lectures, discounts at art supply stores, annual tax and recordkeeping workshop, business-of-art conferences, a resource center, and publications. CAC offers student, senior citizen, individual, and family memberships.

The Foundation Center

79 Fifth Avenue, New York, NY 10003

1-800-424-9836; *www.fdncenter.org*

The Foundation Center Network is an independent national service organization that provides authoritative sources of information on private philanthropic giving. There are Foundation Centers in New York City, Washington, D.C., Cleveland, and San Francisco, with over one hundred cooperating library collections. Toll-free information at 1-800-424-9836 will provide locations.

Grantsmanship Center

P.O. Box 17220, Los Angeles, CA 90017

(213) 482-9860; *www.tgci.com*

The Center conducts proposal-writing workshops throughout the United States and produces publications on funding for nonprofit

organizations, including a quarterly newsletter, *The Whole Nonprofit Catalog*, which is free to public and private nonprofit organizations. Their services are generally designed for use by organizations, not individual artists.

Graphic Artists Guild (GAG)

90 John Street, Suite 403, New York, NY 10038
1-800-500-2672; *www.gag.org*

This national organization represents three thousand professional artists active in illustration, graphic design, textile and needle art design, computer graphics, and cartooning. Its purposes include: to establish and promote ethical and financial standards, to gain recognition for the graphic arts as a profession, to educate members in business skills and lobby for artists' rights legislation. Programs include: group health insurance, bimonthly newsletters, publication of the handbook, *Pricing and Ethical Guidelines*, legal and accounting referrals, artist-to-artist networking, and information sharing.

The Society for Environmental Graphic Design (SEGD)

401 F Street N.W., Suite 333, Washington, D.C. 10001-2728
(202) 638-5555; *www.segd.org*

An international, nonprofit organization founded in 1973, SEGD promotes public awareness and professional development in the field of environmental graphic design—the planning, design, and execution of graphic elements and systems that identify, direct, inform, interpret, and visually enhance the built environment. The network of over one thousand members includes graphic designers, exhibit designers, architects, interior designers, landscape architects, educators, researchers, artisans, and manufacturers. SEGD offers an information hotline, resource binder, quarterly newsletter, biannual journal, a *Process Guide, Technical Sourcebook,* information clarifying the Americans with Disabilities Act as it pertains to signage, an annual competition and conference, and more than fifteen regional groups that help connect people working in the field and offer a variety of tours, demonstrations, and meetings.

Society of Illustrators (SI)

128 East 63rd Street, New York, NY 10021
(212) 838-2560; *www.societyillustrators.org*

Founded in 1901 and dedicated to the promotion of the art of illustration, past, present, and future. Included in its programs are the Museum of American Illustration; annual juried exhibitions for professionals, college students, and children's books; publications; lectures; archives; and library. SI also sponsors member exhibits in one-person and group formats, and government and community service art programs. Membership benefits are social, honorary, and self-promotional and include Artist, Associate, Friend, and Student levels.

Society of Photographer and Artist Representatives, Inc. (SPAR)

60 East 42nd Street, Suite 1166, New York, NY 10165

(212) 779-7464

SPAR was formed in 1965 for the purposes of establishing and maintaining high ethical standards in the business conduct of representatives and the creative talent they represent as well as fostering productive cooperation between talent and client. This organization runs speakers' panels and seminars with buyers of talent from all fields, works with new reps to orient them on business issues, offers model contracts, publishes a newsletter, and offers free legal advice. Categories for members are Regular (agents), Associates, and Out-of-Town.

Society of Publication Designers (SPD)

60 East 42nd Street, Suite 721, New York, NY 10165

(212) 983-8585; *www.spd.org*

Begun in 1964, the SPD was formed to acknowledge the role of the art director-designer in the creation and development of the printed page. In their vision, the art director as journalist brings a visual intelligence to the editorial mission to clarify and enhance the written word. Activities include an annual exhibition and competition, a monthly newsletter, special programs, lectures, and the publication of an annual book of the best publication design.

Volunteer Lawyers for the Arts (VLA)

One East 53rd Street, Sixth Floor, New York, NY 10022

(212) 319-2787

VLA is dedicated to providing free arts-related legal assistance to low-income artists and not-for-profit arts organizations in all creative fields. Five hundred plus attorneys in the New York area annually donate their time through VLA to artists and arts organizations unable to afford

legal counsel. VLA also provides clinics, seminars, and publications designed to educate artists on legal issues that affect their careers. California, Florida, Illinois, Massachusetts, and Texas, to name a few, have similar organizations. Check "Lawyer" and "Arts" phone directory listings in other states, or contact the VLA in New York City for a referral.

■

Other Resources and Web Sites

Clients & Profits (*www.clientsandprofits.com*): free software demo, discussion groups, online brochure.

MicroWarehouse/MacWarehouse (*www.warehouse.com*): software for PC and Mac, with excellent pricing and customer service. Ask to be assigned a corporate sales representative. Developing a personal relationship in these digital times is rare, and this company has it mastered. My rep is extremely knowledgeable and can suggest specific solutions to me by recommending products with which I might not even be aware.

Myers-Briggs Testing Institute (*www.mbti.com*): This site will probably take you to Consulting Psychologists Press, which is the company from which MBTI material is published.

QuickBooksPro (*www.quickbooks.com*): free demo of accounting software, nice Web site, responsive customer service.

Occupational Outlook Handbook (*http://stats.bls.gov/ocohome .htm*): an excellent source, not only to research what's happening in our industry, but our clients' professional arenas as well. Updates are issued every eighteen months to two years.

Lynda.com (*www.lynda.com*): I've included this site as a superb resource for internet and multimedia education.

■

Selected Bibliography

Berens, Linda V., and Dario Nardi. *The Sixteen Personality Types, Descriptions for Self-Discovery*. New York: Telos Publications, 1999.

Bowen, Linda Cooper. *The Graphic Designer's Guide to Creative Marketing*. New York: John Wiley & Sons, 1999.

Brinson, J. Dianne, and Mark F. Radcliffe. *Internet Law and Business Handbook*. Menlo Park, Calif.: Ladera Press, 1994.

——. *Internet Legal Forms for Business*. Menlo Park, Calif.: Ladera Press, 1997.

Crawford, Tad. *AIGA Professional Practices in Graphic Design*. New York: Allworth Press, 1998.

——. *Business and Legal Forms for Illustrators*. Rev. ed. New York: Allworth Press, 1998.

——. *Legal Guide for the Visual Artist*. 4th ed. New York: Allworth Press, 1999.

Crawford, Tad, and Eva Doman Bruck. *Business and Legal Forms for Graphic Designers*. Rev. ed. New York: Allworth Press, 1999.

DuBoff, Leonard D. *The Law [in Plain English™] for Small Businesses*. New York: Allworth Press, 1998.

Feldman, Franklin, Stephen E. Weil, and Susan Duke Biederman. *Art Law: Rights and Liabilities of Creators and Collectors*. 2 vols. Boston: Little, Brown and Company, 1986. Supp. 1993.

Foote, Cameron. *The Business Side of Creativity: The Complete Guide for Running a Graphic Design or Communications Business.* New York: W. W. Norton, 1999.

Gold, Ed. *The Business of Graphic Design.* New York: Watson-Guptill, 1995.

Goleman, Daniel P. *Emotional Intelligence: Why It Can Matter More Than IQ.* New York: Bantam Books, 1995.

Graphic Artists Guild. *Graphic Artists Guild Handbook: Pricing and Ethical Guidelines.* 9th ed. New York: Graphic Artists Guild, 1997.

Gray, John. *Men Are from Mars, Women Are from Venus: A Practical Guide for Improving Communication and Getting What You Want in Relationships.* New York: HarperCollins, 1992.

Heron, Michal, and David MacTavish. *Pricing Photography: The Complete Guide to Assignment and Stock Prices.* 3rd ed. New York: Allworth Press, 2002.

Keirsey, David, and Marilyn Bates. *Please Understand Me: Character and Temperament Types.* 5th ed. Amherst, N.Y.: Prometheus Book Co., 1984.

Leland, Caryn R. *Licensing Art and Design.* Rev. ed. New York: Allworth Press, 1995.

Ries, Al, and Jack Trout. *Positioning the Battle for Your Mind.* 2nd ed. New York: McGraw-Hill, 2001.

Sebastian, Liane. *Electronic Design and Publishing: Business Practices.* 3rd ed. New York: Allworth Press, 2001.

Shim, Jae K., and Joel G. Siegel. *Budgeting Basics and Beyond: A Complete Step-by-Step Guide for Nonfinancial Managers.* Upper Saddle River, N.J.: Prentice Hall, 1994.

Sparkman, Don. *Selling Graphic Design.* 2nd ed. Illustrated by Ed Gold. New York: Allworth Press, 1999.

Weisinger, Hendrie, *Emotional Intelligence at Work.* San Francisco: Jossey-Bass, 1997.

Williams, Theo. *Streetwise Guide to Freelance Design and Illustration.* Cincinnati: North Light Books, 1998.

United States Department of Labor. *Occupational Outlook Handbook.* 2000–01 edition. Lincolnwood, Ill.: NTC/Contemporary Publishing Co., 2000.

■

About the Author

Theo Stephan Williams is the founder of Real Art Design Group, Inc. Real Art is celebrating over sixteen successful years as a full-service graphic design firm with an international client base, including Universal Studios Hollywood, The Walt Disney Company, NCR, and the Mead Corporation, to name a few.

Theo has written three books for the creative industry. This current edition of *The Graphic Designer's Guide to Pricing, Estimating and Budgeting* is a revised and updated version by Allworth Press after countless requests and e-mails to Theo when the first edition went out of print. Her other titles are *The Streetwise Guide to Freelance Graphic Design and Illustration* (second printing, 1999) and *Creative Utopia* (winter, 2002). Theo taught various graphic design courses at both the University of Dayton and Sinclair Community College in Dayton, Ohio, for over seven years before opening a West Coast office for Real Art in 1997. She spoke at the HOW Design Conference in both 1998 and 1999, sharing an insider's perspective on various pricing techniques as well as communication challenges in the creative industry.

Real Art has won hundreds of graphic design and advertising awards from almost every known award-giving organization and has had multiple appearances in *Print* and *How* magazines.

Theo and her husband Joel own an organic olive ranch in Santa Barbara County. Together, they founded Global Gardens in 1998 and

globalgardensgifts.com in 2000, developing products from things grown on their ranch. They also import unique specialty food products under the Global Gardens name. A generous portion of their profits goes to benefit literacy programs in the United States, as well as general education in third-world countries.

■

Index

Books from Allworth Press

Business and Legal Forms for Graphic Designers, Revised Edition with CD-ROM
by Tad Crawford and Eva Doman Bruck (softcover, 8½ × 11, 240 pages, $24.95)

AIGA Professional Practices in Graphic Design
edited by Tad Crawford (softcover, 6¾ × 9⅞, 320 pages, $24.95)

Selling Graphic Design, Second Edition
by Don Sparkman (softcover, 6 × 9, 256 pages, $19.95)

Careers by Design: A Business Guide for Graphic Designers, Third Edition
by Roz Goldfarb (softcover, 6 × 9, 256 pages, $19.95)

Design Connoisseur: An Eclectic Collection of Imagery and Type
by Steven Heller and Louise Fili (softcover, 7¾ × 9⅜, 208 pages, $19.95)

Design Literacy (continued): Understanding Graphic Design
by Steven Heller (softcover, 6¾ × 9⅞, 296 pages, $19.95)

Design Literacy: Understanding Graphic Design
by Steven Heller and Karen Pomeroy (softcover, 6¾ × 9⅞, 288 pages, $19.95)

The Education of a Graphic Designer
edited by Steven Heller (softcover, 6¾ × 9⅞, 288 pages, $18.95)

Sex Appeal: The Art of Allure in Graphic and Advertising Design
by Steven Heller (softcover, 6¾ × 9⅞, 288 pages, $18.95)

**Design Culture: An Anthology of Writing from the AIGA Journal of Graphic
Design** *edited by Steven Heller and Marie Finamore* (softcover, 6¾ × 9⅞, 320 pages,
$19.95)

Looking Closer 3: Classic Writings on Graphic Design
edited by Michael Bierut, Jessica Helfand, Steven Heller, and Rick Poynor
(softcover, 6¾ × 9⅞, 304 pages, $18.95)

Looking Closer 2: Critical Writings on Graphic Design
edited by Michael Bierut, William Drenttel, Steven Heller, and DK Holland
(softcover, 6¾ × 9⅞, 288 pages, $18.95)

Looking Closer: Critical Writings on Graphic Design
edited by Michael Bierut, William Drenttel, Steven Heller, and DK Holland
(softcover, 6¾ × 9⅞, 256 pages, $18.95)

Please write to request our free catalog. To order by credit card, call 1-800-491-2808 or
send a check or money order to Allworth Press, 10 East 23rd Street, Suite 510, New York,
NY 10010. Include $5 for shipping and handling for the first book ordered and $1 for each
additional book. Ten dollars plus $1 for each additional book if ordering from Canada.
New York State residents must add sales tax.

To see our complete catalog on the World Wide Web, or to order online, you can find us
at *www.allworth.com*.